THE ULTIMATE FASHION STUDY GUIDE - THE DESIGN PROCESS

How to Generate Inspiration
& Produce Grade A Fashion Design Projects

First Edition

Victoria Hunter

Hunter Publishing Corporation
Los Angeles

THE ULTIMATE FASHION STUDY GUIDE - THE DESIGN PROCESS

How to Generate Inspiration
& Produce Grade A Fashion Design Projects

By Victoria Hunter

Published by:
HUNTER PUBLISHING CORPORATION
115 West California Boulevard, Suite 411
Pasadena, CA 91105 USA
Telephone: 626 792 3316
Fax: 626 792 7077
Website: www.hpcwww.com
Email: info@hpcwww.com
SAN 853-4853

Edited by Victoria Hunter
Illustrated by Victoria Hunter, Kendall Pata, Linda Wong, Hanya Chang & Angelo Estrada

First Printing 2007. Printed in the United States of America:
Softbound, with the Templates CD-ROM
ISBN# 978-0-9794453-1-6
Softbound ONLY
ISBN# 978-0-9794453-2-3
The Templates CD-ROM ONLY
ISBN# 978-0-9794453-3-0

Disclaimer This Guide is intended to provide fashion design students with techniques and information to assist them during their fashion studies. These techniques and information are not exhaustive and may or may not reflect the techniques and information being used within the fashion industry. Every effort has been made to make this Guide as accurate as possible at the time of printing. However, errors may have been made and we welcome any corrections and comments that will help to improve our product in future. The author, editor, illustrators and publisher shall have neither liability nor responsibility to any person or entity with respect to any loss or damage caused, or alleged to have been caused, directly or indirectly by the information and physical contents contained in this Guide and/or CD-ROM. No guarantee is provided that any person will receive a Grade A for any project or that inspiration will be generated.

About the Author Victoria Hunter is an award-winning graduate of The Fashion Institute of Design & Merchandising in Los Angeles, with over seven years of experience in the fashion education, fashion publishing and fashion design industries; based in the county of Los Angeles, California.

Publisher's Cataloging-in-Publication (Provided by Quality Books, Inc.)
Hunter, Victoria.
 The ultimate fashion study guide : the design process
: how to generate inspiration & produce grade A fashion
design projects / by Victoria Hunter.
 p. cm.
 Includes index.
 LCCN 2007924892
 ISBN-13: 978-0-9794453-1-6 (Softbound with CD-ROM)
 ISBN-13: 978-0-9794453-2-3 (Softbound only)
 ISBN-13: 978-0-9794453-3-0 (CD-ROM only)

 1. Fashion design. I. Title.

TT507.H86 2007 **746.9'2**
 QBI07-600106

9 8 7 6 5 4 3 2 1

INTRODUCTION

The Ultimate Fashion Study Guide – The Design Process is a one-stop resource, covering the fashion design process, from generating inspiration to professional, Grade A presentation. It displays precisely the information and tools needed at each step, in a format that is easy to grasp and interpret; enabling projects to be completed with speed, confidence and great results.

Not only does **The Ultimate Fashion Study Guide – The Design Process** deliver all the support required, but inspiration and insight into exploring your own creative skills and finding your niche within the fashion industry.

The skills described within are here because they have, and do, work for many fashion designers. However, the creative and commercial world of fashion is an ever-evolving and innovative one, so, once you've mastered the basics, we encourage you to keep an open, inquisitive mind and adapt your unique talents not just to your environment, but to your own personal definition of success.

The Ultimate Fashion Study Guide - The Design Process will become one of your most treasured possessions, and one which you will keep throughout your studies and on into the industry. Fill out the ownership form on the following page to make sure that you get it back, should you misplace it.

OWNERSHIP FORM

This Guide is really important to me so, if you find it, please return it to me, or contact me so I can arrange to collect it.

My contact information is:

NAME:

...

ADDRESS:

...

...

...

...

TELEPHONE:

...

EMAIL ADDRESS:

...

NOTES:

...

...

...

...

...

...

...

...

...

...

...

CONTENTS

CONTENTS

The following flow diagram shows the logic behind the elements that are incorporated within
The Ultimate Fashion Study Guide - The Design Process:

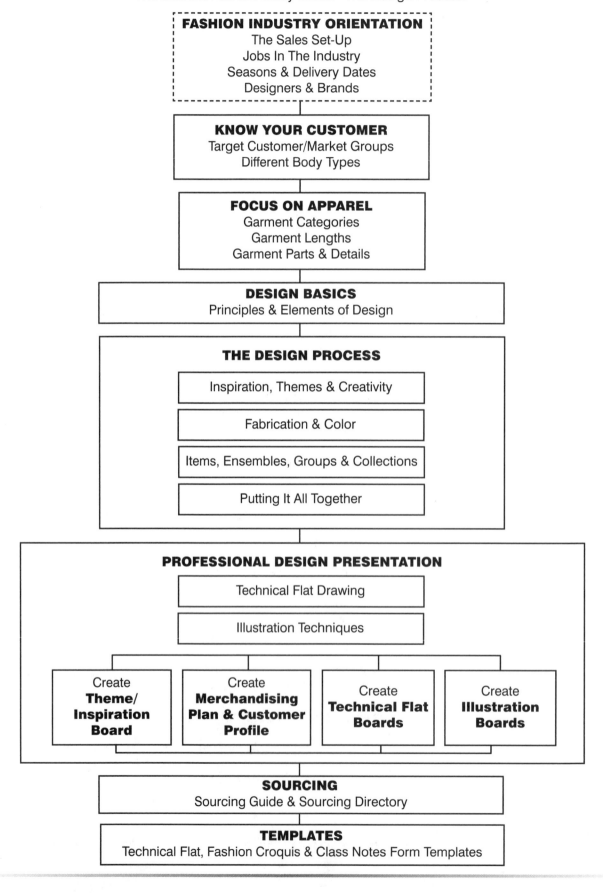

FASHION INDUSTRY ORIENTATION
The Sales Set-Up
Jobs In The Industry
Seasons & Delivery Dates
Designers & Brands

KNOW YOUR CUSTOMER
Target Customer/Market Groups
Different Body Types

FOCUS ON APPAREL
Garment Categories
Garment Lengths
Garment Parts & Details

DESIGN BASICS
Principles & Elements of Design

THE DESIGN PROCESS
Inspiration, Themes & Creativity

Fabrication & Color

Items, Ensembles, Groups & Collections

Putting It All Together

PROFESSIONAL DESIGN PRESENTATION
Technical Flat Drawing

Illustration Techniques

Create
**Theme/
Inspiration
Board**

Create
**Merchandising
Plan & Customer
Profile**

Create
**Technical Flat
Boards**

Create
**Illustration
Boards**

SOURCING
Sourcing Guide & Sourcing Directory

TEMPLATES
Technical Flat, Fashion Croquis & Class Notes Form Templates

FASHION INDUSTRY ORIENTATION

Get an insight into the business of the fashion industry and see where the design process fits in to the whole picture, as well as view the fashion designer's role from a business perspective. The following topics are included:

Page #

THE SALES SET-UP

INTRODUCTION

Being a successful fashion designer is about DESIGN and SALES.

FROM A DESIGN PERSPECTIVE:

There are many different platforms on which fashion designers succeed. Some designers are superb at creating the best quality custom-made designs using the highest quality materials and craftsmanship – known as 'haute couture' (French for 'high fashion') – and selling them at extremely high prices to a niche market of wealthy clients. Other designers find success in developing sophistocated, high quality, high priced clothing that is not custom-made, but has been made in advance to sizing specifications that meet the needs of the target customer – known as 'Prêt à Porter' (French for 'Ready to Wear'; English for 'Off-the-Shelf'). Other designers take their talent and specific skill of being able to identify and interpret a trend/need to deliver medium to low-cost styles in larger volumes.

The key to your success: Find out where your design strengths lie

FROM A SALES PERSPECTIVE:

If you want to earn a living as a fashion designer, you have to look at your design skills from a business perspective. A business succeeds when its profits are greater than its costs. In other words, your designs have to sell.

The key to your success: Get savvy about the business of fashion

By connecting to the industry, you can look at existing fashion businesses with a view to finding out who's doing what, how successful their strategies are and where you think you might best fit in. You'll not only learn vital information about the ebb and flow of the fashion process, but you'll be able to be that much more focused throughout your studies and position yourself for entry into your career, once school is over. You will help yourself to make decisions in the future by finding out as much information as you can, now.

The following subjects are covered, within this section:

SELLING YOUR LINE

TRADE SHOWS

APPAREL MARTS

BUYERS

SELLING YOUR LINE

Selling your line incorporates the following elements:

1. Sourcing the names and addresses of potential retail customers
2. Establishing the names of the buyers there
3. Providing the buyer with information about your line (via email, phone, personal visit, mail, trade shows, etc.)
4. Securing an order and negotiating price, delivery and terms
5. Fulfillment of the order, on time
6. Collecting monies owed
7. Continued contact for future sales.

There are two main options from which to choose when it comes to selling your line:

SELL IT YOURSELF

You may opt to carry out the above tasks personally or hire your own dedicated sales person, known as a 'Corporate Rep,' to act on your behalf or on behalf of the company you work for. A Corporate Rep works solely for one company and, in return, they are paid a basic salary, plus a commission on sales made.

HIRE AN INDEPENDENT SALES REPRESENTATIVE OR 'REP.'

There are a network of sales reps who make their living by selling lines to buyers. The reps are most likely to be located in a sales room at a fashion, or apparel 'market.' There are a number of these 'marts' located in major cities throughout the world. A rep will carry a number of different lines from different designers. These lines do not compete with each other, yet do appeal to the same buyers in terms of the customer profile and price. A great rep will already have established a reputation within the industry and have existing buyers and contacts. The rep will typically cover a particular geographic area with which he/she is familiar and will charge you a commission of 7-10 percent of the sales price on any garments she sells to buyers within this area. You will be required to supply your rep with samples from your line which he/she should display in the showroom to entice buyers. You may hire more than one rep to cover the various geographic areas you wish to cover.

Garment Manufacturer
Sells Goods at
Wholesale Prices
(adding a % profit (mark-up)
to the manufacturing cost)

(Middle-Man/Distributor)

Retailer
Buys Goods at
Wholesale Prices
then Sells Goods at
Retail Prices
(adding a % profit (mark-up)
to the wholesale price he paid)

(Middle-Man/Distributor)

Target Customer/End-User
Buys Goods at
Retail Prices
(plus added tax)

TRADE SHOWS

Trade shows are organized events, usually two to four days in duration, where buyers and sellers of the same commodity come together to do business. They are held at exhibition centers or apparel marts, in major cities around the world. Sellers typically rent a booth to show off their wares and sell to buyers who attend the event. Many trade shows are open only to buyers. However, should you get an opportunity to attend a trade show, it's a great place to learn about who's doing what within the industry.

Some of the biggest trade shows that take place within the fashion industry include:

D&A (Designers & Agents) - London, Los Angeles, New York, Tokyo (www.designersandagents.com)
FAME (Fashion Avenue Market Expo) - New York, United States (www.fameshows.com)
MAGIC (Men's Apparel Guild In California) - Las Vegas, Nevada, United States (www.magiconline.com)
MilanoVendeModa - Milan, Italy (www.milanovendemoda.it)
Prêt à Porter - Paris, France (www.pretparis.com)

APPAREL MARTS

Apparel marts, or market centers are places where companies and reps can permanently show their wares and buyers come to buy. These marts allocate times throughout the year where the focus is on promoting trade within a particular category of goods, such as fashion or gifts. These are called market dates.

Here are some of the main apparel marts in the United States:

Americas Mart, Atlanta
240 Peachtree Street, Suite 2200
Atlanta, GA 30303
Tel: 800-ATL-MART
www.americasmart.com

California Market Center
110 East 9th Street, Suite A727
Los Angeles, CA 90079
Tel: 800-225-6278
www.californiamarketcenter.com

Chicago Apparel Center
350 West Mart Center Drive
Chicago, IL 60654
Tel: 800-677-6278
www.merchandisemart.com

Dallas International Apparel Mart
2100 Stemmons Freeway
Dallas, TX 75207
Tel: 800-DAL-MKTS
www.dallasmarketcenter.com

Denver Merchandise Mart
451 East 58th Avenue, Suite 4270
Denver, CO 80216
Tel: 800-289-6278
www.denvermart.com

Fashion Center Information Kiosk
7th Avenue at 39th Street,
New York City
Tel: 212-398-7943
Email: info@fashioncenter.com

Fashion Center New York City
249 West 39th Street
New York, NY 10018
Tel: 212-764-9600
www.fashioncenter.com

Fashion Market of San Francisco
Concourse Exhibition Center
8th Street at Brannan Street,
San Francisco
www.fashionsanfrancisco.com

BUYERS

A buyer is an individual whose job is to source and purchase products for resale. Therefore, buyers are people to whom garment manufacturers wish to sell their goods. There are many different types of company where buyers of apparel can be found, including the following:

CATALOGS
Goods are sold via a printed catalog that is mailed out to potential customers.
Example: Newport News

DEPARTMENT STORES
Different categories of goods are sold, in different areas, under one roof.
Examples: Bloomingdales, Macys

DISCOUNT STORES
Retail prices are lower, due to volume buying.
Example: Target

MASS MERCHANT
Each and every location is consistent in terms of the goods offered and their physical layout.
Example: Sears

OFF-PRICE STORES
Retail prices are lower, due to buying left over/out of season goods.
Examples: Ross, TJMaxx

ONLINE STORES
Goods are sold via the web.

SPECIALTY STORES
One category of goods is sold or one type of customer is catered to. This includes boutiques.
Examples: Bebe, Fred Segal

TV SHOPPING
Goods are sold via television programs and commercials.
Example: Home Shopping Network.

WHOLESALERS
Goods are purchased in bulk, to be sold off in smaller lots, to retailers.

JOBS IN THE INDUSTRY

The following overview includes jobs within the major areas that form the foundation of the
fashion industry as a whole:

TREND FORECASTING/ ANALYST	**FASHION DESIGNER**	COLOR FORECASTING/ ANALYST
TRIM DESIGNER	FABRIC & TRIM SOURCING/BUYER	TEXTILE DESIGNER
PRODUCTION/ MANUFACTURER	FIRST PATTERN MAKER	SAMPLE SEWER
FIT MODEL	PRODUCTION PATTERN MAKER	GRADER
MARKER MAKER	CUTTER	SEWER
	INDEPENDENT CONTRACTOR	
WHOLESALER/DISTRIBUTOR	CORPORATE/INDEPENDENT SALES REP	BUYER
TRADE EVENT PLANNER	MERCHANDISER	FASHION REPORTING - NEWS/ PUBLICATIONS/MAGAZINES
COSTUMER	RETAILER	STYLIST
CUSTOM TAILOR	MODEL	

SEASONS & DELIVERY DATES

INTRODUCTION

The timing of the fashion industry revolves around 'markets' – trade events held throughout the year at 'market centers,' or 'apparel marts,' in major cities around the world. Sales representatives show one or more lines of clothing, on behalf of garment manufacturers, from booths that they temporarily hire or from showrooms that they permanently occupy. Buyers attend these events and place orders. Since these are 'trade' events, they are not open to the general public and garments are sold in bulk, at wholesale prices. These markets occur at specific times of the year, and in advance of the season for which the garments have been designed, thereby allowing a garment manufacturer time to cut, sew, trim, tag and deliver the goods to fulfill the orders that have been received.

SEASONS & DELIVERY DATES

Traditionally, the following seasons and delivery schedules apply within the fashion industry, however, notice how often new shipments are delivered into the stores where you shop today, particularly in the fast-moving markets, like Juniors? So, keep in mind that seasons and deliveries will vary from company to company and from market to market. Ultimately, deliveries are driven by demand.

We've identified below whether or not a season is Major or Minor, in terms of the volume of anticipated sales. Some garment manufacturing companies opt not to include a collection at all for some seasons. In other cases, they may design a collection for a minor season, but sell it at the same time as the previous season's collection – just for a later delivery.

MAJOR SEASONS:

SPRING
Designed: August
Sold at Market: October
Delivered: January

FALL
(Known as Fall 2, if the Early Fall/Transition Season was acknowledged).
Designed: March
Sold at Market: June
Delivered: August

MINOR SEASONS:

SUMMER
Designed: November
Sold at Market: January
Delivered: March

EARLY FALL/TRANSITION
Designed: February
Sold at Market: April
Delivered: June

HOLIDAY/CRUISE
Designed: June
Sold at Market: September
Delivered: October

SEASON	MONTH DESIGNED	MONTH SOLD	MONTH DELIVERED
SPRING	AUGUST	OCTOBER	JANUARY
SUMMER	NOVEMBER	JANUARY	MARCH
EARLY FALL/TRANSITION	FEBRUARY	APRIL	JUNE
FALL/FALL 2	MARCH	JUNE	AUGUST
HOLIDAY/CRUISE	JUNE	SEPTEMBER	OCTOBER

DESIGNERS & BRANDS

INTRODUCTION

Keeping abreast of who is doing what, or has done what in the industry is an important part of your success. Here's an alphabetical list of examples of successful designers and brands; take some time to research a few of them - identify their target customer, price points, distribution channels and their 'signature look':

Abboud, Joseph
ABS by Allen Schwartz
American Rag
Armani, Giorgio
Ashley, Laura
Baby Phat
Badgley Mischka
Bahama, Tommy
Balenciaga, Cristobal
Balmain, Pierre
Banana Republic
BCBG Max Azria
Bebe
Beene, Geoffrey
Benetton
Biba
Blass, Bill
Blumarine
Boss, Hugo
Buchman, Dana
Burberry, Thomas
Cardin, Pierre
Cavalli, Roberto
Cerruti, Nino
Chalayan, Hussein
Chanel, Gabrielle
Chloé
Claiborne, Liz
Cole, Kenneth
Comme des Garçons
Courrèges, André
Dassler, Adi
De Castelbajac, Jean-Charles
Diesel
Dior, Christian
DKNY
Dockers
Dolce & Gabbana
Duke, Randolph
Ecko, Marc
Ellis, Perry
Emanuel, David & Elizabeth
Escada
Esprit
Etro
Façonnable

Farhi, Nicole
Fendi
Féraud, Louis
Ferre, Gianfranco
Ferretti, Alberta
Fiorucci, Elio
Fisher, Eileen
Ford, Tom
Frank, Paul
French Connection
Galliano, John
Gap, The
Gaultier, Jean Paul
Geddes, Anne
Gernreich, Rudi
Givenchy, Hubert de
Grès, Madame
Gucci
Guess?
Hall, Kevan
Halston
Hannah Montana
Head, Edith
Hermès, Thierry
Herrera, Carolina
Hilfiger, Tommy
Hurley
J. Crew
Jacobs, Marc
Jaeger, Dr Gustav
Johnson, Betsey
Jones New York
Juicy Couture
Kane, Karen
Karan, Donna
Kensie
Kenzo
Klein, Anne
Klein, Calvin
Kors, Michael
Krizia
Lacoste, René
Lacroix, Christian
Lagerfeld, Karl
L.A.M.B.
Lang, Helmut

Lange, Liz
Lanvin, Jeanne
Laroche, Guy
Laundry by Shelli Segal
Lauren, Ralph
Léger, Hervé
London Fog
Lucky Brand Jeans
Mac & Jac
Mackie, Bob
Marni, NYC
Matsuda, Mitsuhiroi
MaxMara
McCardell, Claire
McCartney, Stella
McFadden, Mary
McLaren, Malcolm
McQueen, Alexander
Miller, Nicole
Missoni
Miss Sixty
Miu Miu
Miyake, Issey
Mizrahi, Isaac
Moschino, Franco
Mossimo
Mugler, Thierry
Muir, Jean
Nautica
Nike
Nine West
North Face, The
Oldham, Todd
Oscar de la Renta
Patou, Jean
Piatta Sempione
Prada, Miuccia
Pringle
Pucci, Emilio
Pulitzer, Lilly
Pumpkin Patch
Quant, Mary
Quiksilver
Rabanne, Paco
Rampage
Rhodes, Zandra

Ricci, Nina
Rich & Skinny
Rocawear
Rodriguez, Narciso
Roxy
Rykiel, Sonia
Saint Laurent, Yves
Sander, Jil
Schiaparelli, Elsa
Sean John
Sherman, Ben
Smith, Paul
St. John
Stars, Michael
Steffe, Cynthia
Strauss, Levi
Style & Co.
Sui, Anna
Tadashi
Taylor, Ann
Theory
Tracy, Ellen
Turk, Trina
Tyler, Richard
UGG
Ungaro, Emanuel
Valentino
Versace, Gianni
Via Spiga
Von Furstenberg, Diane
Voyage
Vuitton, Louis
Wang, Vera
Westwood, Vivienne
XOXO
Yamamoto, Yohji

KNOW YOUR CUSTOMER

Successful fashion designers know who buys their clothes, and why. The following topics are included:

Page #

Target Customer/Market Groups 16
The major target customer groups that are already identified, according to their age, sex, figure and the size ranges offered to them.

Different Body Types 34
Fashion designers also have to take into consideration the fit of the clothes they design and the ways in which they compliment the bodies of their target customer. The major body types are shown and analyzed.

TARGET CUSTOMER/MARKET GROUPS

INTRODUCTION

The business of fashion is just like any other, in that, in order to be successful at it, you have to sell the clothes you design and make, and furthermore, bring in more money (eventually) than you have paid out – a 'profit.' There are multiple factors that need to come together in order for this to happen:

1. The garments are what the <u>customer</u> wants.
2. The garments are what the <u>customer</u> needs.
3. The garments are what the <u>customer</u> can afford.
4. The garments are available where the <u>customer</u> shops.
5. The garments fit and function as the <u>customer</u> expects.
6. The garments are available at a time when the <u>customer</u> wants and needs them.
7. Having enough funds to finance the operation.
8. Having the infrastructure and vendors to expedite the operation.

With the exception of items 7. and 8., it is easy to see how vital it is for a garment manufacturing company to understand a great deal about their customer. Nowadays, marketeers are so sophisticated that they seem to be able to pre-empt what garments their customers want and need. This is not a coincidence – a great deal of time and money is spent in gathering information about people because the more data known about a person, the easier it is to comply with factors 1-6, above.

Through the successes of past and present fashion designers, we can identify distinct 'groups' of people, known as target customers. We understand some basic, but vital, factors about these groups of people, such as whether they are male or female, their age range, their figure type, their size range and the prices they will pay. At this stage, the price is not stated as specific amounts, but by price range, or category – budget, moderate, better and/or designer (see descriptions below). The recognized target customer groups are listed below and described over the next few pages:

CHILDRENSWEAR	WOMENSWEAR	MENSWEAR
- Layette/Newborn - Infant - Toddler - Little Girls - Little Boys - Big Girls/Kids - Big Boys/Kids	- Tween - Junior/Junior Plus - Contemporary - Missy/Misses - Designer - Plus Size - Petite - Maternity	- Casual - Contemporary - Designer - Big & Tall

PRICE RANGES/CATEGORIES:

In addition to the different customer groups, there are also recognized pricing standards, as follows:
BUDGET: Clothing made in large volumes at low cost and sold at a low retail price.
MODERATE: Clothing made at mid-range cost and sold at a mid-range retail price.
BETTER: Clothing made at high cost and sold at a high retail price.
DESIGNER: Clothing made at very high cost and sold at a very high retail price.

CUSTOMER PROFILE

A customer profile is a more in-depth look at your target customer's lifestyle and their buying habits. It includes statistical data, known as 'demographics,' such as their income, place of residence, age, marital status, number of children; their occupation; the fashion magazines and clothing brands they buy; their favorite stores and designers; brief descriptions of their lifestyle/leisure activities. The customer profile becomes incorporated within the presentation of your collection (see 'Customer Profile Boards,' page 184).

CHILDRENSWEAR

LAYETTE/NEWBORN
Boys & Girls

AGE	3 months	6 months	9 months
SIZE	3M	6M	9M

Age Range: 3-9 months old

Size Range: 3M-9M

Figure Type: Underdeveloped; straight

Price Range: Budget, Moderate, Better or Designer

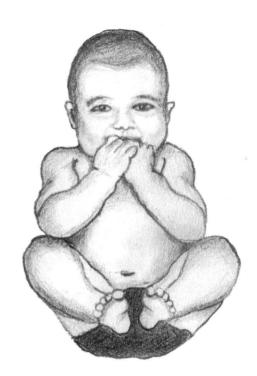

NOTES:

While the clothing is to be worn by the baby, the people we really have to appeal to are the parents, friends and family of the child, since they are doing the buying.

It is important to be able to get the clothes on and off easily, because the baby needs regular diaper changes; use fabrics that are gentle on the baby's skin, comfortable, safe to wear (hypo-allergenic, natural, flame resistant, non-toxic when sucked or chewed etc.) and easy to launder (easy care).

The price range is across the spectrum, depending upon the manufacturer.

Styling is usually simple, predominantly functional (including built-in 'room' for a diaper/nappy) with small, non-cumbersome decoration/trim that cannot be detached, for safety purposes.

Many clothes for newborns are made from knit fabrics because of their natural stretch and comfortable properties.

Multiple layering pieces are offered, since the baby's temperature is paramount, not only to the baby's health, but for peace-of-mind of the parents.

Use of color tends to stay mostly within the pastel range – reflecting the softness of the baby, in either neutral colors, or colors that traditionally indicate the sex of the baby.

Prints, if used, are usually light and delicate. Small, naturally inspired motifs and words are commonly seen, such as animals and flowers/plants. At the top end of the scale, decoration may be limited simply to a brand name and/or logo.

A collection may include 'onesie's, or bodysuits (all-in-one romper with long or short sleeves/legs); smock-style/swing tops coupled with elasticated diaper-covers, dresses, bibs, cardigans, sweaters, sweatsuits, robes, hooded towels, hats and socks.

CHILDRENSWEAR

INFANT
Boys & Girls

AGE	12 months	18 months	24 months
SIZE	12M	18M	24M

Age Range: 12-24 months old

Size Range: 12M-24M

Figure Type: Underdeveloped with a round tummy

Price Range: Budget, Moderate, Better or Designer

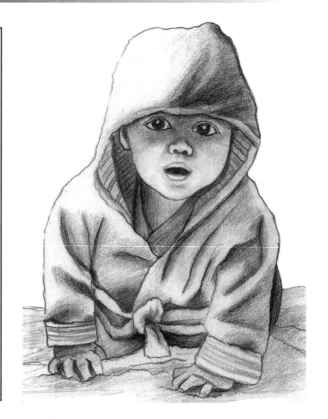

NOTES:

As with a newborn baby, the clothing is to be worn by the infant, but the people we really have to appeal to are the parents, friends and family of the child, since they are doing the buying.

It is still important to be able to get the clothes on and off easily, because of diaper changes; use fabrics that are gentle on the infant's skin, comfortable, safe to wear (hypo-allergenic, natural, flame resistant, non-toxic when sucked or chewed, etc.) and easy to launder (easy care).

The price range is across the spectrum, according to the manufacturer. Styling is still likely to be fairly simple and should be able to accommodate a diaper/nappy.

Trim and decoration are typically small, non-cumbersome and non-detachable, for safety purposes.

Many of the clothes for infants are made from knit fabrics.

Multiple layering pieces are offered.

Pastel colors are still often seen, although some brighter, bolder colors and more prints may now be incorporated.

Small, naturally inspired motifs and words are still common. At the top end of the scale, decoration may be limited simply to a brand name and/or logo.

A collection may include jackets, dresses, skirts, pants, shirts, shorts, dungarees/overalls, cardigans, sweaters, sweatsuits, Tees, tanks, johnny shirts, robes, hats, scarves, gloves and socks.

CHILDRENSWEAR

TODDLER
Boys & Girls

AGE	1-2 yrs	2-3 yrs	3-4 yrs
SIZE	2T	3T	4T

Age Range: 1-4 years old

Size Range: 2T-4T

Figure Type: Underdeveloped with a round tummy

Price Range: Budget, Moderate, Better or Designer

NOTES:

As with newborn/layette and infant, it is the parents, friends and family who ultimately choose and buy for a toddler. Having said that, girls, in particular, typically start to become interested in, and perhaps even a little impertinent about, the clothes they want to wear, during this time! Safety and comfort are key factors at this stage, since the child is now becoming very active and inquisitive. They are now learning to crawl and then walk, so clothing needs to be resilient, non-restrictive and easy care.

Fashion really starts to come into play, for girls – including lots of prints, colors and more unique styling. Remember that they still may well be wearing a diaper/nappy. For boys, practicality and the parents' idea of what makes him look good are more dominant.

Price ranges across the board, from budget to designer, depending upon the income and lifestyle of the parent(s).

Now at an age where they are beginning to recognize and make bonds with the world around them, toddlers are stimulated by the learning processes that they are encountering. Often, these are to characters that they relate to – in the books, videos and TV programs that they are exposed to. A girl toddler may become very 'into' everything 'Barbie®,' 'Disney®/Cinderella/Belle®/ Princess' or everything 'Ballerina'. Whereas themes for boys tend to be based around construction (Bob the Builder®), jobs that (perhaps) their parents would like them to have in the future (Fireman, Policeman etc.) and Superheros (Spiderman®, Batman®). Not forgetting Sesame Street, Telly Tubbies etc.

Clothing for toddler boys often include the 'classics' of a conservative man's wardrobes – a plaid shirt, a polo shirt, cargo pants/shorts, a cable-knit sweater, Tees, etc. Colors tend to be bold for boys, and either soft or strong/striking for girls.

Aside from the safety and movement necessities of the designs, now the contents of any collection is less about the child's special needs, as an infant or newborn, and more about being a miniature version of an adult person, as is appropriate to their age and innocence. They are starting to want to dress themselves so snaps, Velcro® and other easy-to-operate closures are often used.

CHILDRENSWEAR

LITTLE GIRLS

AGE	4 yrs	5 yrs	6 yrs	6-7 yrs
SIZE	4	5	6	6X
SIZE	Small (S)	Medium (M)	Large (L)	Extra Large (XL)

Age Range: 4-7 years old

Size Range: 4-6X or S-XL

Figure Type: Underdeveloped, straight

Price Range: Budget, Moderate, Better or Designer

NOTES:

Now girls are really getting 'into' their clothes, and accessories.

Fabrics often have stretch, are comfortable and easy care.

Styling is fashion-forward, yet age-appropriate.

Prints and embellishments are vital to most collections for little girls.

Casualwear, schoolwear and some formalwear may be included.

CHILDRENSWEAR

LITTLE BOYS

AGE	4 yrs	5 yrs	6 yrs	7 yrs
SIZE	4	5	6	7
SIZE	Small (S)	Medium (M)	Large (L)	Extra Large (XL)

Age Range: 4-7 years old

Size Range: 4-7 or S-XL

Figure Type: Underdeveloped, straight

Price Range: Budget, Moderate, Better or Designer

NOTES:

Boys clothing tend to remain similar in styling, without as much focus on fashion as girls, until they reach their teens.

Focus is on bold colors, stripes, sports, motifs, resilience, comfort and easy care.

A collection may be casual or more formal and may include schoolwear.

CHILDRENSWEAR

BIG GIRLS/KIDS

AGE	6-7 yrs	7-8 yrs	8-9 yrs	9-10 yrs	10-11 yrs	11-12 yrs
SIZE	7	8	10	12	14	16
SIZE	Small (S)	Small (S)	Medium (M)	Medium (M)	Large (L)	Extra Large (XL)

Age Range: 6-12 years old

Size Range: 7-16 or S-XL

Figure Type: Underdeveloped, straight

Price Range: Budget, Moderate, Better or Designer

NOTES:

As with little girls, big girls are also very conscious of, and excited by, their clothes and accessories.

Fabrics often have stretch but are less focused towards easy care.

Styling is fashion-forward.

Prints and embellishments are vital to most collections for big girls.

Casualwear, schoolwear and some formalwear may be included.

CHILDRENSWEAR

BIG BOYS/KIDS

AGE	7-8 yrs	9-10 yrs	11-12 yrs	12-13 yrs	13-14 yrs	14-15 yrs	15-16 yrs
SIZE	8	10	12	14	16	18	20
SIZE	Small (S)	Small (S)	Medium (M)	Medium (M)	Large (L)	Large (L)	Extra Large (XL)

Age Range: 7-16 years old

Size Range: 8-20 or S-XL

Figure Type: Underdeveloped, straight

Price Range: Budget, Moderate, Better or Designer

NOTES:

Boys clothing tends to remain similar in styling, without as much focus on fashion as girls, until they reach their teens.

Focus is on bold colors, stripes, sports, motifs, resilience, comfort and easy care.

A collection may be casual or more formal and may include schoolwear.

WOMENSWEAR

TWEEN

SIZE	2-4	5-8	9-12	13-16	17-20
SIZE	Extra Small (XS)	Small (S)	Medium (M)	Large (L)	Extra Large (XL)

Age Range: 8-12 years old

Size Range: 2-20 or XS-XL (may also be available in half sizes)

Figure Type: Underdeveloped

Price Range: Typically Budget

NOTES:

A relatively new category of target customer that is defined as being a fashion forward female who is no longer considered a child, but not yet considered a teenager.

Designs are youthful, trendy and somewhat body conscious, but are more innocent than the styling for juniors. This customer still has some interest in toys.

Styling changes rapidly so prices are mainly budget, since the garments are not designed to last for years.

WOMENSWEAR

JUNIOR

SIZE	0-1	3-5	7-9	11-13	15
SIZE	Extra Small (XS)	Small (S)	Medium (M)	Large (L)	Extra Large (XL)

Age Range: 15-25 years old

Size Range: 0-13 & 15 (& 17, for athletic wear)

Figure Type: Underdeveloped

Price Range: Typically Budget

JUNIOR PLUS

SIZE	1X	2X	3X
SIZE	17-19	21-23	25-27
SIZE	Small (S)	Medium (M)	Large (L)

Age Range: 15-25 years old

Size Range: 1X-3X or S-L

Figure Type: Underdeveloped/larger than Junior

Price Range: Typically Budget

NOTES:

Designs are youthful, trendy and body conscious.

Styling changes rapidly so prices are mainly budget, since the garments are not designed to last for years.

WOMENSWEAR

CONTEMPORARY

SIZE	0	2	4	6	8	10	12	14	16
SIZE	Extra Small (XS)	Extra Small (XS)	Small (S)	Small (S)	Medium (M)	Medium (M)	Large (L)	Large (L)	Extra Large (XL)

Age Range: 20-40 & up

Size Range: 0-16 or XS-XL (& 18, for athletic wear)

Figure Type: Fully developed but slim; based on a missy fit
Typically 5'4"-5'9" tall

Price Range: Budget, Moderate, Better & Designer

NOTES:

Styling is fashion forward, body conscious and provocative.

WOMENSWEAR

MISSY/MISSES

SIZE	6	8	10	12	14	16	18

Age Range: 35 & up

Size Range: 6, 8, 10, 12, 14, 16, 18

Figure Type: Fully developed; heavier & less slim;
Based on a missy fit

Price Range: Budget, Moderate or Better

NOTES:

Styling is based on last seasons' fashions and is often concerned with concealing those parts of the body that have become out of proportion.

Styling may also be more traditional or conservative.

WOMENSWEAR

DESIGNER

SIZE	4	6	8	10	12

Age Range: 25 and up

Size Range: 4, 6, 8, 10 & 12

Figure Type: Fully developed but slim; based on a missy fit

Price Range: Designer

NOTES:

Designs are fresh, fashion-forward, sophisticated, well made and expensive!

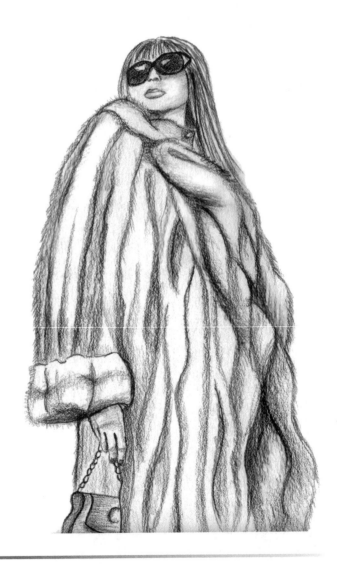

WOMENSWEAR

PLUS SIZE

SIZE	0X	1X	2X	3X
SIZE	12	14-16	18-20	22-24

Age Range: 25 and up

Size Range: 0X-3X or 12-24

Figure Type: Fully developed; heavy; based on a missy fit
Typically 5'4"-5'9" tall

Price Range: Moderate

NOTES:

Styling and coloration are often focused around concealing the parts of the body that are out of proportion and creating a slimmer, longer look.

Darker colors are more slimming and are often used.

Princess seams and straight vertical lines in general help to elongate the appearance of the body.

Longer length jackets in dark colors also help to create a slimmer-looking silhouette.

WOMENSWEAR

PETITE

SIZE	0P	2P	4P	6P	8P	10P	12P	14P	16P
SIZE	Extra Small (XS)	Extra Small (XS)	Small (S)	Small (S)	Medium (M)	Medium (M)	Large (L)	Large (L)	Extra Large (XL)

Age Range: 25 and up

Size Range: 0P-16P or XS-XL

Figure Type: Fully developed; slender; based on a missy fit.
Typically under 5' 4" tall

Price Range: Moderate or Better

NOTES:

Styling is often a more traditional or conservative adaptation of last years' designer styles and typically include a high percentage of coats and suits.

WOMENSWEAR

MATERNITY

SIZE	4-6	6-8	10-12	12-14	16-18	18-20	22-24	26-28
SIZE	Extra Small (XS)	Small (S)	Medium (M)	Large (L)	Extra Large (XL)	1X	2X	3X

Age Range: 16 and up

Size Range: 4-28 or XS-XL & 1-3X

Figure Type: Pregnant

Price Range: Moderate or Better

NOTES:

Maternitywear is, naturally, greatly concerned with accommodating the 'bump,' throughout the pregnancy.

Styling varies greatly, but pregnant women still want to be able to wear clothing that is fashion-forward and flattering.

Comfort and support are key factors to consider.

MENSWEAR

Clothing for men is approached in a slightly different way to womenswear. Relatively speaking, it is only in the recent past that menswear has diversified from its traditional formal offerings of jackets and suits, or casual T-Shirts and polo shirts. Nowadays, more men are into more fashion.

Mens' figures, too, are more easily accommodated to, since they are straighter, have no 'lady lumps' and tend to wear looser-fitting garments. The size ranges for men, therefore, are similar between the different target customer groups so we have included one sizing area, followed by the target customer descriptions.

MENS FORMALWEAR SIZING

HEIGHT INDICATOR

The following height indicators are often used in sizing men's clothing:

SIZE	XS (Extra Short)	S (Short)	R (Regular)	L (Long)	XL (Extra Long)
HEIGHT	5'1"- 5'4"	5'5" - 5'7"	5'8" - 5'10"	5'11" - 6'2"	6'3" - 6'5"

CONTEMPORARY MAN

JACKETS

Sizing is based on the chest measurement (34-52") plus a height indicator:

SIZE	S (Small)	M (Medium)	L (Large)	XL (Extra Large)	XXL (Extra, Extra Large)
CHEST	34-36"	38-40"	42-44"	46-48"	50-52"

PANTS

Sizing is based on the waist measurement (28-46"), plus a height indicator:

SIZE	S (Small)	M (Medium)	L (Large)	XL (Extra Large)	XXL (Extra, Extra Large)
WAIST	28-30"	32-34"	36-38"	40-42"	44-46"

DRESS SHIRTS

Sizing is based on the neck measurement (14-18.5"), plus a sleeve measurement:

SIZE	S (Small)	M (Medium)	L (Large)	XL (Extra Large)	XXL (Extra, Extra Large)
NECK	14-14.5"	15-15.5"	16-16.5"	17-17.5"	18-18.5"

SIZE	S (Small)	M (Medium)	L (Large)	XL (Extra Large)	XXL (Extra, Extra Large)
SHORT	31-31.5"	32.32.5"	33-33.5"	34-34.5"	n/a
REGULAR	32.5-33"	33.5-34"	34.5-35"	35.5-36"	36.5-37"
LONG	n/a	35-35.5"	36-36.5"	37-37.5"	38"

CASUAL & ATHLETIC TOPS/SWEATERS

Sizing is based on the chest measurement (34-56"):

SIZE	S (Small)	M (Medium)	L (Large)	XL (Extra Large)	XXL (Extra, Extra Large)	XXXL (Extra, Extra, Extra Large)
CHEST	34-36"	38-40"	42-44"	46-48"	50-52"	54-56"

BIG & TALL MAN

TARGET CUSTOMER GROUPS

Here are the major groups for menswear:

CASUAL

Includes tanks, tees, sweatsuits, polo shirts, shirts, sweaters, cardigans, casual jackets, boxers, shorts, socks, hats and pants, in all styles, from urban, street, surf/skate and westernwear to athletic.

Age Range: 15 & up
Figure Type: All figure types
Price Range: Budget, Moderate & Better

CONTEMPORARY

Includes tanks, tees, sweatsuits, polo shirts, shirts, sweaters, cardigans, casual jackets, boxers, shorts, pants, socks, sportcoats, vests, coats and suits. Styling is more conservative than casualwear.

Age Range: 15 & up
Figure Type: All mid-range figure types
Price Range: Moderate & Better

DESIGNER

Clothing collections including all types of garments. Styling is fashion forward. Fabrics are expensive/unique. Garments are well constructed often including some tailoring.

Age Range: 25 & up
Figure Type: All mid-range figure types/slim
Price Range: Designer

BIG & TALL

Includes all types of garments made specifically for big and tall men.

Age Range: 25 & up
Figure Type: Big & Tall
Price Range: Budget, Moderate & Better

DIFFERENT BODY TYPES

INTRODUCTION

Many people perceive successful fashion designers as being exceptionally creative people. Though this may well be true, you are becoming increasingly appreciative, through your fashion studies, that the ability of a designer to sell their designs is truly the proof of success. There are a number of key elements that must be present for success to be realized.

Consistent, 'fresh' designs, appropriate quality and pricing, the ability to produce and deliver garments on time, the ability to fund operations/production, effective sales and distribution, appropriate and effective marketing and public relation activities and understanding what your customer wants are all key elements for success.

In this section, however, we focus on another key element – understanding what your customer needs; specifically, how to design garments that look good on their specific body type.

The male and female bodies to the right and opposite are both examples of well-proportioned bodies that can easily accommodate different types and styles of garments.

It is the majority of customers however, whose body types are less slender or less well-proportioned, that rely on the ability of a designer/design house to deliver clothing that fits well on their bodies, accentuates their attributes AND conceals their less flattering features. These are key elements in building customer loyalty; where customers will return to buy from a specific design house, season after season.

> The **Major Body Types** and the
> **Counter-Active Design Techniques**
> that can be used to disguise their
> particular disproportions are detailed in the
> following pages.

A WELL-PROPORTIONED FEMALE FIGURE

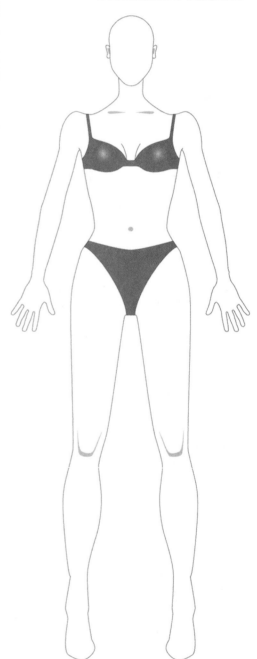

A WELL-PROPORTIONED MALE FIGURE

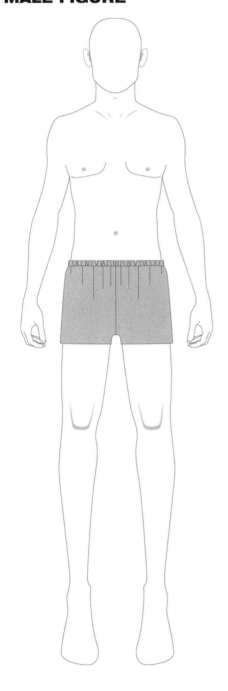

GENERAL TIPS:

FIT:
No matter what size and shape a person is, their clothes should fit them. Clothes that are too small (in particular) or too large are not flattering on any body type (unless a fashion trend takes precedence).

SUPPORT:
Structured garments are those that have built-in support to control or enhance certain areas. Built-in bras, the use of Lycra® and boning, or well positioned seam and stylelines are all useful tools for structuring.

UNDERWEAR:
Even if you are not designing a line of lingerie, don't overlook the results that great underwear can produce. A padded or push-up bra can do wonders for a small bustline. An under-wired bra can reposition a tired bustline or control large breasts. Panties that are too tight inevitably cause the dreaded VPL (Visible Panty Line); a thong eliminates this.

PRINCIPLES & ELEMENTS OF DESIGN:
Frequently refer to the principles and elements of design to help you to design well for the body type of your target customer.

FABRIC:
Choice of fabric dramatically impacts the visual effect of size and shape. Shiny fabrics will illuminate any curve, bump or bulge; fabrics with pile and texture add bulk; fabrics with lots of body tend to create a block of mass and drapable fabrics are more likely to create the optical illusion of space and movement.

VISUAL LINES:
Stylelines, seamlines, changes in color, trim, and the addition of layering pieces and accessories all create visual lines that divide the outfit and define proportion. Hemlines create a widening, horizontal line and should be positioned at the slimmest, not widest part of the body where possible.

Major Body Types

THIN (TUBE)

THICK (RECTANGLE)

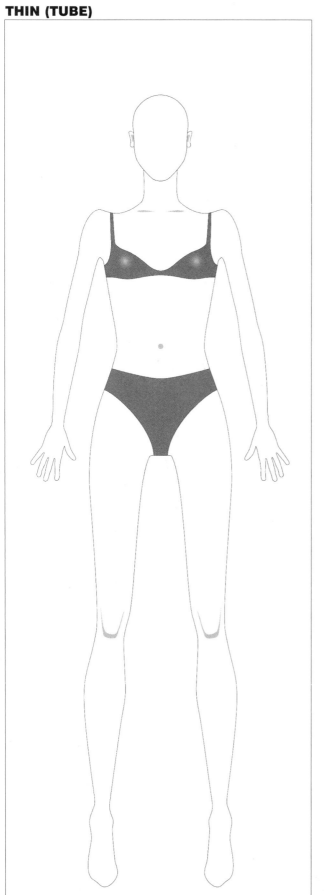

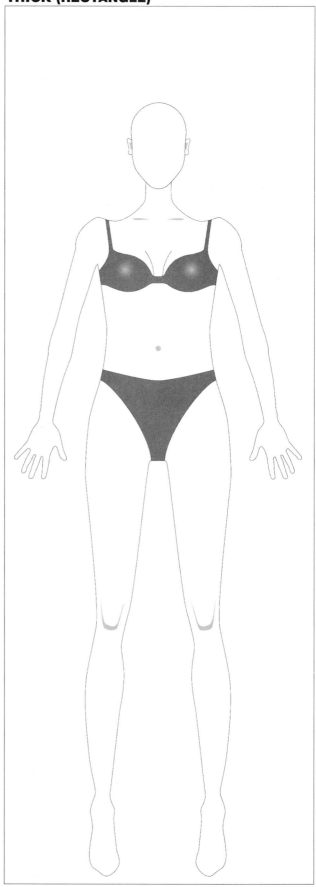

Major Body Types

THICK (RECTANGLE)

CURVY (HOURGLASS)

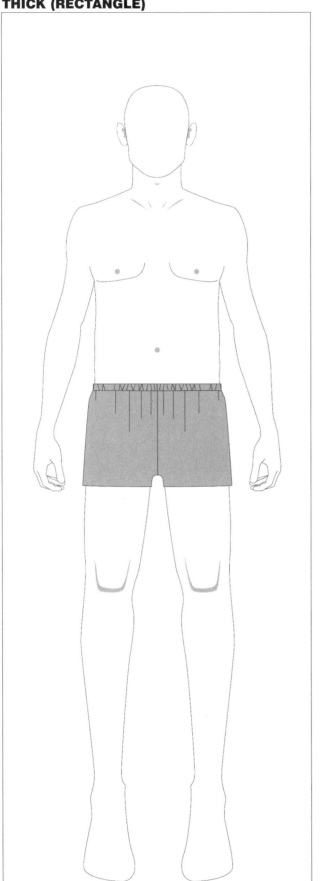

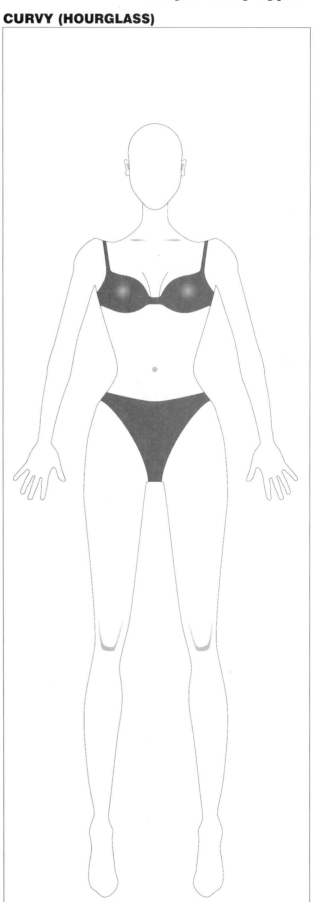

Major Body Types

TOP HEAVY (TRIANGLE)

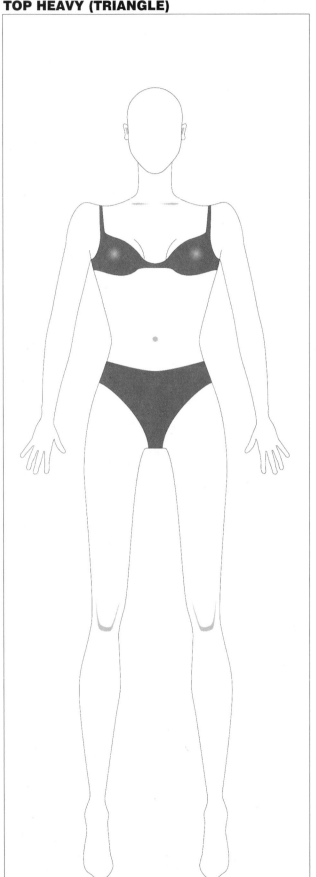

BOTTOM HEAVY (TRIANGLE)

Major Body Types

MIDDLE HEAVY (DIAMOND)

MIDDLE HEAVY (DIAMOND)

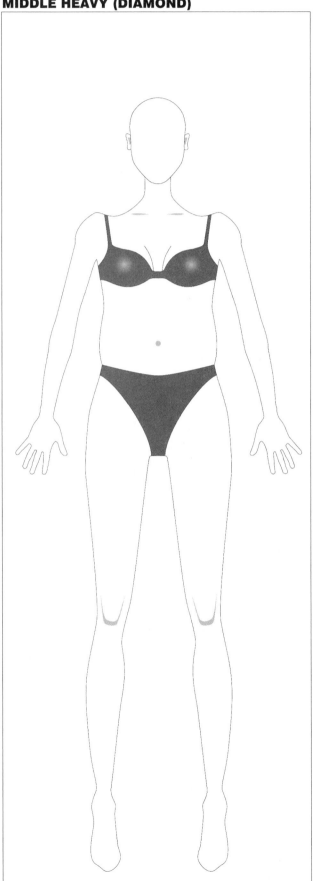

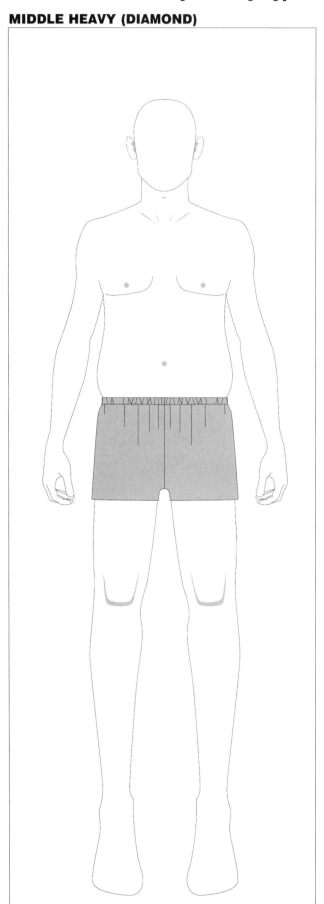

Major Body Types

HEAVY (OVAL)

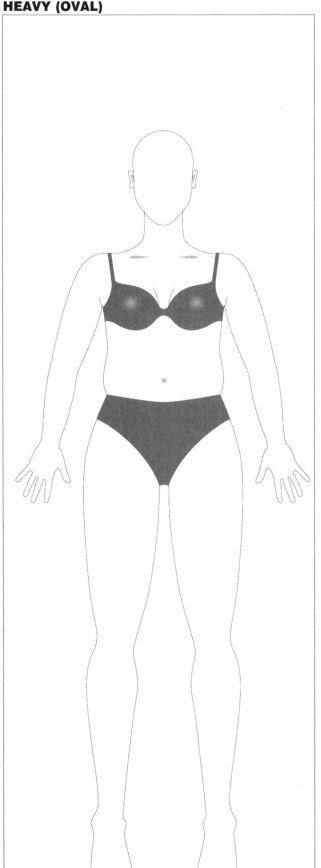

HEAVY (OVAL)

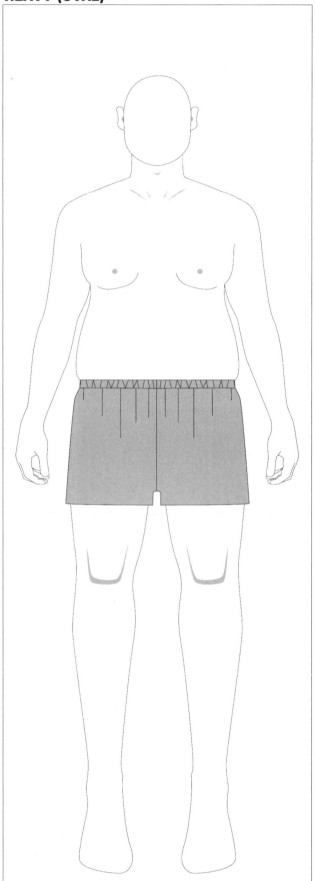

Major Body Types

SHORT & SLIM

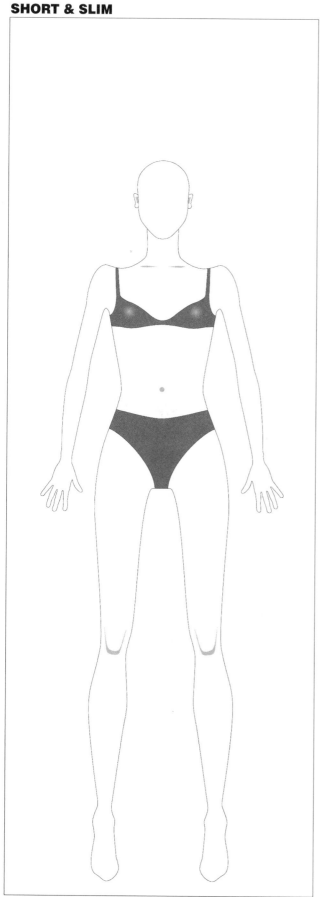

SHORT & SLIM

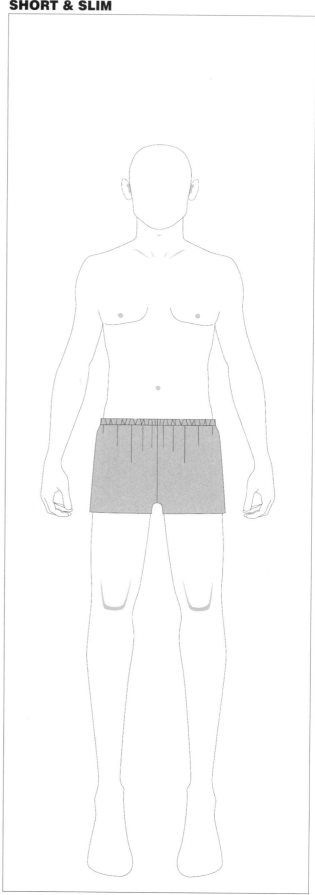

Major Body Types

SHORT & STOCKY

SHORT WAISTED

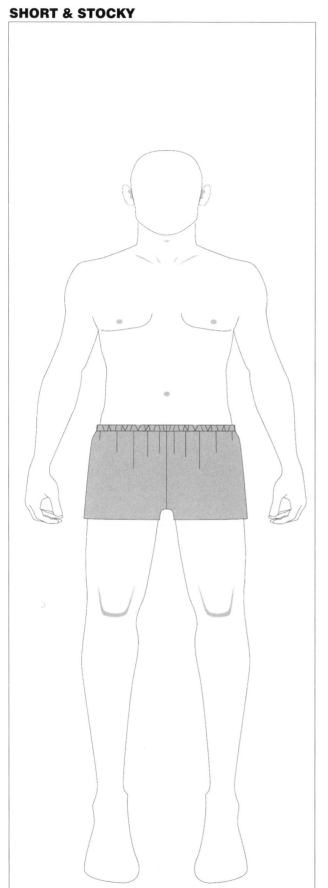

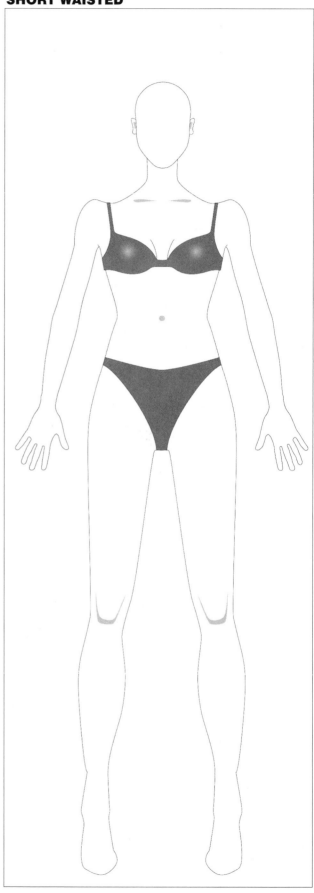

Major Body Types

LONG WAISTED

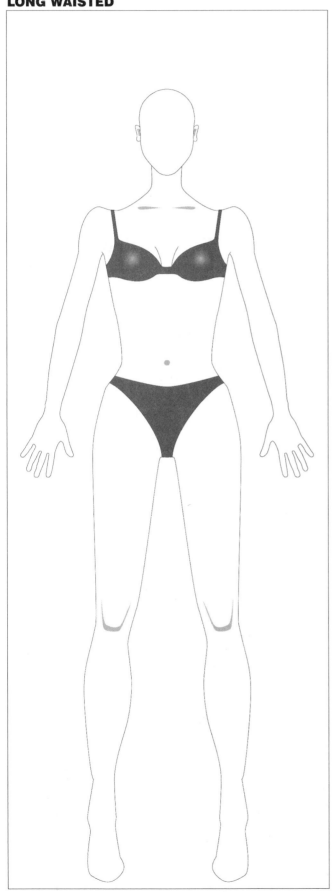

Counter-Active Design Techniques

THIN (TUBE)

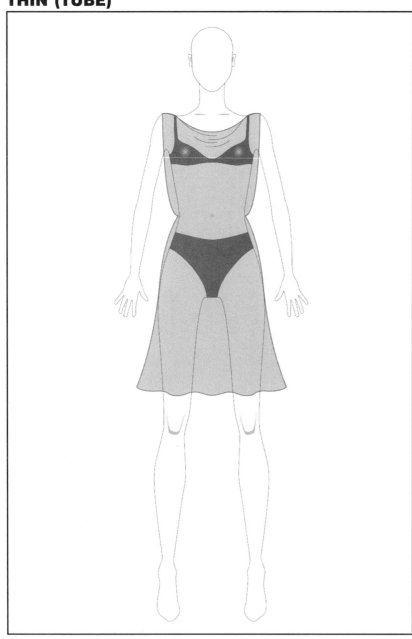

 AVOID

Loose-fitting, shapeless garments with no foundation or structure.

Tight fitting outfits that bring no shape to the silhouette.

 AIM TOWARDS

Belted or waisted looks.

Blouson-style tops.

Pants and skirts that bring shape to the hipline with details such as pleats, gathers and ruffles.

Garments with added interest such as pockets and epaulettes.

Garments with extra fabric draped in, such as cowl necklines and dirndl skirts.

Larger scaled, swirly prints to 'fill out' the silhouette.

Some use of fabrics with texture/pile or stiffness/body.

Some use of horizontal or diagonal lines to add the illusion of bulk at the shoulders, waist and hips.

It is relatively simple to bring this very slim, straight body into proportion, since it is always easier to add bulk than to hide it.

Our recommended techniques are based on the assumption that the person with this body type is seeking a more curvaceous silhouette. However, the priority is always to design with your particular target customer in mind. For example, a young girl may not want to add bulk, whereas an older woman may want to appear more curvy and mature.

Trends in body types must also be taken into account; are we in a Marilyn Monroe/Jennifer Lopez phase or a Twiggy/Kate Moss phase?

Counter-Active Design Techniques

THICK (RECTANGLE)

 AVOID

Large scale prints and designs.

Garments with little shape or structure.

Fabrics that have a heavy pile/texture.

 AIM TOWARDS

Using horizontal lines with belted or wasted looks.

Blouson-style or fitted tops for women; fitted shirts and jackets for men.

Pants and skirts with details such as pleats, gathers and ruffles, for women. Flat front, well fitted pants for men.

Creating shapely silhouettes such as the A-line; adding shape with the use of shoulder pads, epaulettes, flared pants etc.

Using drapable fabrics to reduce the 'solid mass' effect.

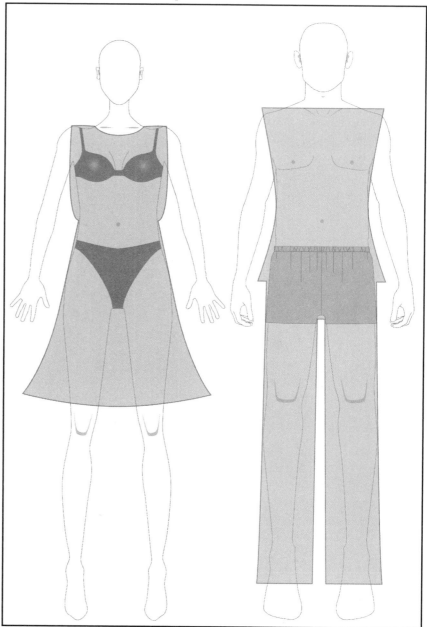

With a straight body such as the rectangle, the goal is to create a slimming silhouette for the men, and add curves/shape for the women.

Counter-Active Design Techniques

CURVY (HOURGLASS)

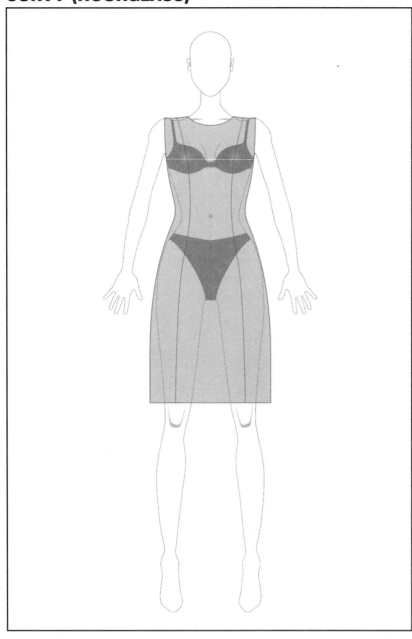

 AVOID

Tight fitting outfits that cling to every curve.

Belted and waisted looks.

Pockets, pleats, gathers, epaulettes, over-sized cuffs and the like around the bustline, hips, shoulders and wrists.

Fabrics with a heavy pile/texture – they'll just add bulk.

Garments with extra fabric draped in, such as blouson-style tops, cowl necklines and dirndl skirts.

 AIM TOWARDS

Fitted garments with structure/ foundation for control (and/or appropriate underwear).

Pants and skirts that are well fitting and structured at the waist, then flare out somewhere below the hip.

Smaller scaled, geometric prints.

Creating sleek, long, vertical lines.

Using monochromatic colors to hide curves.

In some cultures and eras this body type is considered to be highly desirable and a perfect proportion for a woman.

For the purpose of this exercise, though, we've focused our techniques on reducing the effects of such a curvaceous body type.

Always remember to consider the needs of your target customer and the trends of the times when applying these techniques. Your customer may just want to enhance and show off her attributes this season.

Counter-Active Design Techniques

TOP HEAVY (TRIANGLE)

 AVOID

Shoulder pads, epaulettes and structured jackets (especially double breasted ones).

Tops with details that add clutter and bulk such as pockets, large collars, ruffles, gathers and over-sized closures.

Halter and cropped tops that further emphasize the top half.

Boat or square necks that add width to the shoulders.

Sweaters or jackets with a heavy pile/ texture that add bulk.

Horizontal lines across the shoulders and bust.

AIM TOWARDS

Necklines that are open vertically, such as V necks and shawl collars.

Pants and skirts that are well fitting at the waist and hip, are narrow to the hem, or flare out somewhere below the hipline.

Smaller scaled, geometric prints.

Using monochromatic colored layering pieces to hide curves up top.

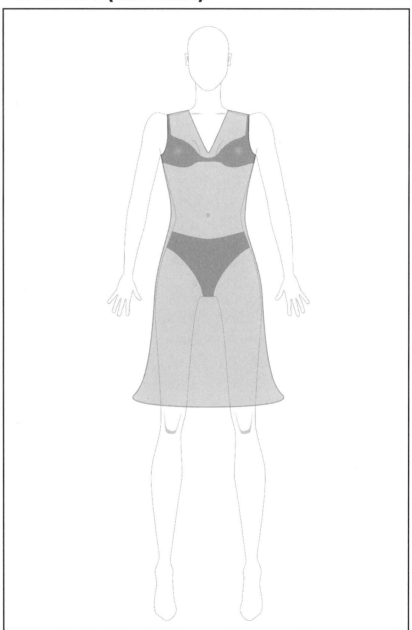

In order to balance out the top heavy, triangular body type, focus should be drawn away from the top half. Too much fabric, the addition of too many details or showing too much skin up top are all likely to add emphasis there and should be avoided.

Creating longer vertical lines with simple, structured garments, however, will help to control the bust and add length, rather than width to the top half.

Counter-Active Design Techniques

BOTTOM HEAVY (TRIANGLE)

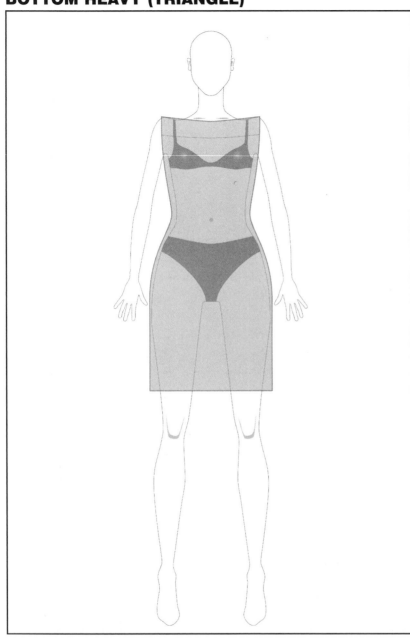

 AVOID

Raglan sleeves which narrow the shoulders.

Adding bulk at the hip level with belts, pockets, gathers or large cuffs.

Large scale printed skirts, especially swirly designs.

 AIM TOWARDS

Shoulder pads, epaulettes, structured jackets/tops, wide lapels, scarves and shawls to add width to the shoulder area.

Loose-fitting tops with details such as pockets, wide collars, ruffles and gathers.

Adding a layering piece, like a shirt to add width, not bulk, up top.

Boat, square or off-the-shoulder necklines to add width up top.

Sweaters or jackets with a pile/texture that add bulk.

Horizontal lines across the shoulders and bust.

Well-fitting pants/skirts around the hip and butt areas.

The opposite problem exists for the bottom heavy triangle to that of the top heavy triangle. The focus, therefore, needs to be drawn towards the top half and away from the bottom half. Too much fabric or the addition of too many details on the bottom half are all likely to add emphasis there and should be avoided.

Counter-Active Design Techniques

MIDDLE HEAVY (DIAMOND)

AVOID

Belts, cumerbunds and waisted looks.

Tops or shirts that pull at the waist to create bulging or gaping.

Pants or skirts that pull at the waist to create an overhang ('muffin-top'), cause pleats to open or puckers to form at the end of darts.

Cropped tops and low-riding pants/ skirts.

AIM TOWARDS

Hip length shirts, cardigans and jackets that skim the waist.

Pants and skirts that are well fitting and structured at the waist.

Tops that are large enough not to cling to the waistline.

Vests, in neutral colors, to conceal the waist.

Using monochromatic colors and sleek vertical lines to hide curvature at the waist.

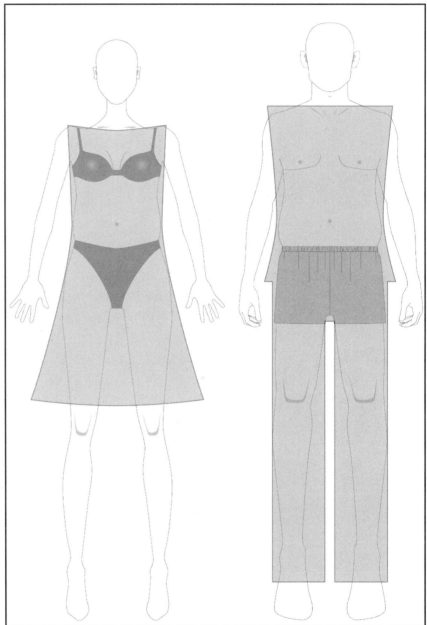

For both and men and women with the middle heavy, diamond body type, the main focus is to avoid bringing emphasis to, or creating bulges, at the waistline.

Counter-Active Design Techniques

HEAVY (OVAL)

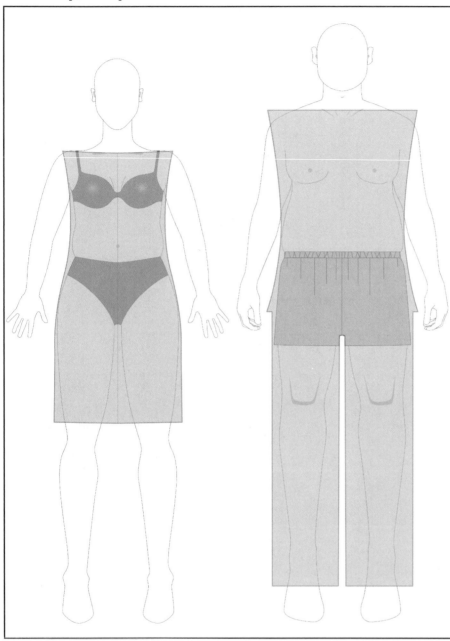

 AVOID

Tight-fitting outfits that cling to every curve; belts, cumerbunds and waisted looks.

Bulky pockets, pleats, gathers, epaulettes and over-sized details.

Fabrics with a heavy pile/texture and plaids – they'll just add bulk.

Garments with extra fabric included, such as blouson-style tops, pleated skirts etc.

 AIM TOWARDS

Well-fitting jackets that taper in at the waist, have high armholes, back vents and end just under the buttocks.

Smaller scaled, geometric prints.

Creating sleek, long, vertical lines.

Using monochromatic and dark colors.

For those with a heavy, oval body type, the goal is simply to reduce bulk and create a slimming silhouette.

Counter-Active Design Techniques

SHORT (SLIM)

AVOID

Horizontal lines that widen and shorten the overall appearance.

Jackets and tops that fall below the high hip level.

Cropped pants or over-long shorts.

Pants or shorts with a long, loose crotch.

Over-sized garments or garments that incorporate an excessive amount of fabric.

AIM TOWARDS

Garments that incorporate smaller details/have smaller proportions.

Smaller scale prints.

Jackets with three or four buttons, instead of one or two.

Shorter skirts for women.

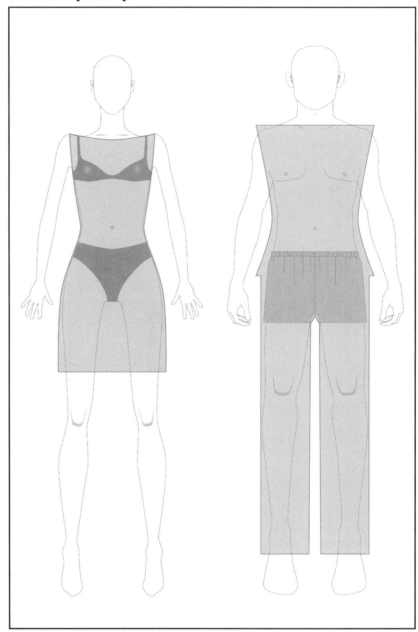

For short but slim body types, particularly men, the overall goal is to lengthen the appearance and avoid shortening/widening.

Counter-Active Design Techniques

SHORT (STOCKY)

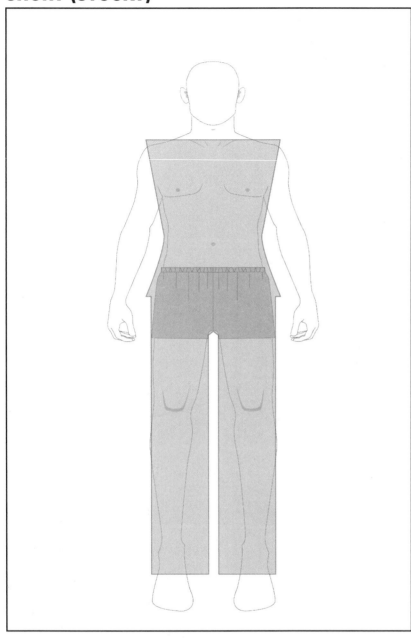

As for the short, slim person, the overall goal for the short, stocky figure type is to lengthen the appearance and avoid shortening/widening, but with more emphasis.

 AVOID

Horizontal lines than widen and shorten the overall appearance.

Jackets and tops that fall below the high hip level. X-Long coats.

Cropped pants or over-long shorts.

Pants or shorts with a long, loose crotch.

Over-sized garments or garments that incorporate an excessive amount of fabric. Avoid pleat-front pants and skirts.

 AIM TOWARDS

Pointed collars and vertical/diagonal open necklines that will offset a rounder face and/or shorter neck.

Jackets and tops with structured shoulders or set-in sleeves that define the shoulder point, not extend beyond it.

Garments that incorporate smaller details/have smaller proportions. Smaller scale prints. Jackets with three or four buttons, instead of one or two.

Shorter skirts for women.

Shoes that are not too delicate.

Counter-Active Design Techniques

SHORT WAISTED

 AVOID

Pants or skirts with high waistlines.

Belted and waisted looks.

Cropped tops.

☑ **AIM TOWARDS**

High or stand-up collars to elongate the torso.

Tops that have elongating vertical or diagonal lines.

Tops that are slightly longer than average.

Hip-length shirts or cardigans.

Blouson-style tops that disguise the position of the waistline.

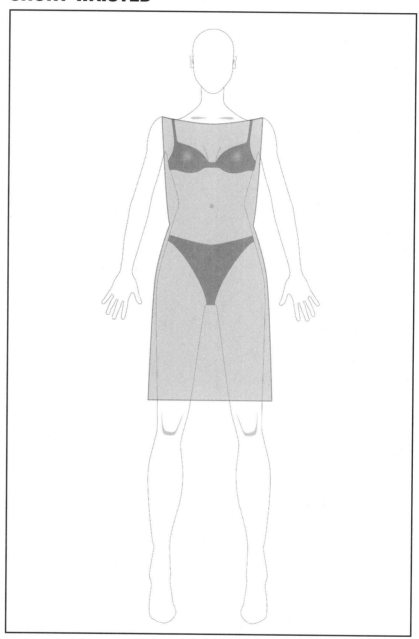

For this body type, the waistline falls slightly higher than the average person, giving the appearance of a short torso. The techniques described below are therefore aimed towards elongating the upper body to bring the overall appearance back into proportion.

Counter-Active Design Techniques

LONG WAISTED

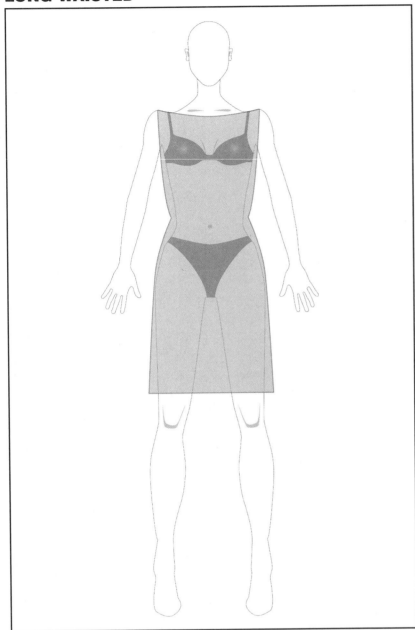

 AVOID

High or stand-up collars that further elongate the torso.

Low-riding, hip-hugging or cropped pants.

Tops that are slightly longer than average.

 AIM TOWARDS

Pants or skirts with high waistbands.

Empire waistlines.

Longer, slim-fitting skirts.

Longer pants without cuffs (these will shorten the look of the legs even further).

Jackets and overshirts that are shorter than the top worn underneath.

For this body type, the waistline falls slightly lower than the average person, giving the appearance of a long torso and short legs. The techniques described here are therefore aimed towards elongating the lower body to bring the overall appearance back into proportion.

FOCUS ON APPAREL

The Fashion Industry uses specific terminology to identify different categories and lengths of apparel. Designers utilize changes to the garment parts and other construction details as design tools. These are examined in this section:

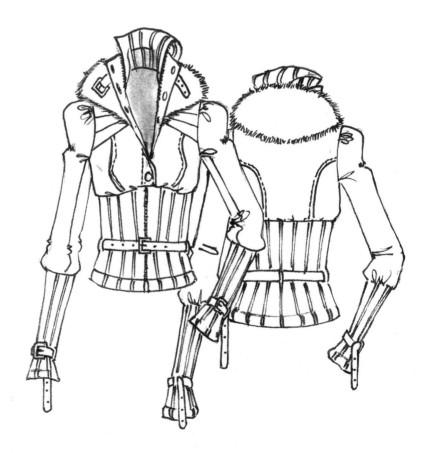

GARMENT CATEGORIES

INTRODUCTION
The following are commonly recognized categories of apparel within the garment industry:

ACCESSORIES

A collective term for an array of items designed to complete and/or enhance an outfit, including bags, belts, gloves, hats, jewelry, scarves and shoes.

ACTIVEWEAR/ACTIVE SPORTSWEAR

Mixed separates that are designed to be worn while performing sporting activities like cycling, hiking, running, skiing, tennis etc. Aside from aesthetics, one of the key factors is how well the garments perform in extreme circumstances. The structure of the garment and the fabric(s) from which they are made are often required to withstand and allow for strenuous movement, wick away sweat, protect the body from extreme weather conditions and the like.

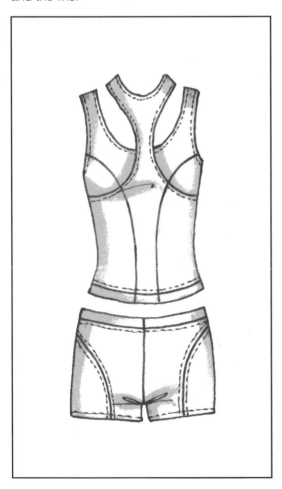

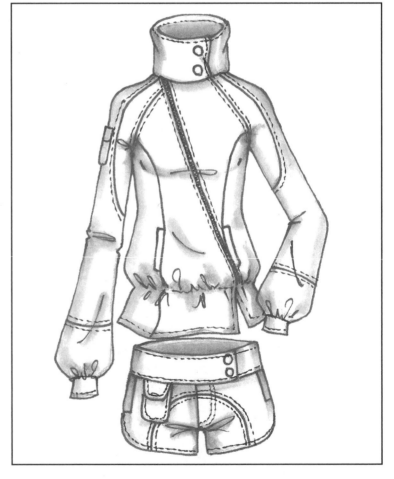

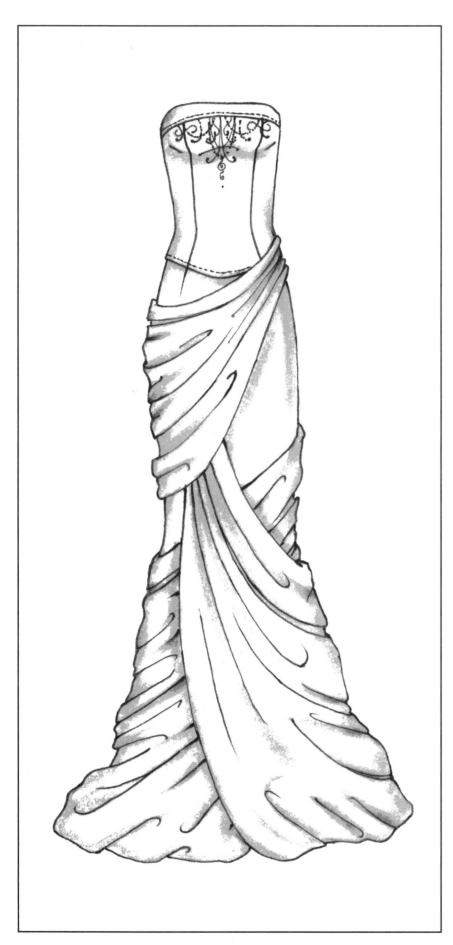

BRIDALWEAR

Items of clothing designed to be worn at a wedding, including dresses and ensembles for a bride, bridesmaid, maid of honor and mother of the bride. Also includes two piece suits (jacket and pant), three piece suits (jacket, pant and vest) and tuxedos for the groom, groomsmen and page boy.

CLUBWEAR

Mixed separates and dresses designed for social events.

DRESSES

Dresses and two-piece skirt ensembles.

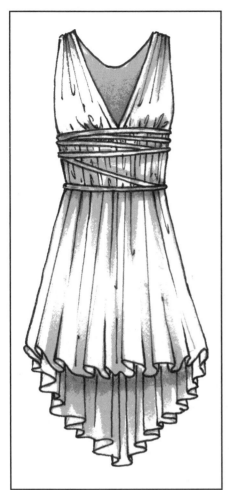

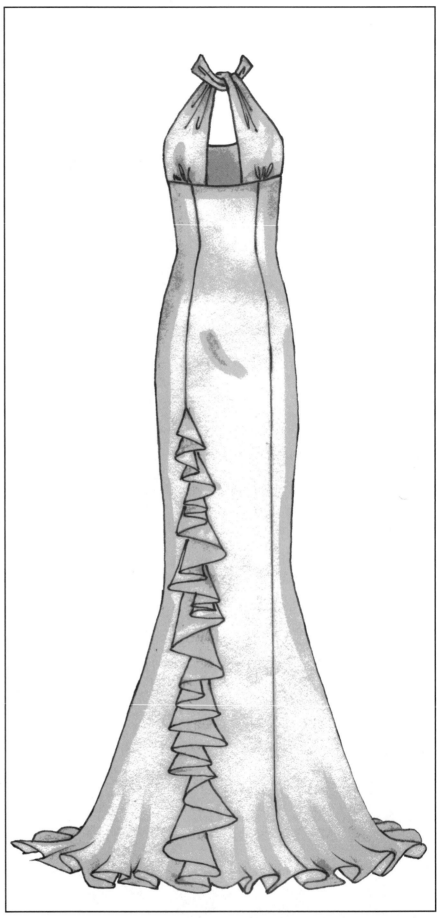

EVENINGWEAR

Full length dresses, cocktail dresses and mixed separates designed to be worn at upscale social, evening events.

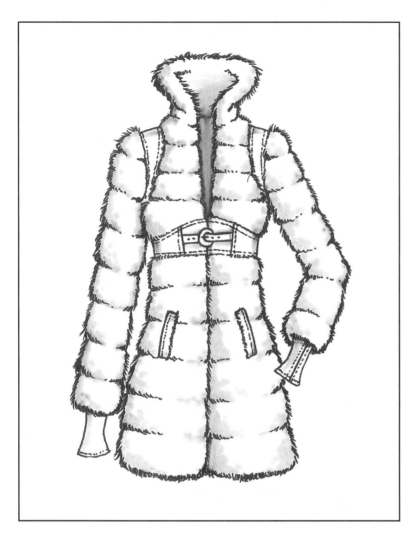

FUR

Garments, often jackets, vests, capes and coats made from the real fur/skin of animals or 'faux' (man-made) fur. Common real or faux furs include fox, leopard, mink and rabbit.

KNITWEAR

A collective term for garments that are made from knits. A fully fashioned knit is one where the pieces that make up a garment are knitted and shaped on a loom, before being sewn together. A cut-and-sewn knit is one where the pieces are cut out from yardage of knitted fabrics (just as with woven fabrics), then sewn together. Knitwear includes tops, skirts, sweaters, cardigans, shawls, capes, coats, hats, gloves and scarves.

INTIMATE APPAREL/ LINGERIE/ UNDERWEAR

A collective term for under garments that are designed to be worn beneath your clothes. Key considerations include the look/sex appeal, the support and shaping they provide and their ability to appear invisible under your clothes. Garments include, bras, bustiers, camisole tops, garter belts and panties.

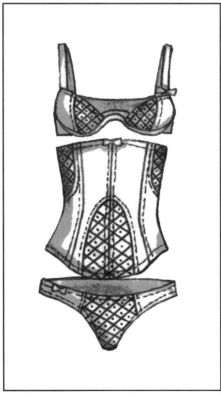

LEATHERWEAR

Garments made from the skin or hide of animals such as alligators, cows, goats (kid leather), sheep (shearling) and snakes. Skin can be real or man-made ('faux').

LOUNGEWEAR & ROBES

Mixed separates, traditionally in loose-fitting styles, that are designed to be worn when relaxing.

OUTERWEAR

Garments designed to be worn over an outfit to protect it, and you, from the elements, including capes, coats and jackets.

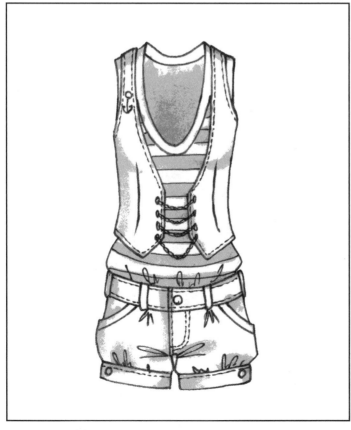

RESORTWEAR

Also referred to as Cruise, these are mixed separates designed to be worn on vacation or, literally, on a cruise ship. Traditionally, this type of apparel is geared towards older women who are looking for casual clothing with a bit of 'bling.' Nowadays, resortwear is incorporated into collections for younger markets too.

SLEEPWEAR

Garments for wearing to bed including, pajamas, nighties (nightgowns or nightdresses) and dressing gowns.

STREETWEAR

Mixed separates that are designed to be worn by the younger generation. Styling tends to be casual but edgy and focused around lifestyle sporting activities such as BMX biking and skateboarding.

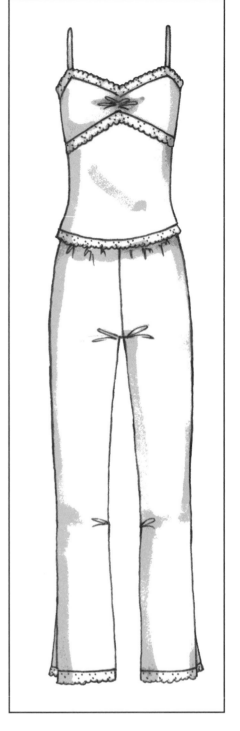

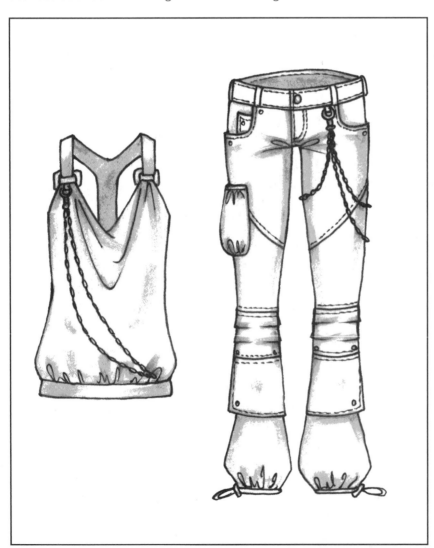

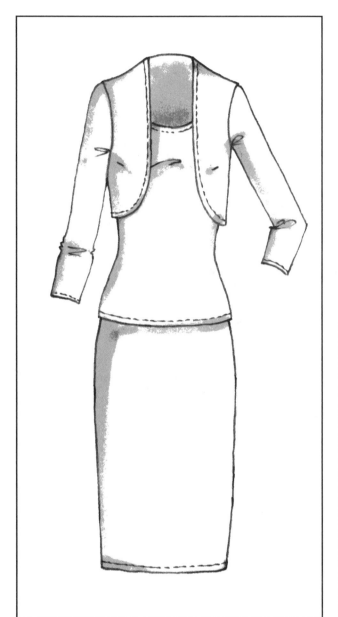

SPECIAL OCCASION

Somewhat formal/traditional dresses and mixed separates designed to be worn at upscale social events such as proms and weddings.

SPORTSWEAR

Mixed separates that are designed to be worn every day. Can be casual, or more dressy. There are two types of sportswear; coordinated sportswear where the pieces are designed to be combined in a specific way; and related sportswear, where more variations are possible, since the pieces are designed to intermix.

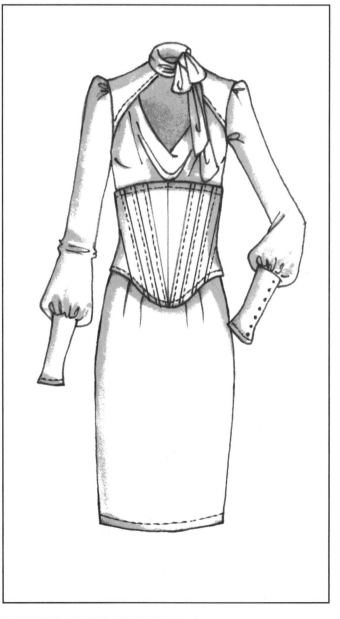

SUITS

Mens and womens suits, including:

Two piece pant suits (jacket and pant).
Three piece pant suits (jacket, pant and vest).
Two piece skirt suits (jacket and skirt).
Three piece skirt suits (jacket, skirt and vest).

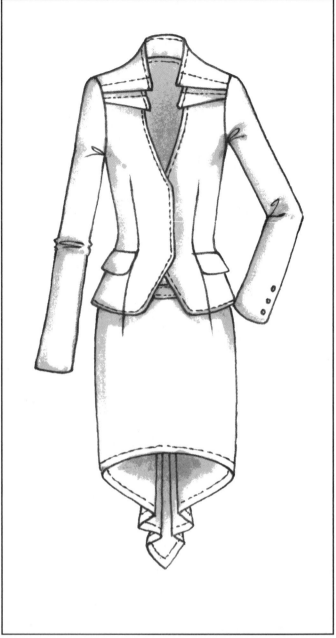

SURFWEAR

Mixed separates that are designed to be worn by the younger generation. Styling tends to be casual but edgy and focused around the lifestyle of a surfer.

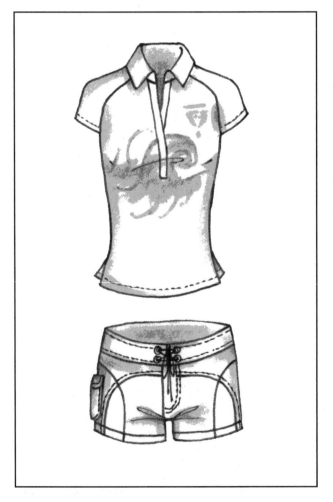

SWIMWEAR & BEACHWEAR

Garments designed to be worn for swimming, sunbathing and hanging out at the beach or pool. Includes one and two piece swimsuits and bikinis, sarongs and cover-ups.

WESTERNWEAR

Mixed separates designed for, or inspired by, cowboys and girls.

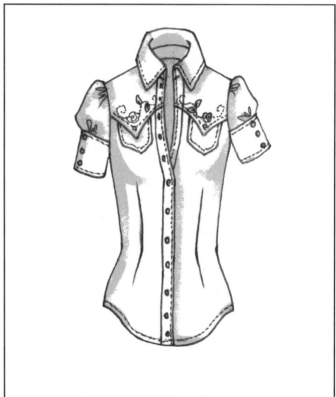

UNIFORMS & WORKWEAR

Mixed separates to be worn at school or at work. Garments often have embroidered or appliquéd names and logos on them and are designed to resist wear and tear (have durability) and to be laundered easily and often (are easy care).

GARMENT LENGTHS

INTRODUCTION

The length of a garment is as much a part of the design as the color, style, print or trim. These are all key factors that a designer must take into account with direct regards to their target customer, as well as what's going on within the marketplace. Here are some points to consider:

FAD
A fad is a very short-lived fashion or style, that moves quickly through the fashion cycle of introduction, to peak, then decline. Therefore, in fast-moving markets, such as the junior market, it is key to be able to anticipate the up-coming fad, where length of a garment is concerned. A junior customer is, typically, less concerned with hiding their body, but very style and price conscious.

TRENDS
A trend is a longer-lasting fashion or style. A trend transcends more types of customer, normally older, than a fad – simply because it's more 'mellow'. All markets are influenced by trends in lengths, particularly the contemporary market; these customers want to be fashionable, but generally will not do so at the risk of being a 'fashion victim' (wearing something simply because it is in style, regardless of whether or not it suits them). They are older than the junior customer and are conscious of their more mature body types; they know what looks good on them and what does not. For example, a savvy designer might spot an upcoming trend in length – let's say it's micro mini skirts. However, he knows that the vast majority of his contemporary customers will not buy skirts that are extremely revealing, so he interprets that trend into something he knows his customer will buy. His offerings for next season might, therefore, include one or more skirts that are finished 4" above-the-knee, in addition to his best-selling 2" above-the-knee skirts.

CLASSICS
A classic style is one that becomes accepted for a long period of time, and is simply updated from season to season. The reason that is has become accepted for a long period of time is that it is, typically, a great, flattering and moderate design that goes to no extremes, so it suits many different body types and is, therefore, able to transcend fads and trends (is accepted and always looks good without being greatly influenced by the fads and trends). Having said that, classic lengths are most often seen in the misses and other, more traditional, markets.

The following pages provide 'at-a-glance' overviews of the typical lengths that are commonly referred to, within the fashion industry today, and the terminology used to describe these lengths.

Garment Lengths

COATS & JACKETS

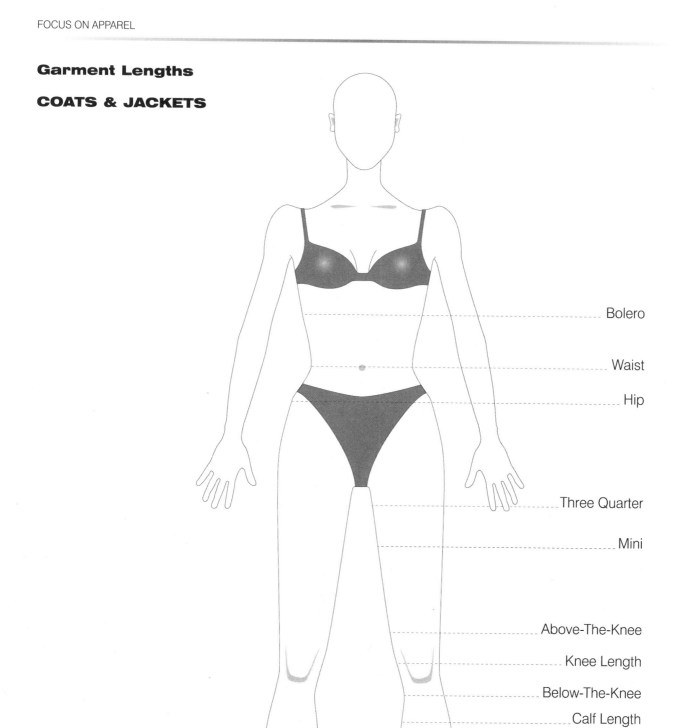

Bolero

Waist

Hip

Three Quarter

Mini

Above-The-Knee

Knee Length

Below-The-Knee

Calf Length

Midi

Maxi

Ankle Length

Full Length

Garment Lengths

DRESSES, SKIRTS & PANTS

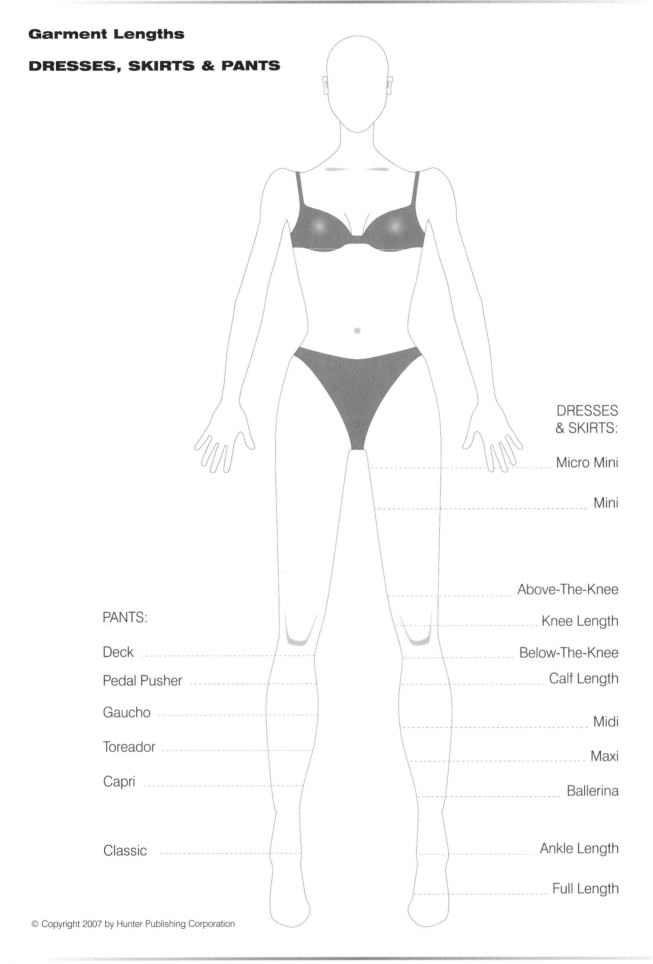

DRESSES
& SKIRTS:

Micro Mini

Mini

Above-The-Knee

PANTS: Knee Length

Deck Below-The-Knee

Pedal Pusher Calf Length

Gaucho Midi

Toreador Maxi

Capri Ballerina

Classic Ankle Length

Full Length

Garment Lengths

SHORTS & SLEEVES

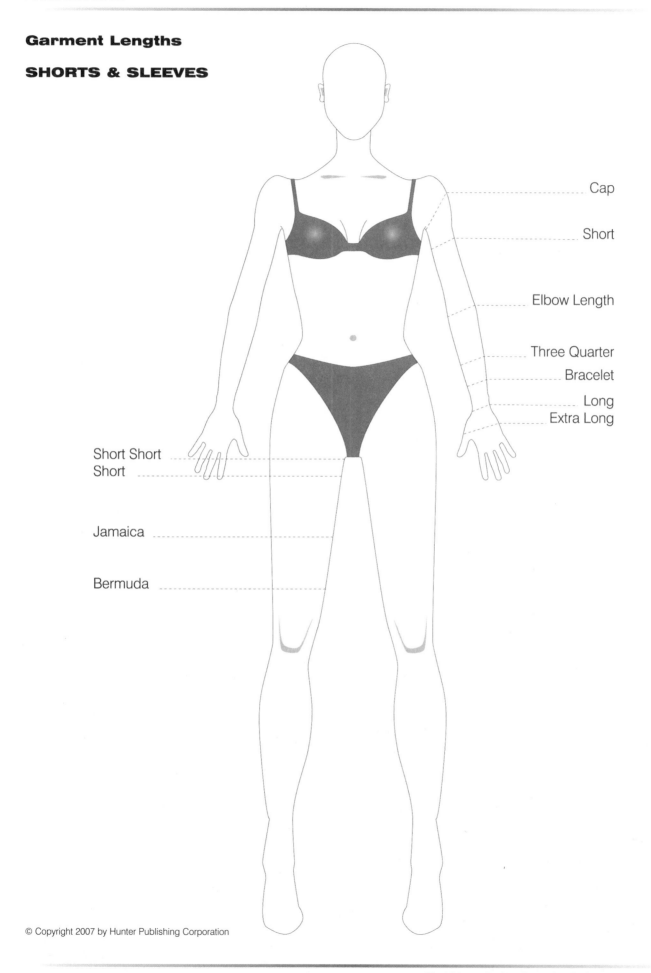

Cap

Short

Elbow Length

Three Quarter

Bracelet

Long

Extra Long

Short Short

Short

Jamaica

Bermuda

GARMENT PARTS & DETAILS

INTRODUCTION

Every part of a garment, and the details incorporated within it, provide a designer with an opportunity to make choices and decisions that culminate in the overall style and mood the garment achieves.

Stylelines, seam and hemlines, stitches, cuffs, collars, lapels, sleeves, necklines, yokes, pockets, darts, godets, gores, tucks, pleats, ruffles, gathering, draping, elastic, smocking, quilting, notions and items of trim are all tools that designers can use to portray their vision to their customers.

The following are samples of garment parts and details; it is not a definitive collection, but a selection to stimulate your imagination and help you when you begin the designing process.

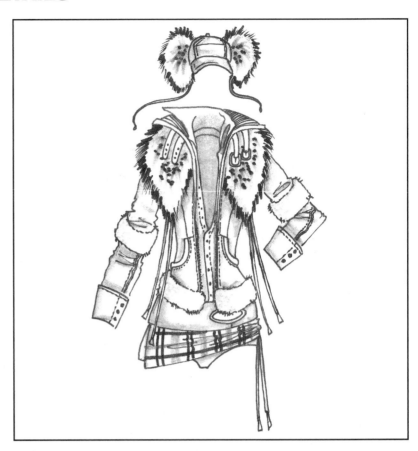

GLOSSARY OF GARMENT PARTS & DETAILS TERMINOLOGY

Collar: Fabric attached to, or folding over from the neckline.

Cuff: Fabric attached to, or folding back from the hemline; often seen on sleeves and pants.

Dart: A dart is a fold in the fabric used to control excess fabric and shape a garment. These folds start from a point within the garment and extend to the cut line, or extend from point to point within the body of a garment (often called a 'fisheye' dart (see example #3 on Page 71)).

Drape: Excess fabric that is sewn in such a way that it can naturally hang in position, for decorative effect.

Gather: Excess fabric that has been drawn together and sewn in place; creating fullness; also called shirring.

Godet: An additional piece of fabric sewn into a garment, adding flare or drape.

Gore: A panel of fabric; most often used to produce skirts.

Hemline: The bottom edge of a garment.

Lapel: Fabric attached to, or folding over from the center front of a garment and attaching to the collar.

Neckline: The shape created by the top edge of a garment covering the upper body.

Pleat: A fold in the fabric; variations in the direction, number and size create different effects.

Quilting: Two pieces of fabric placed either side of batting and sewn into position; stitching can vary in style and shape to create decorative effects.

Ruffle: A piece of fabric or trim that is cut or gathered in such a way as to create a rippled effect.

Sleeve: Fabric attached to, or extending from the armhole.

Styleline: A visible line on a garment; created by sewing two pieces of fabric together, by a visible stitch, tuck, dart, accessory, appliqué, print or item of trim.

Seamline: A line on a garment created by sewing two or more pieces of fabric together.

Smocking: Multiple horizontal, vertical and/or diagonal elasticated stitches that create a decorative, ruched effect; may also be functional by allowing that part of the garment to stretch for getting on and off.

Tuck: A fold in the fabric; often narrower than a pleat and often stitched into place.

Yoke: A styleline most often seen across the chest and/or back of a top and across the hips of a skirt or pant.

DARTS

Use the following basic examples of dart manipulation to stimulate your imagination:

1. Dart
 NOTE: The dotted line shows the dart underlay.
2. Armhole
3. Fisheye, Waist
4. Mid Shoulder
5. Side Seam
6. Mid Neck
7. Shoulder Point
8. Side Seam Hem
9. Princess Seam & Bust

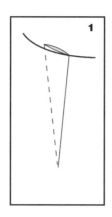

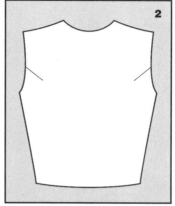

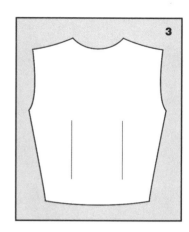

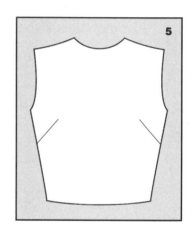

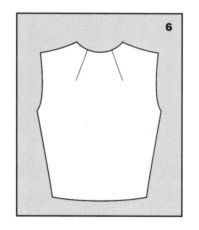

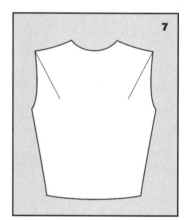

Computer generated technical flats showing creative use of darts

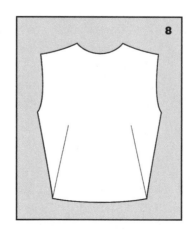

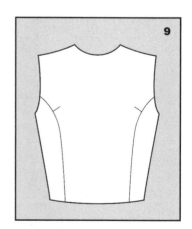

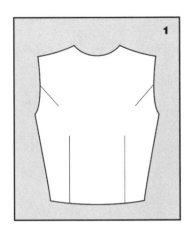

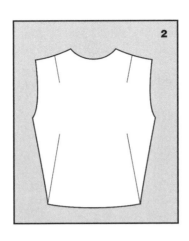

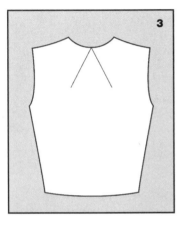

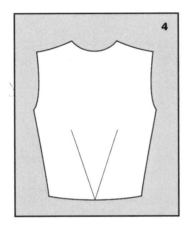

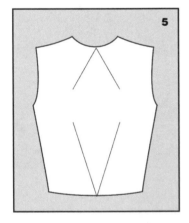

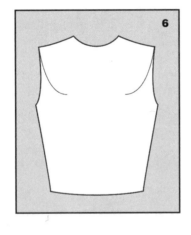

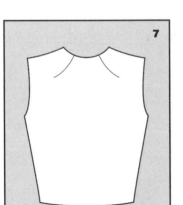

DARTS

Use the following basic examples of dart manipulation to stimulate your imagination:

1. Armhole & Waist
2. Mid Shoulder & Side Seam Hem
3. Diagonal Center Front Neck
4. Diagonal Center Front Waist
5. Diagonal Center Front Neck & Waist
6. Curved Armhole/Shoulder Point
7. Curved Mid Neck
8. Curved Side Seam

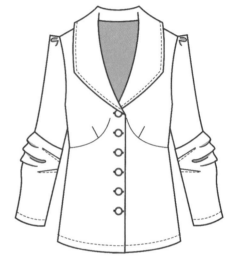

Computer generated technical flats showing creative use of darts

DARTS

Use the following basic examples of dart manipulation to stimulate your imagination:

1. Parallel Shoulder
2. Parallel Diagonal
3. Curved into Neckline
4. Radiating
5. Intersecting Inverted T
6. Intersecting Inverted Y with Gathers
7. Intersecting Curved & Straight with Gathers
8. Crossing

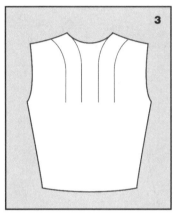
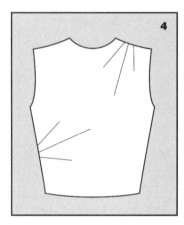

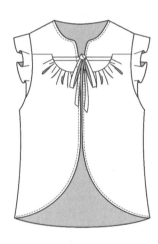

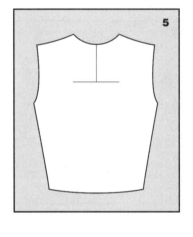
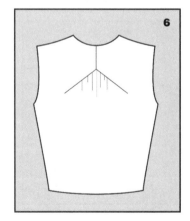

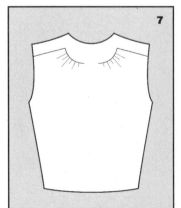
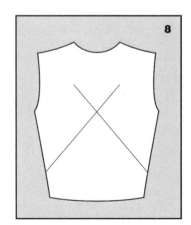

Computer generated technical flats showing creative use of darts

STYLE & SEAMLINES

Use the following basic examples of style and seamline manipulation to stimulate your imagination:

1. Empire Waistline
2. Regular Waistline
3. Dropped Waistline
4. Shaped Yoke
5. High Waistline
6. Low Riding Waistline

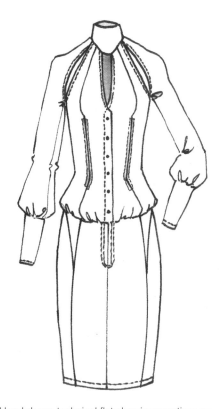

Hand drawn technical flat showing creative use of style and seamlines

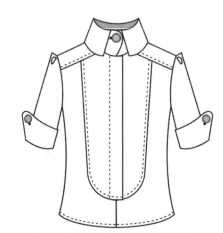

Computer generated technical flats showing creative use of style and seamlines

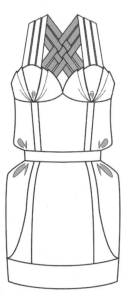

STYLE & SEAMLINES

Use the following basic examples of style and seamline manipulation to stimulate your imagination:

1. Classic Princess Seam
2. Princess Seam to Armhole
3. Shoulder
4. High Straight Yoke
5. Rectangular Bib
6. Circular Bib
7. Scooped Bib
8. High Curved Yoke

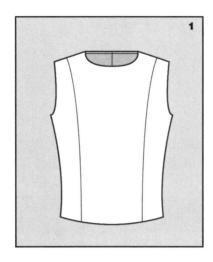
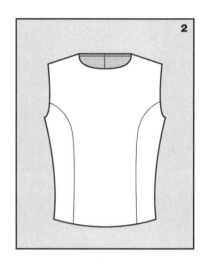

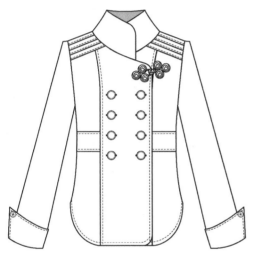

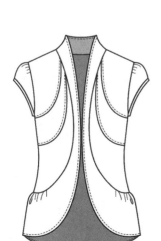

Computer generated technical flats showing creative use of style and seamlines

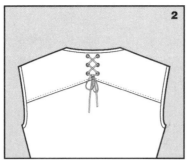

STYLE & SEAMLINES

Use the following basic examples of style and seamline manipulation to stimulate your imagination:

1. Raglan Yoke
2. High Angled Yoke
3. Western Yoke
4. Diagonal Combination
5. Curved, Decorative
6. Curved Bustline
7. Angled Panel
8. Shoulder with V

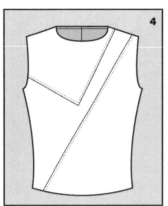

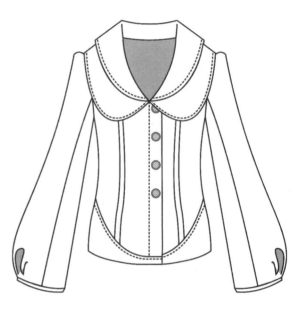

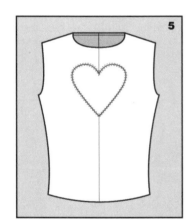

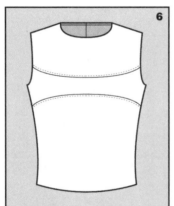

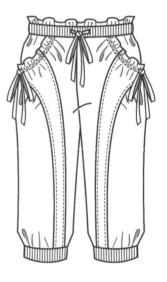

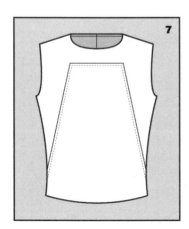

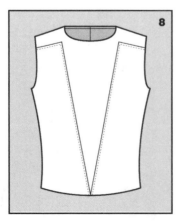

Computer generated technical flats showing creative use of style and seamlines

STYLE & SEAMLINES

Use the following basic examples of style and seamline manipulation to stimulate your imagination:

1. Simple Curved Yoke
2. Pointed Yoke
3. Squared Yoke
4. Asymmetrical Yoke
5. Decorative Yoke
6. Lightening Flash Yoke
7. Undulating Yoke
8. Asymmetrical Gores

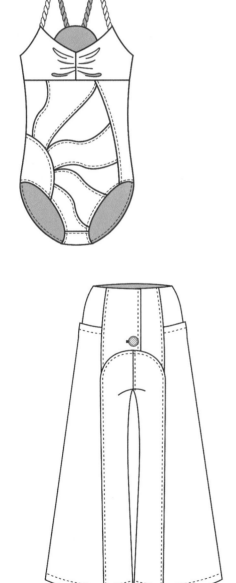

Computer generated technical flats showing
creative use of style and seamlines

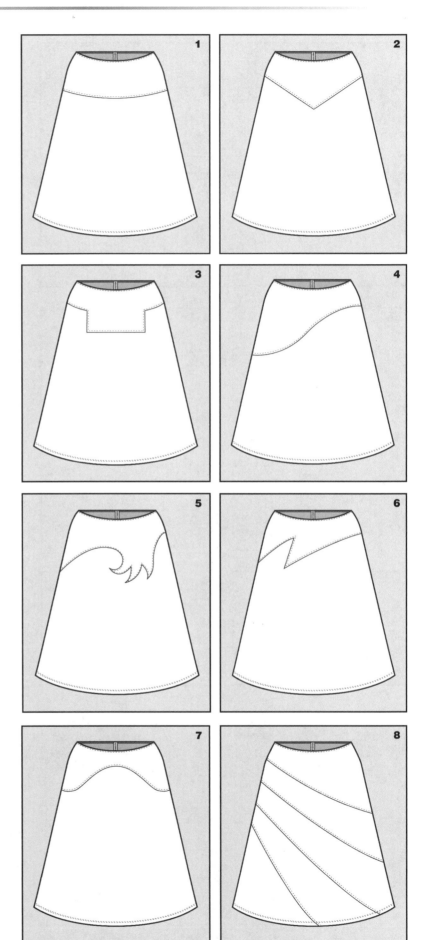

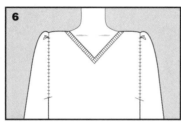

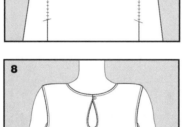

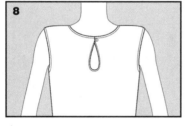

NECKLINES

Use the following basic examples of different necklines to stimulate your imagination:

1. Crew
2. Jewel
3. Scoop
4. Bateau/Boat
5. Shaped Vee
6. V
7. Placket
8. Keyhole
9. Drawstring
10. Square

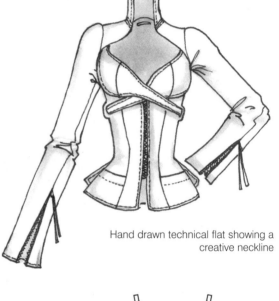

Hand drawn technical flat showing a creative neckline

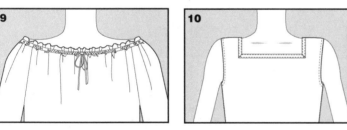

Computer generated technical flats showing creative necklines

NECKLINES

Use the following basic examples of different necklines to stimulate your imagination:

1. Plunging
2. Off-the-Shoulder
3. Halter
4. Surplice/Wrapover
5. Bustier
6. Sweetheart
7. Strapless
8. One-Shoulder

Computer generated technical flats showing creative necklines

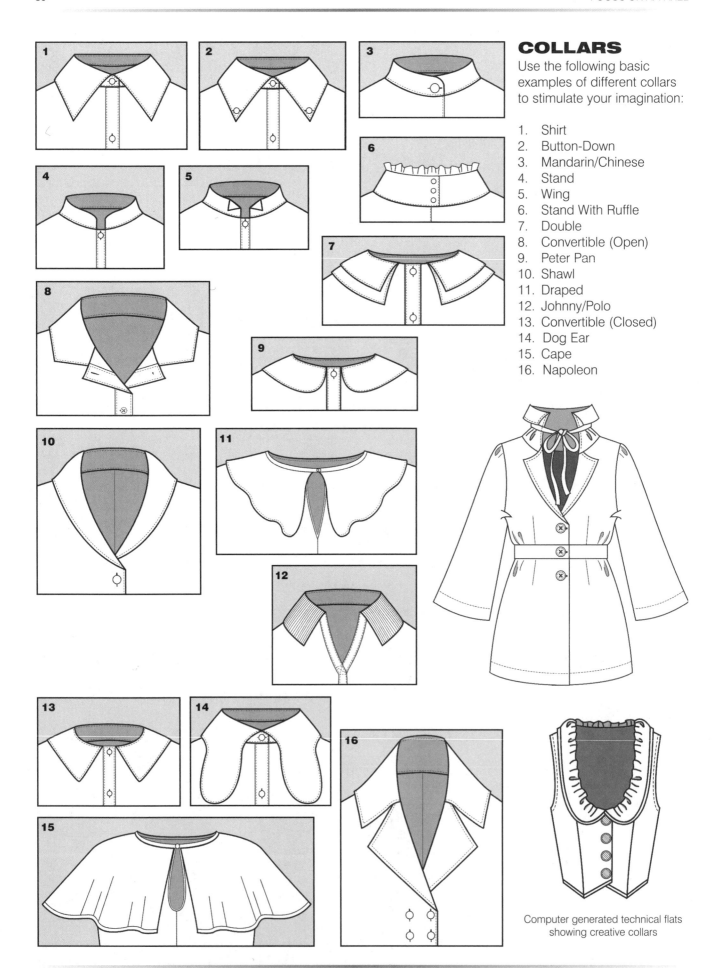

COLLARS

Use the following basic examples of different collars to stimulate your imagination:

1. Shirt
2. Button-Down
3. Mandarin/Chinese
4. Stand
5. Wing
6. Stand With Ruffle
7. Double
8. Convertible (Open)
9. Peter Pan
10. Shawl
11. Draped
12. Johnny/Polo
13. Convertible (Closed)
14. Dog Ear
15. Cape
16. Napoleon

Computer generated technical flats
showing creative collars

COLLARS & LAPELS

Use the following basic examples of different collars and lapels to stimulate your imagination:

1. Butterfly
2. Turtleneck
3. Funnel
4. Chelsea
5. Cowl
6. Bumper
7. Cloverleaf Lapel
8. Peaked Lapel
9. Fishmouth Lapel
10. Notched Lapel

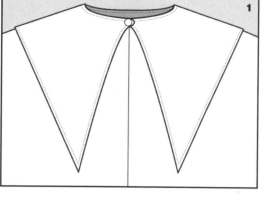

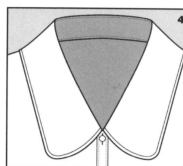

One hand drawn and two computer generated technical flats showing creative collars and lapels

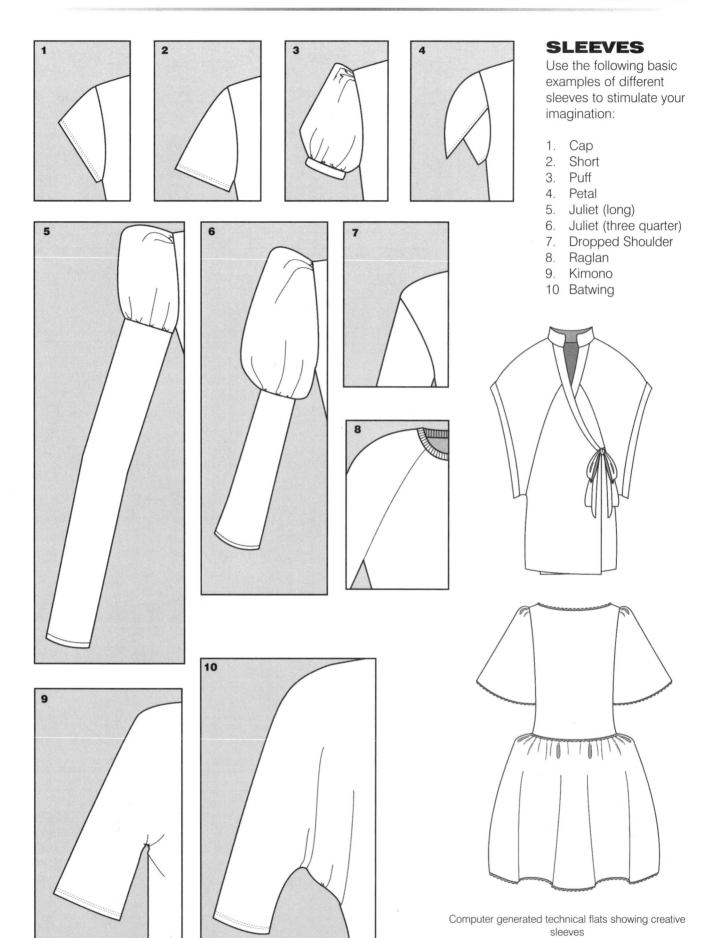

SLEEVES

Use the following basic examples of different sleeves to stimulate your imagination:

1. Cap
2. Short
3. Puff
4. Petal
5. Juliet (long)
6. Juliet (three quarter)
7. Dropped Shoulder
8. Raglan
9. Kimono
10 Batwing

Computer generated technical flats showing creative sleeves

SLEEVES

Use the following basic examples of different sleeves to stimulate your imagination:

1. Bishop
2. Dolman
3. Leg-of-Mutton
4. Bell

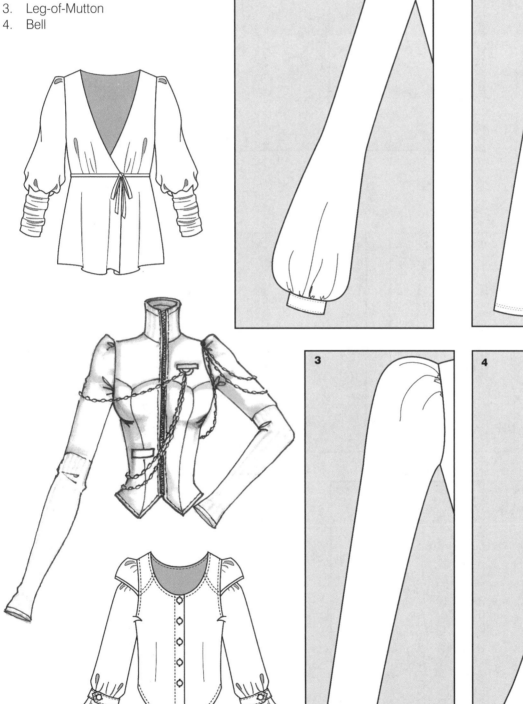

Two computer generated and one hand drawn technical flat
showing creative sleeves

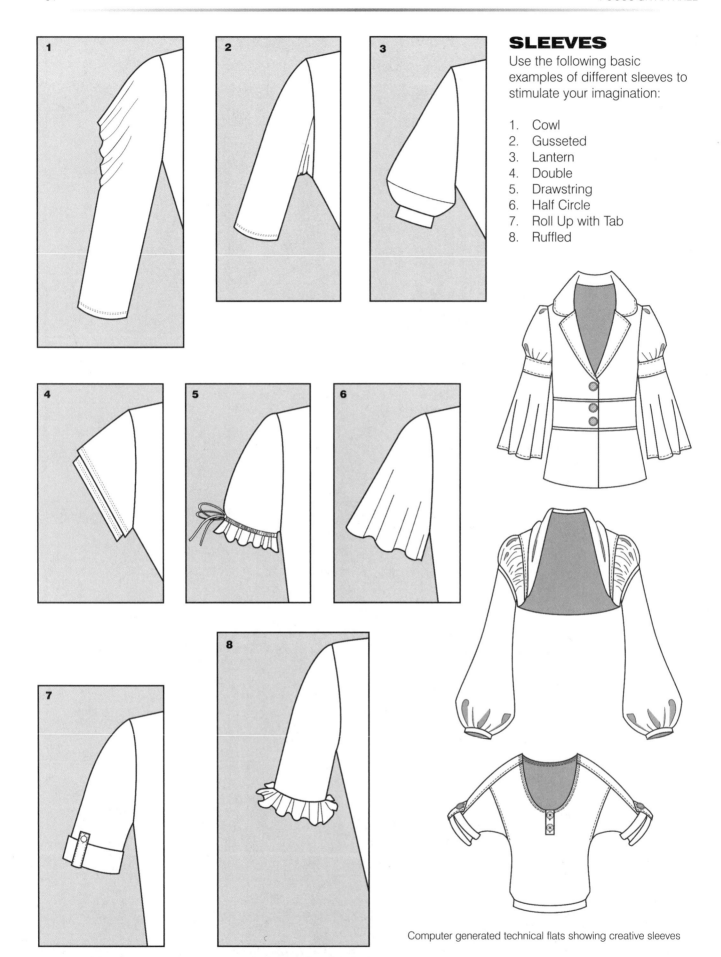

SLEEVES

Use the following basic examples of different sleeves to stimulate your imagination:

1. Cowl
2. Gusseted
3. Lantern
4. Double
5. Drawstring
6. Half Circle
7. Roll Up with Tab
8. Ruffled

Computer generated technical flats showing creative sleeves

CUFFS

Use the following basic examples of different cuffs to stimulate your imagination:

1. Barrel
2. Banded
3. French
4. French (With Cufflink)
5. Ribbed
6. Gauntlet
7. Funnel
8. Roll-Up
9. Petal
10. Zipper
11. Pant
12. Lace

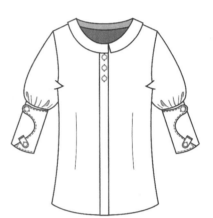

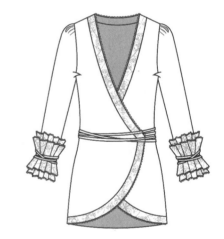

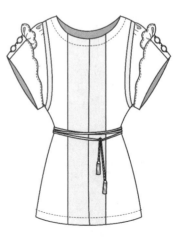

Computer generated technical flats showing creative cuffs

HEMLINES

Use the following basic examples of different hemlines to stimulate your imagination:

1. Shaped
2. Scalloped
3. Surplice/Wrapover
4. Asymmetrical
5. Bubble
6. Fringed
7. Layered

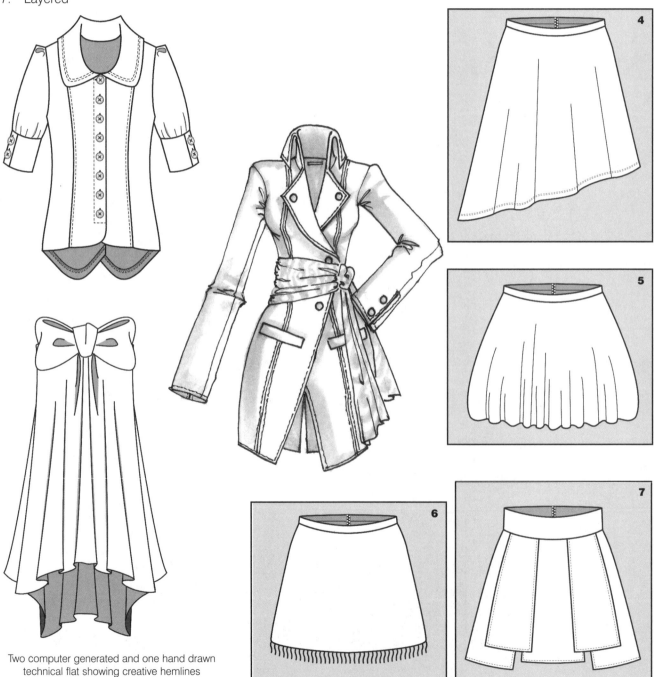

Two computer generated and one hand drawn technical flat showing creative hemlines

Use the following basic examples of draping and elastic to stimulate your imagination:

DRAPING

1. Cocoon Shrug
2. Soft Draped Sleeve
3. Heavy Draped Sleeve (Swags)
4. Draped Side Seam
5. Draped Printed Skirt

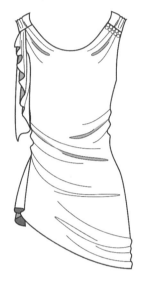

ELASTICATED

6. Top
7. Sleeve
8. Stitch

Computer generated technical flats showing creative use of draping and elastic

GATHERS

Use the following basic examples of gathering techniques to stimulate your imagination:

1. Skirt
2. Top
3. Into Empire Waistline
4. Sleeve
5. Into Dart
6. Into Back Yolk
7. Into Side Seam
8. Into Center Front Seam

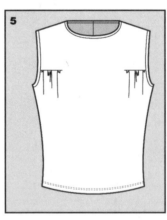

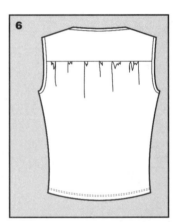

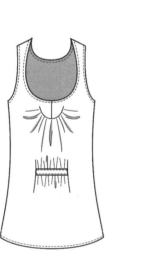

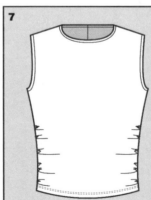

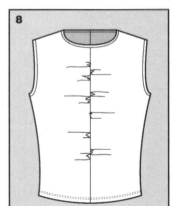

Two computer generated and one hand drawn technical flat
showing creative use of gathers

GODETS

Use the following basic examples of different godets to stimulate your imagination:

1. Panel
2. Swags
3. Multiple
4. Rounded

Computer generated technical flats showing creative use of godets

POCKETS

Use the following basic examples of different pockets to stimulate your imagination:

1. Rounded Patch
2. Square Patch with Cuff
3. Cargo
4. Square Flap
5. Bellows
6. Gusseted
7. Curved Flap
8. Zippered
9. Besom/Welt
10. Kangaroo

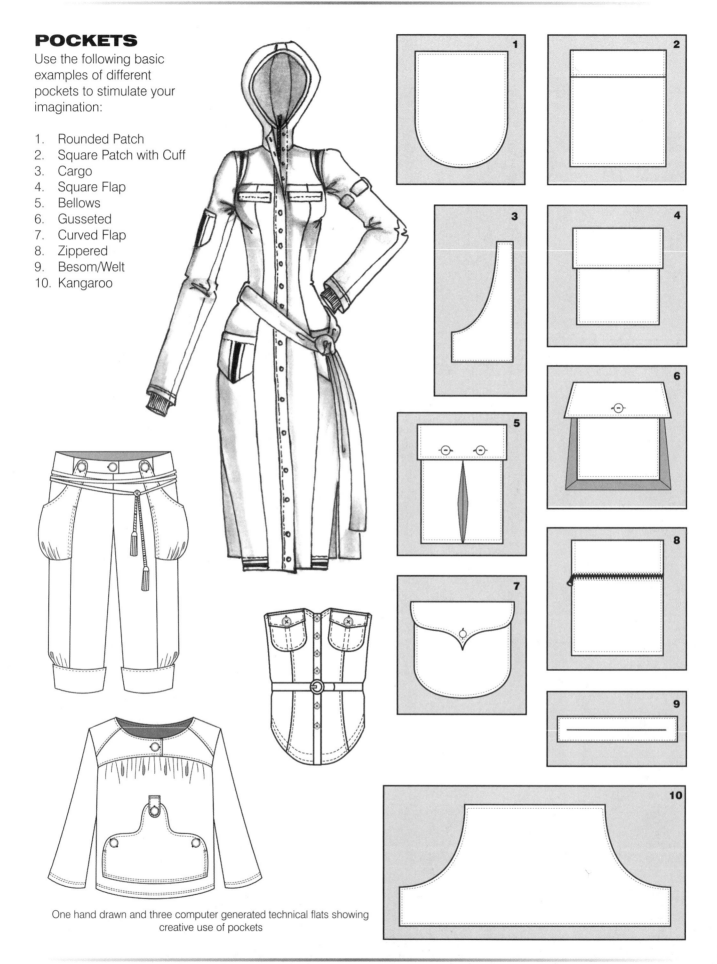

One hand drawn and three computer generated technical flats showing creative use of pockets

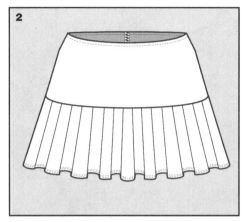

PLEATS

Use the following basic examples of different pleating techniques to stimulate your imagination:

1. Accordion
2. Box
3. Pleat-Front Pant
4. Knife
5. Inverted
6. Into Shoulder Seam

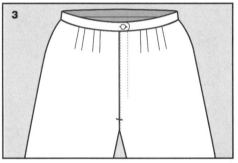

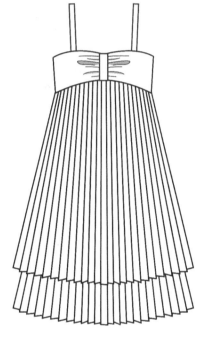

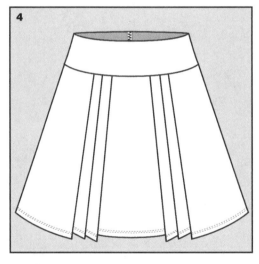

Computer generated technical flats
showing creative use of pleats

Use the following basic examples of quilting, ruffles and smocking to stimulate your imagination:

QUILTING

1. Quilting
2. Quilted Vest

RUFFLES

3. Armhole
4. Skirt

SMOCKING

5. Smocked Shirt
6. Smocking Stitch
7. Smocked Top

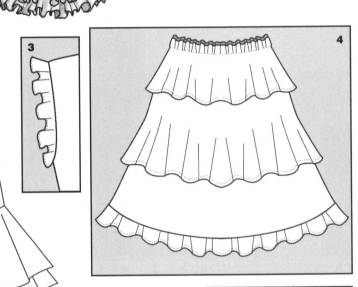
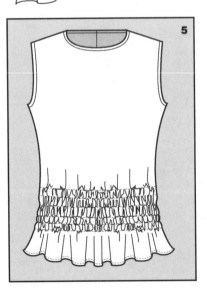
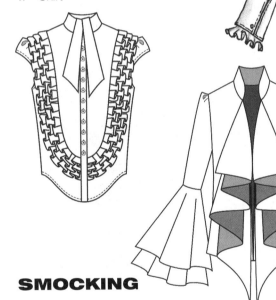
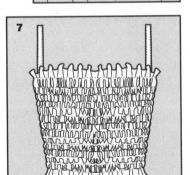
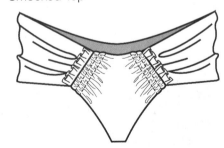

Four computer generated and one hand drawn technical flat showing creative use of quilting, ruffles and smocking

STITCHING

Use the following basic examples of different stitching techniques to stimulate your imagination:

1. Coverstitch
2. Reverse Coverstitch
3. Overlock, Lettuce Leaf
4. Merrow, Lettuce Leaf
5. Single Top Stitch
6. Saddle Stitch
7. Whipstitch
8. Merrow
9. Overlock

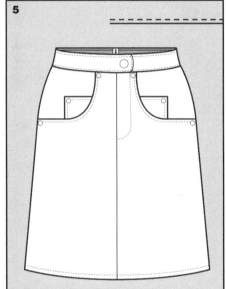

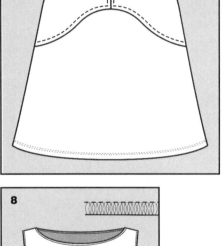

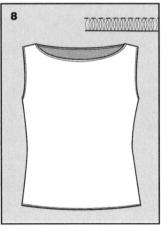

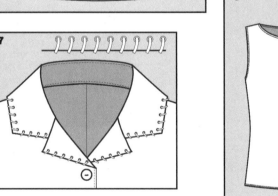

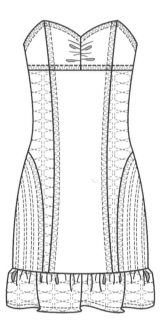

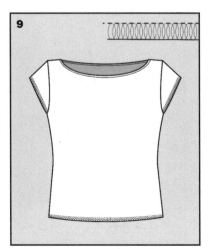

Computer generated technical flats showing creative use of stitching

Use the following basic examples
of tucks and tiers to stimulate
your imagination:

TUCKS

1. Tucks
2. Pintucked Blouse
3. Tank with Pintucked Bib

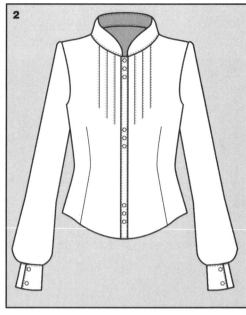

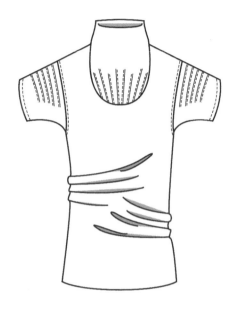

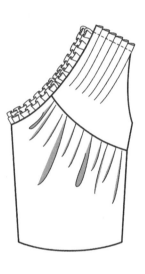

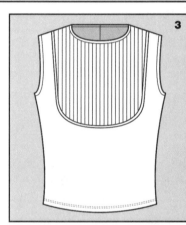

TIERS

4. Sleeve
5. Top
6. Skirt

Computer generated technical flats showing creative use of
tucks and tiers

OPENING & CLOSING/ ON & OFF

Use the following basic examples of different ways to get garments on and off to stimulate your imagination:

1. Simple Opening
2. Drawstring
3. Zipper
4. Elasticated
5. Button
6. Placket
7. Button & Loop
8. Tie

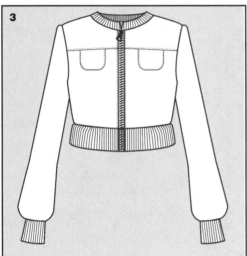

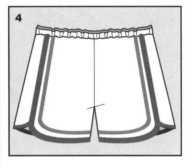

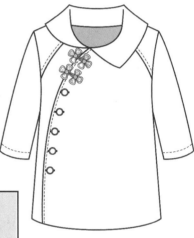

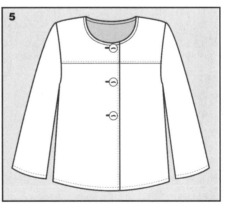

Computer generated technical flats showing creative openings

OPENING & CLOSING/ ON & OFF

Use the following basic examples of different ways to get garments on and off to stimulate your imagination:

1. Snaps/Poppers
2. Bow
3. Bias Cut
4. Lace Up
5. Stretch Fabric
6. Buckles

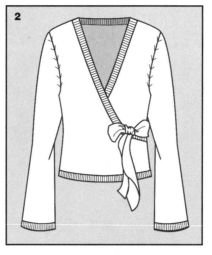

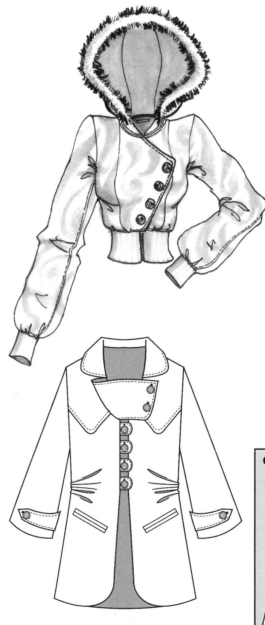

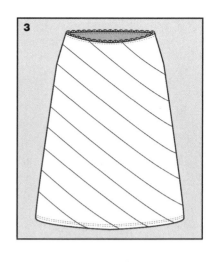

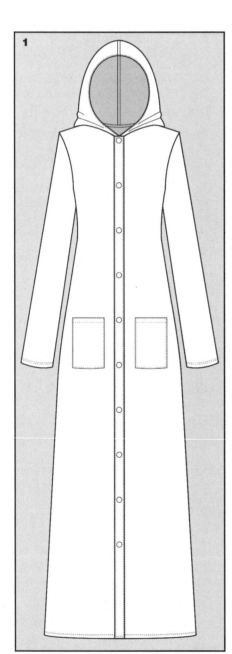

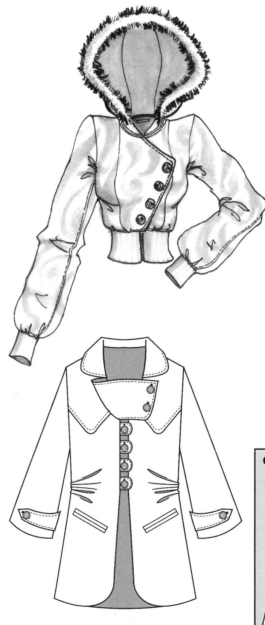

One hand drawn and one computer generated technical flat showing creative openings

NOTIONS & TRIM

Use the following basic examples of notions and trim to stimulate your imagination:

1. Appliqués
2. Belt Buckle
3. Buttons
4. Diamanté Trim
5. Embroidered Ribbon
6. Fur Trim
7. Fur/Leather Trim
8. Fur/Satin Trim
9. Mushroom Trim
10. Grosgrain Bow
11. Net Trim

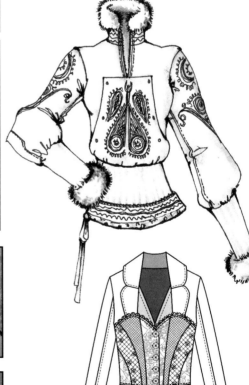

Two computer generated and one hand drawn technical flat showing creative use of notions & trim

NOTIONS & TRIM

Use the following basic examples of notions and trim to stimulate your imagination:

1. Leather Placket
2. Pleather Piping
3. Pom Poms
4. Poppers/Snaps
5. Soutache Lacing
6. Crocheted Wool Trim
7. Metal Zipper 1
8. Jeans Zipper
9. Molded Zipper
10. Invisible Zipper
11. Metal Zipper 2
12. Coil Zipper

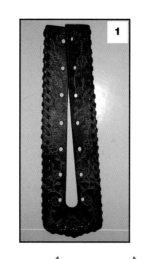

Computer generated technical flats showing
creative use of notions & trim

DESIGN BASICS

This section gives you a foundation for developing your own design style, based on proven techniques:

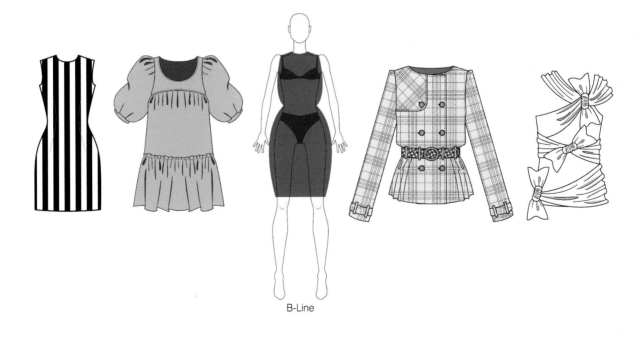

B-Line

PRINCIPLES & ELEMENTS OF DESIGN

INTRODUCTION

It is acknowledged that good designs take into account five basic principles and five basic elements. The principles of design are Proportion, Rhythm, Balance, Emphasis and Unity. The elements of design are Line, Shape, Color, Value and Fabric.

TOOLS, NOT RULES

Before we look closely at each item, it is important to understand the context in which the principles and elements apply. In essence, these are the components that make up a design; each of which provides creative possibilities for a designer to tap into and explore. They may also be viewed as a checklist, against which a designer can constructively critique his, or her work.

There are no 'right' or 'wrong' options. Ultimately, it is the designer's good taste, ability to 'interpret' fashion trends into what their target customer wants and skill in pulling the components together that results in winning designs.

Each of the principles and elements of design are examined in this section:

Principles:

PROPORTION

RHYTHM

BALANCE

EMPHASIS

UNITY

Elements:

LINE

SHAPE

COLOR & VALUE

FABRIC

PRINCIPLES

PROPORTION

This refers to the relationship between the sizes of the different parts of a garment.

In a well proportioned design, the size of the different parts will relate to, but not be the same as, each other.

• Subtle changes have dramatic effects.

• Remember, it's not about a design choice being 'right' or 'wrong,' it's about what will appeal to your target customer.

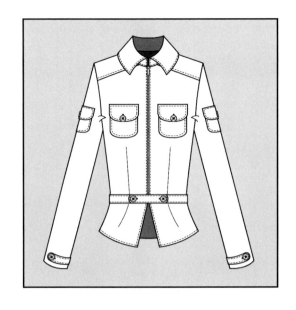

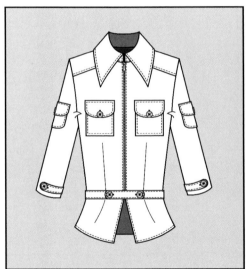

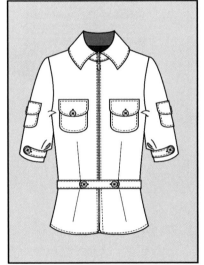

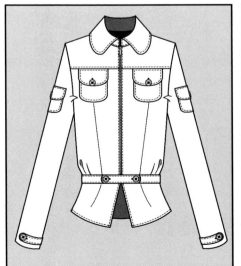

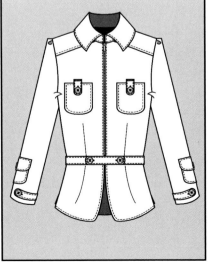

Computer generated technical flat
showing proportion

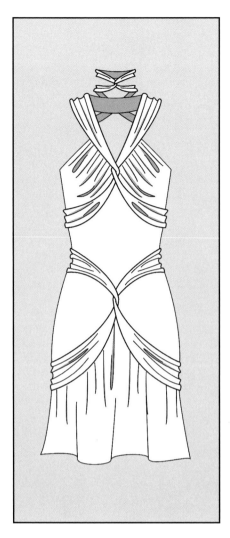

PRINCIPLES

RHYTHM

This refers to the movement created by repeating lines and shapes.

A uniform rhythm is created by repeating one element in one size.

A progressive rhythm is created by repeating one element in different sizes.

Computer generated technical flat
showing rhythm

PRINCIPLES

BALANCE

This refers to how the garment 'weighs up' visually. In other words, is it comfortable to look at?

When both sides of a garment are the same (symmetrical), it is said to have an even, or formal, balance. When both sides of a garment are not the same (asymmetrical), it is said to have an uneven balance.

• Remember, it's not about a design choice being 'right' or 'wrong,' it's about what will appeal to your target customer.

PRINCIPLES

EMPHASIS

This refers to the highlighting of certain features which draw the eye to a focal point on the garment.

Computer generated technical flat showing emphasis

PRINCIPLES

UNITY

This refers to the effect created when every aspect of both the principles and elements of design work together in harmony. Let's look at some of the classics:

Right:
Christian Dior's "New Look," 1947

Bottom Left:
André Courrèges, 1970

Bottom Center:
Karl Lagerfeld's updated "Chanel Suit," 2004

Bottom Right:
Yves Saint Laurent's "Mondrian Dress," 1965

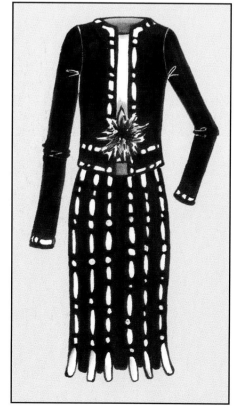

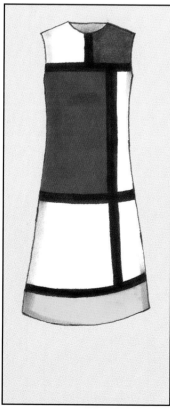

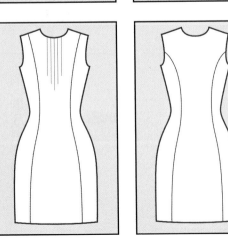

LINE

This refers to the directional effect created by the construction details, trim, notions and/or design of the fabric.

Whether lines are straight or curved, they play an important part in the overall look of a garment.

Vertical lines have a slimming effect.

Notice how the spacing and positioning of lines affect the perceived width of the body.

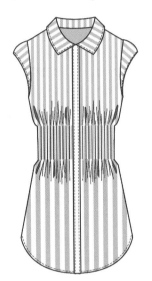

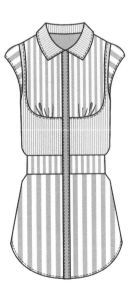

Computer generated technical flats showing creative use of vertical lines

LINE continued

Horizontal lines have a widening effect.

Notice how a steep diagonal line slims the look of the body, since it is closer to being a vertical line.

When a diagonal line is shallow, and closer to being a horizontal line, it widens the look of the body.

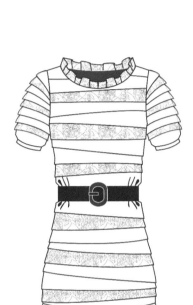

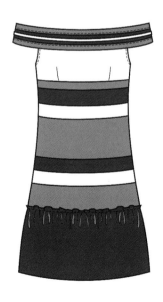

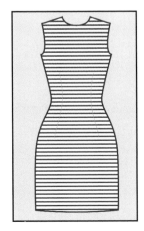

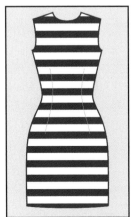

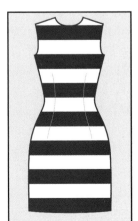

Computer generated technical flats showing creative use of horizontal lines

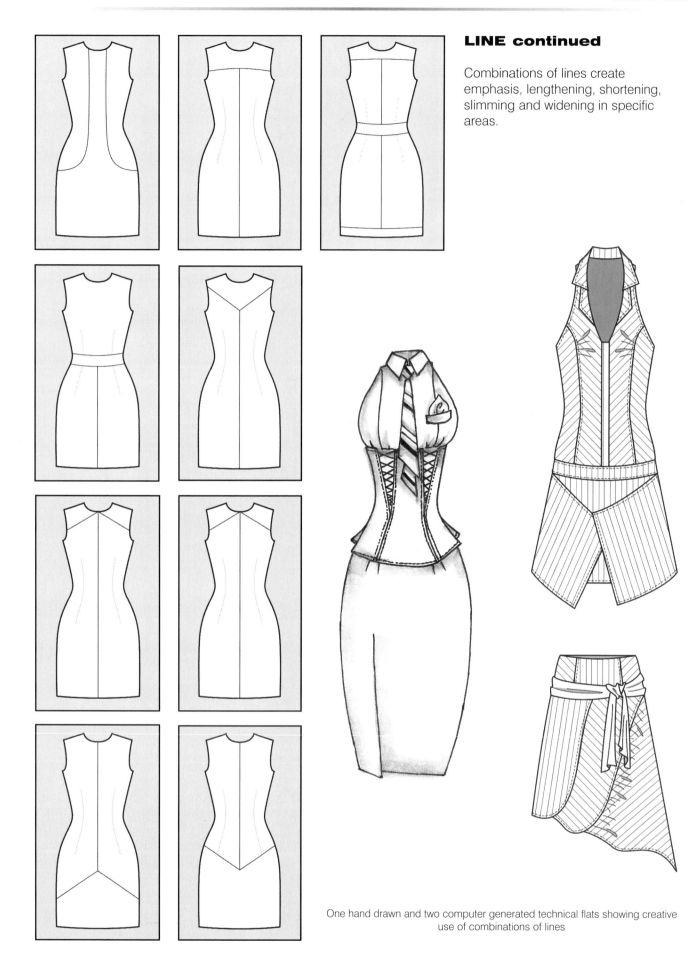

LINE continued

Combinations of lines create emphasis, lengthening, shortening, slimming and widening in specific areas.

One hand drawn and two computer generated technical flats showing creative use of combinations of lines

ELEMENTS

SHAPE

This refers to the silhouette, or outline created by the garment, or outfit/ensemble. There are many different, recognized silhouettes:

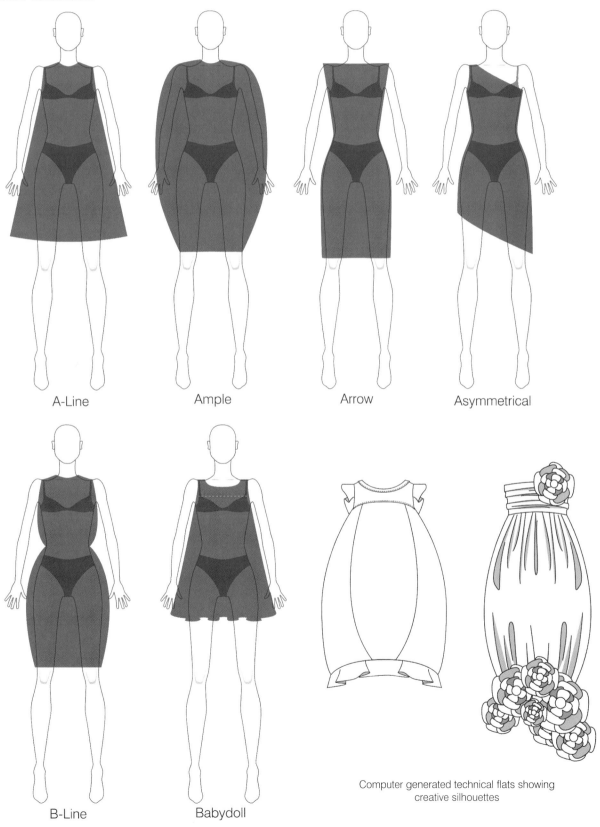

A-Line Ample Arrow Asymmetrical

B-Line Babydoll

Computer generated technical flats showing creative silhouettes

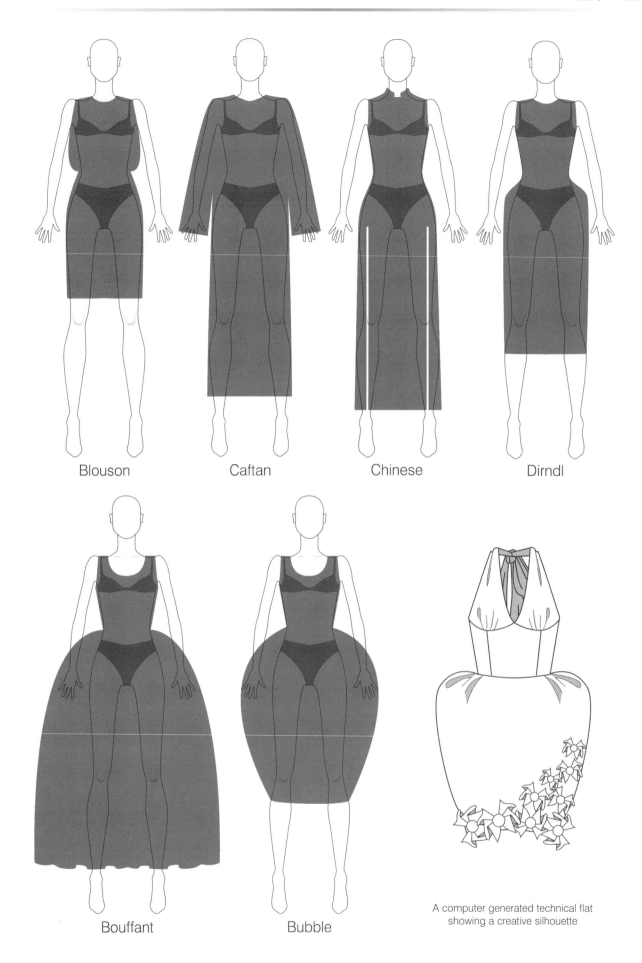

Blouson Caftan Chinese Dirndl

Bouffant Bubble

A computer generated technical flat
showing a creative silhouette

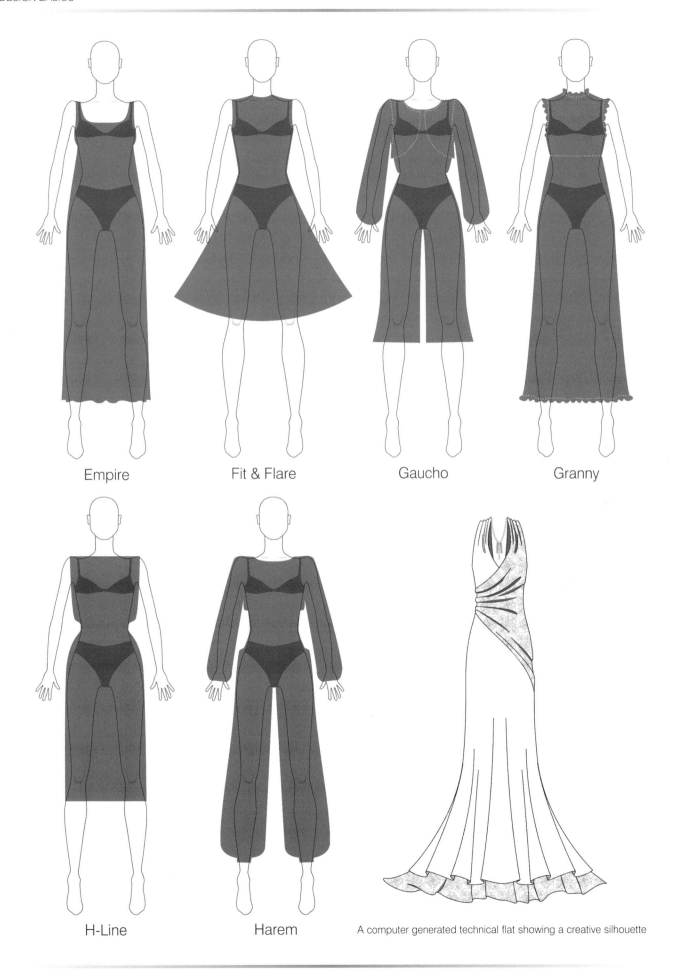

Empire

Fit & Flare

Gaucho

Granny

H-Line

Harem

A computer generated technical flat showing a creative silhouette

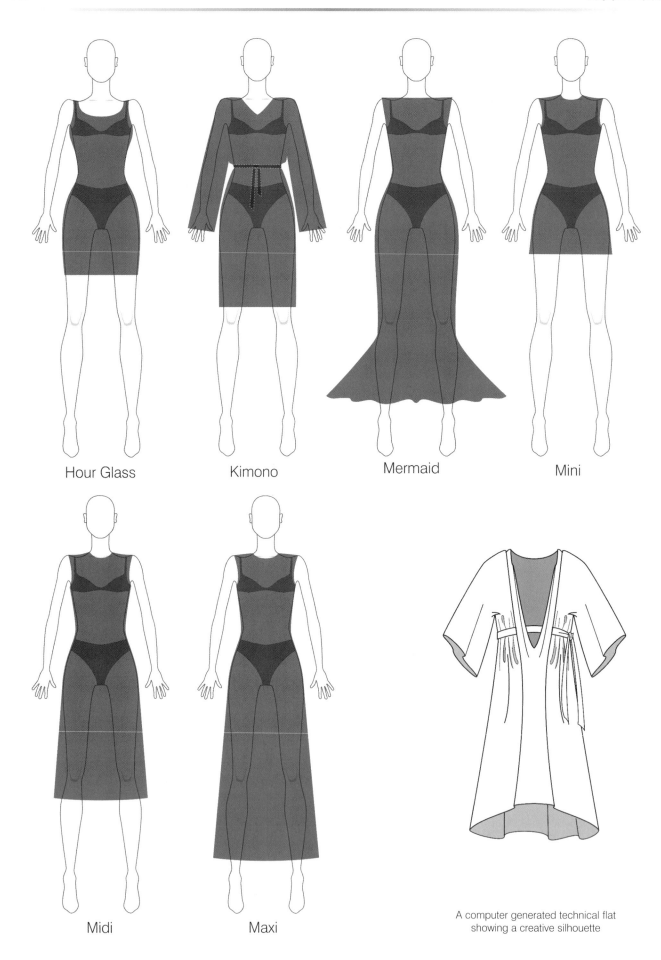

Hour Glass Kimono Mermaid Mini

Midi Maxi

A computer generated technical flat
showing a creative silhouette

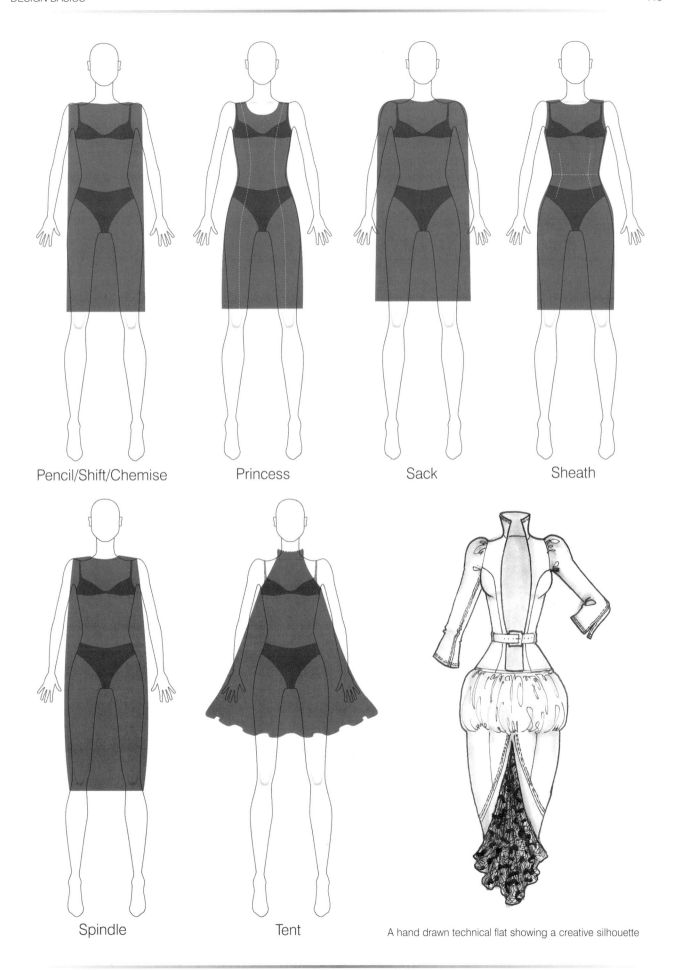

Pencil/Shift/Chemise Princess Sack Sheath

Spindle Tent A hand drawn technical flat showing a creative silhouette

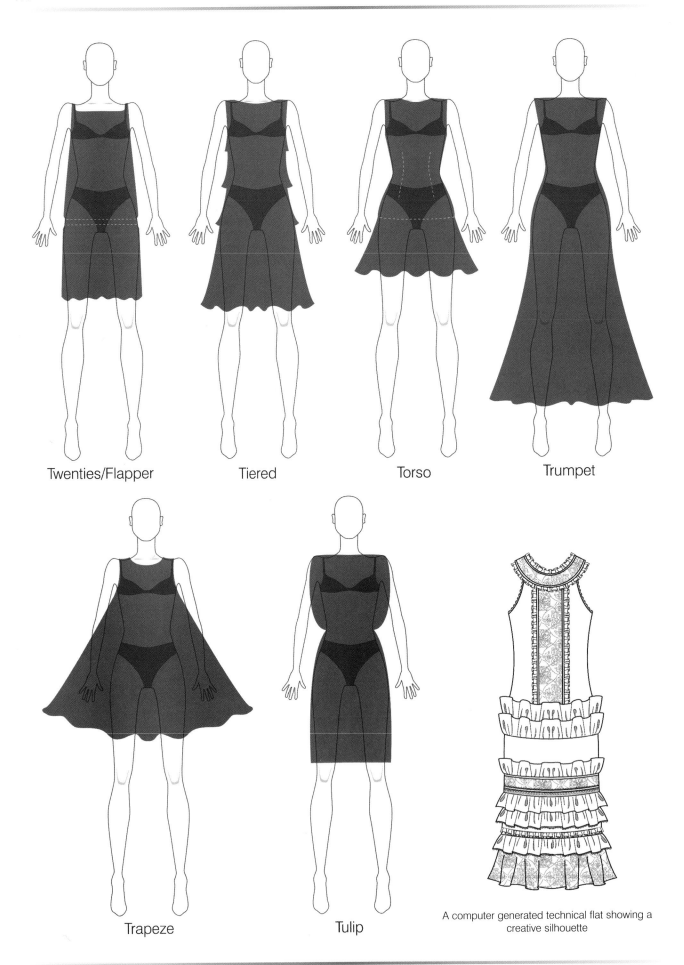

Twenties/Flapper Tiered Torso Trumpet

Trapeze Tulip A computer generated technical flat showing a creative silhouette

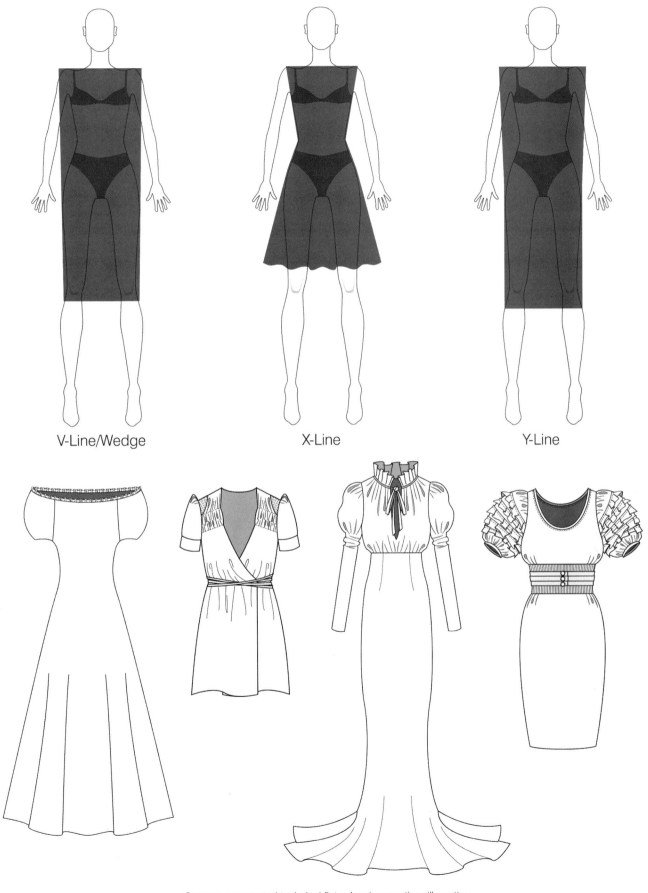

V-Line/Wedge X-Line Y-Line

Computer generated technical flats showing creative silhouettes

ELEMENTS

COLOR

Color can be determined when 'white light' from the sun, consisting of a spectrum of six colors (red, orange, yellow, green, blue and violet) reflects from the surfaces of the objects we see. Some of the colors within the white light are absorbed by the object, the rest are reflected and become recognized by our eyes as the object's color. In fashion, colors should complement the design, season, target customer, purpose, and each other. Remember, too, that color can be symbolic, emotion-evoking, healing and create optical illusions.

VALUE

This refers to the degree of intensity of a color. Contrasts in intensity can be used to create dramatic or subtle, but pleasing, effects.

NEUTRALS

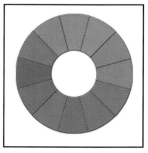

SHADES

TINTS

TONES

GLOSSARY OF COLOR TERMINOLOGY

Colorway: The term used when referring to the choice of colors being offered for one garment. The fabrication and style remain identical, only the color changes.

Color Story: A color story relates to the colors offered within groups. They define which garments have been designed to be worn together to produce color-coordinated outfits. Therefore, a color story is 'told' by an outfit or ensemble, rather than an individual garment.

Cool Colors: Colors such as black, blue and green, that often have a cold, calming effect on our emotions; some say that they physically slow down the heart rate, decrease the body temperature and relax our muscles.

Hue: This is a general term that refers to the name of the color, for example, violet.

Neutral Colors: Any color with a very low intensity/saturation.

Pantone®: A global, industry standard system that enables accurate specification and communication of color.

Primary Colors: These are red, yellow and blue; they are 'primary' because they cannot be created by mixing other colors together.

Saturation: The term used to describe the intensity, strength and purity of a color.

Secondary Colors: These are green, orange and violet (or indigo). They are created by mixing equal amounts of the primary colors together.

Shades: These are created by adding black to a color.

Tertiary Colors: These are yellow-green, blue-green, blue-violet, red-violet, red-orange and yellow-orange. They are created by mixing primary and secondary colors together.

Tints: These are created by adding white to a color.

Tones: These are created by adding grays to a color.

Value: The term used to describe the luminosity, lightness or darkness of a color. A color's value is raised by adding white or lighter colors and lowered by adding black or darker colors.

Warm Colors: Colors such as red, orange and yellow that often have a warming, stimulating effect on our emotions; some say that they can even physically increase our body temperature, increase the amount of adrenaline we produce and raise our blood pressure.

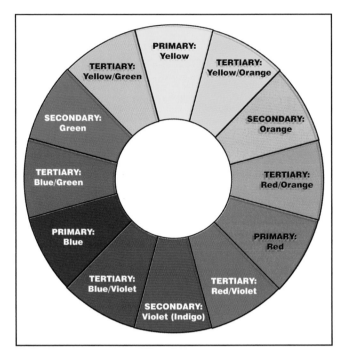

THE THEORY OF COLOR

There are various different theories that relate to color. One of which is the standard color wheel. It offers a simple way of looking at color and various methods of combining them, for great effects. It includes twelve primary, secondary and tertiary colors:

The Primary Colors:
Yellow, Red, Blue

The Secondary Colors are added:
Orange, Violet, Green

The Tertiary Colors are added:
Yellow-Orange,
Red-Orange,
Red-Violet,
Blue-Violet,
Blue-Green,
Yellow-Green

A hand drawn fashion illustration showing creative use of color

COLOR SCHEMES CREATED BY COMBINING COLORS ON THE COLOR WHEEL

The color schemes below are well known methods of combining color.

However, you can get creative with the color wheel by switching one or more of the colors within a combination and applying tints, tones and shades to one or more of the colors within your combination. Use your imagination and personal taste to decide what works for you, your target customer and season.

Monochromatic

A monochromatic color scheme is created by using one color, combined with tints, tones and shades of that color.

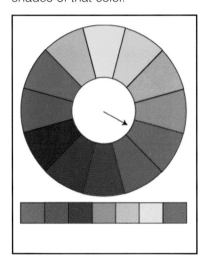

Complementary

This color scheme is created when two colors directly opposite each other on the color wheel, are used together.

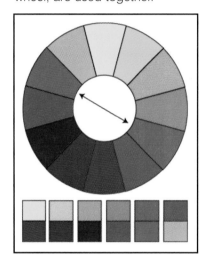

Triadic

This is created by using three colors that are equally separated around the color wheel.

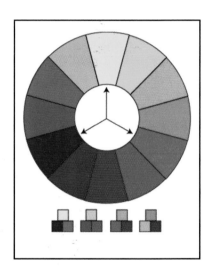

Double Complementary

This color scheme is created when two pairs of complementary colors that are adjacent to each other on the color wheel, are used.

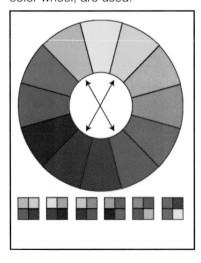

Split Complementary

A color scheme created by combining one color with the two colors that sit either side of its compliment, on the color wheel.

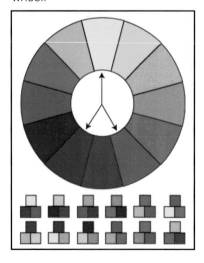

Analogous

A color scheme created by using two or more colors that sit next to each other on the color wheel.

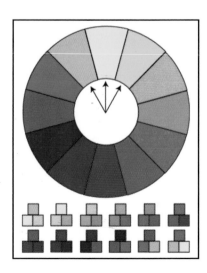

COLOR ASSOCIATIONS & COMMENTS

BLACK:

Death; Sprouting/Gestation; Re-birth; Sophistication; Security. Black apparel is often worn for formal and serious occasions, like black tie events, work and funerals. It makes for staple and classic apparel that has a slimming effect. It is also associated with rebellious groups such as punks and gothics. Worn by most target customer groups, with the exception of childrenswear.

BLUE:

Soothes organic disabilities; Stimulates the intellect; Heaven; Serenity; Air; Water; Cold; Wisdom; Space; Solitude; Calm; Trust. Blue apparel is another staple in most peoples' wardrobes. Since there are so many different hues, it lends itself to more items of clothing than black. In darker shades, it can represent formality. Denim jeans remain popular for casual wear.

GREEN:

Calming for colds, hay fever and the liver; "GO;" Life; Earth; Envy; Luck; Healing; Money; Oxygen; Nature; Balance. Green apparel has its limitations, since it can 'clash' with skin and hair coloring, particularly those hues with more yellow in them. However, it is quite commonly used for uniforms and sporting apparel.

ORANGE:

Stimulates the solar plexus; Stimulates the intellect; Revitalizes the lungs; Cheerful; Sociable; Calm; Friendly. Orange apparel has it's limitations; not everyone can wear this color. It is quite commonly used for sporting apparel.

PINK:

Affection; Sweetness; Calm; Feminine. Pink apparel is most commonly and consistently used for childrenswear for girls, although it translates into many areas of womenswear, depending upon current trends. Often used for sleepwear, lingerie and robes.

PURPLE:

Helps combat skin problems & fevers; Royalty; Wealth; Reflection; Penitence; Spiritual awareness. Purple apparel is fairly uncommon. When used, it tends to be in moderation, mixed with other colors. Softer tones of lavender are more common.

RED:

Stimulates physical & mental energy; "STOP;" Vigor; Life; Sexuality; Fertility; Martyrdom; Blood; Passion; Obsession; Desire; Speed; Power; Danger; Courage; Strength; Aggression. Red apparel does not suit everyone. It is often seen in lingerie.

WHITE:

Mourning; Winter; Purity; Spirituality; Religious Festivals. White apparel is a staple in everyone's wardrobe. The ability to keep it clean can present a problem for some markets, e.g. childrenswear.

YELLOW:

Stimulates the nerves; Stimulates the intellect; Sun; Confidence; Creativity; Fear; Cowardice. Yellow apparel also has its limitations because not everyone can wear it. Often used, in pastel shades for neutral-gender newborn/layette items.

BROWN:

Earth; Warmth; Stability; Unsophisticated; Unexciting. Brown apparel, particularly lighter hues, are a wardrobe staple. It is often worn by boys/men and also for hiking/outdoor clothing.

ELEMENTS

FABRIC Consider the texture, the drape, the hand, the luster, the overall look and performance of the fabrics chosen, and the effect that different fabrics have on each other when used together.

General Tips:

TEXTURED or PILE
fabrics add bulk.

MATTE fabrics do not reflect the light therefore tend to recede into the background when worn with shinier fabrics. Matte fabrics may give the appearance of a solid mass or block of color.

A hand drawn technical flat showing creative combinations of fabric

SHINY fabrics reflect the light to show off curves and bulges; they highlight the area(s) they cover, making them 'come forward' or stand out.

PATTERNED
FABRICS distract the eye from the shape of the body. Large, organic prints make the area(s) they cover appear larger, while small, geometric prints make the area(s) they cover appear smaller.

Chenille

Wool/Angora Rabbit

Athletic Mesh

Batik

Quilting

Shirting

Slinky

Calico

Corduroy

Canvas

Bengaline

Brocade

Fleece

Tweed

Charmeuse

Flocked Denim

Velvet

Denim

Peau de Soie

Habutai

Terry Cloth

Wool Gabardine

Pleather

Flannel

THE DESIGN PROCESS

Here comes the exciting part; honing in on the fashion design process allowing you to combine your imagination with the information and skills you have gathered so far.

Page #

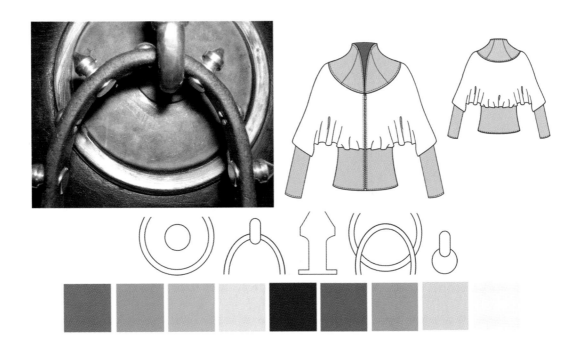

INSPIRATION, THEMES & CREATIVITY

INTRODUCTION

Fashion is a constantly moving and ever-evolving process; its lifeblood comes from the minds of designers throughout the world who skillfully channel their ideas into fresh looks that satisfy their customers' needs and wants.

Designers have many tools at their disposal to help them to expedite the processes involved in design work. They employ their passion, flair and individual taste throughout the search for **inspiration**. They use their lateral thinking skills to apply focus to this inspiration and develop **themes and sub-themes**. Along with their knowledge of the target customer, they **creatively** manipulate the principles and elements of design into new styles. Each of these topics are examined in this section:

INSPIRATION

THEMES & SUB-THEMES

CREATIVITY

TREND FORECASTING

INSPIRATION

Inspiration can come from anything that sparks the designer's imagination and gets their creative juices flowing. The pursuit of inspiration can be a source of great excitement as well as, unfortunately, frustration, especially for those designers who have not yet learned to trust their instincts or come to understand the ebb and flow of their creative mind. Here are some tips and suggestions to help you during those times of frustration:

INSPIRATION versus COPYING (PLAGIARISM)

To take inspiration from something is to use that subject or object as a springboard from which to develop your own ideas. To exactly replicate, or copy, an object is plagiarism; there should be no doubt whatsoever in the mind of any designer, that it is illegal and unethical to do this. It is also important to recognize that within the fashion industry in particular, where specific designs and style elements become popular at a given time, there is a great deal of 'cross-pollination' of ideas. The key point to remember is not to cross the line, albeit a fine line at times, into exact replication. Designers may take inspiration from ideas by other designers, but change the designs to a point that they become their own. In fact, for some design houses, their specific marketing strategy is to 'knock-off' styles directly from the runway; in other words, they reproduce the style but introduce enough change to differentiate their garment from the original.

FEELING UN-INSPIRED

We've noticed how much weight fashion design students give to their own inspirational skills and that of their fellow students. It's easy to become panicked when you feel un-inspired yourself, especially when others around you appear to have ideas coming out of their ears. During these times, remember the following:

All designers experience a lack of inspiration from time to time, particularly when they are learning to understand when and how their own minds work best.

Inspiration doesn't always just happen, there are tools to use, and work that can be done, in order to generate it.

> **When seeking inspiration, channeling your energy and focus are major factors to take into account. It is easy to feel lost without these.**
>
> **Remember that when you work within the industry, particularly for an existing design house, you will have a great deal of information on hand which will allow you to focus your energies; from past designs that have sold well to a clear understanding of who your target customer is and what they want.**

SOURCES OF INSPIRATION

There are a number of places where inspiration can be found in abundance. Make an effort to tap into these sources on a regular basis and utilize the internet where applicable.

Art Galleries
Books
Exhibitions
Magazines
Movies
Museums
Newspapers
Online
Shows
Stores
Travel
Television

GENERATING INSPIRATION

The key to generating inspiration is to tap into your passion. Passion naturally evokes enthusiasm, lateral thinking, a desire to put in effort and time, and adds enjoyment and satisfaction into the mix. Ultimately, passion breeds the elements needed for motivation, longevity and success.

A PASSION FILE

You'll know passion when you encounter it because you will feel a strong emotional response. When you feel passionate about something, no matter what form it takes, do what you can to capture and add it to your passion file. It may be an image, an object, a poem, a sound, a smell, a feeling or reaction, so sketch it, photograph it, tear it out (where possible) or write it down. Your passion file will become your own very personal source of inspiration – one to which you can always turn when your flow of ideas is not so forthcoming.

> # A PASSION FILE IS AN ESSENTIAL TOOL FOR EVERY DESIGNER - start yours now!

A MUSE

A muse is a person, real or fictional, that a designer uses to hone in on their target customer. An image, real or mental of this person is called upon by the designer whenever they begin to design for them. The idea is that this person helps the designer to picture what they might wear and when; their attitude, lifestyle and behavior.

THEMES & SUB-THEMES

A theme is simply an area of inspiration a designer chooses to focus upon for development of a particular collection. Typically a collection will be based around a central theme made up of groups based on sub-themes of the central theme. Themes and sub-themes are valuable tools that enable the designer to concentrate their creative skills to develop a tight, cohesive collection.

A THEME FOR YOUR TARGET CUSTOMER

Remember to choose a theme that relates to the lifestyle and mentality of the target customer and is based around the area of your inspiration. The design process begins with a CUSTOMER PROFILE; that is a detailed look at your customer, their age, place of residence, figure type, occupation, income, lifestyle and behaviors.

THEMES & PROBLEM SOLVING

Working with themes and sub-themes not only brings consistency and cohesiveness to a collection, giving it a clear, powerful 'punch,' but it helps the designer in the decision-making process where the principles and elements of design are concerned.

EXAMPLES OF THEMES & SUB-THEMES

Target Customer	Central Theme	Sub-Themes
Toddler Boy (Moderate)	**Farmyard Fun**	**Mucky Pups** - Sportswear group for playtime **Cock-a-Doodle-Do** - Sleepwear group **Barnhouse Bop** - Sportswear group for social occasions
Junior Girl (Budget)	**Outer Space**	**Star Struck** - Dress group **A Stroll on the Moon** - Casual sportswear group **Space Bar** - Dressy sportswear group
Contemporary Woman (Designer)	**Day at the Races**	**Brand's Hatch** - Dress group **The Winners' Paddock** - Dressy sportswear group for daytime **Final Furlong** - Dressy sportswear group for the evening

CREATIVITY

You'll notice that we've tackled inspiration and creativity as separate subjects. In the fashion design process, we see **inspiration** as the vehicle that brings ideas to the table; **themes and sub-themes** as the means to hone in on one inspirational area for development into a powerful, cohesive collection. We see **creativity** as the unique, skillful work of the designer's mind in metamorphasizing these ideas, through lateral thinking, into groups and collections directed specifically towards their target customer and season.

RESEARCH

This is an important part of the creative process and includes gathering more information and images on your chosen inspiration, themes and sub-themes – adding more and more fuel to your fire!

> **The following pages contain sample subjects and images to get you started. Each subject, or image, could become the inspiration for a theme and a platform from which to generate your own creativity.**

TREND FORECASTING

The art of trend forecasting in the fashion world is to identify, through extensive research, the direction in which styling will evolve in the future. The garment manufacturing industry is one in which great amounts of time and money are invested in designing, selling, making and delivering product into stores. So, being able to accurately forecast trends for a particular target customer is essential to protect the investment made and to ensure that a future line of clothing will sell well enough to generate a profit and keep the business alive. Companies who successfully carry out trend forecasting, therefore, develop a competitive edge in the industry. In the fashion industry, knowing about future trends isn't just important to garment manufacturers; it is vitally important to everyone within the chain of supply, from the fiber producer to fabric, trim and notion manufacturers.

Trend forecasting is an in-depth science that involves acute analytical skills, experience, time, effort and money; which is why many garment manufacturers buy these services from trend forecasting companies who specialize in the process. These services can be very expensive, sometimes preventing smaller companies from being able to afford them. Most often services are provided in the form of a subscription to printed publications, or online data and imagery, that predict trends in design themes, body shapes, use of color and/or graphics for a specific season and target customer group; many trend forecasting companies also provide individual consulting services.

Here are the main elements involved in trend forecasting:

PAST TRENDS: Identifying those trends that were highly successful in the past and those that weren't provides valuable information and clues.

CAUSES: There are many influences on the success or failure of a trend, including political, cultural, technological and financial factors. By understanding the likely reason(s) behind past sales figures, forecasters are more accurately able to predict what will happen in the future.

OBSERVATION & ANALYSIS: Trend forecasting relies heavily on observing peoples' behaviors, lifestyles, moods and buying habits, to identify emerging customer wants and needs. These observations take place in different countries throughout the world; on the street, at trade shows, at flea markets, in retail stores, at art galleries and museums and on the runways. The skill is in spotting signals that other less experienced viewers may miss; signals that indicate that there is a gap in a particular market that needs to be fulfilled. Once observations have been made, results are carefully analyzed, along with the data from past trends and causes, and interpreted into predictions.

TREND FORECASTING RESOURCES: Here are the Web sites of some companies that provide the services described above: www.style.com (free information); www.peclersparis.com; www.fashionsnoops.com; www.promostylamericas.com; www.fashioninformation.com; www.snapfashun.com; www.wgsn.com; www.tobereport.com; www.fashionwindows.com; www.sachapacha.com; www.lebook.com.

Sample Inspirational Subjects

Abstraction	Cogs	Frightening
Aerial Photographs	Coils	Frost
Aircraft	Combat	Fun
Aliens	Commercials	Fur
Alphabet	Computers	Furniture
Ancient History	Construction	Games
Animals	Cooking	Gangsters
Archaeology	Costumes	Garbage
Asian	Cowboys	Gases
Atoms	Cubism	Geography
Babylon	Circus	Geometry
Beauty	Dams	Glass
Bicycles	Dancing	Glory
Biology	Danger	Gold Digging
Birds	Darwinism	Good & Evil
Boats	Dinosaurs	Grease
Body Functions	Dirt	Greece
Body Parts	Disasters	Grocery Stores
Boiling	Dots	Hate
Bonfire Night	Dragons	Heaven
Books	Dreams	Heroes
Boxing	Eastern Culture	Hippy
Brain	Eating	Historic Events
Bridges	Eggs	Hobbies
Bronze Age	Egypt	Holidays
Buddhism	Electricity	Hope
Buildings	Emotions	Horror
Candy	Engineering	Horses
Canoeing	England	Houses & Homes
Card Games	Environment	Hunting
Cars	Europe	Ice
Cartoons	Evolution	Ice Age
Castles	Eyes	Inner Cities
Caves	Fairies	Insects
Celebrities	Families	Inventors
Cells	Famous People (Past or Present)	Japan
Celtic	Farming	Jet Engine
Chemistry	Feminism	Knights in Armor
Child Bearing	Fields	Knitting
China	Fire	Las Vegas
Christianity	Fish	Law Enforcement
Christmas	Flowers	Leaves
Churches	Food	Light
Clouds	Foreign Countries	Love
Coal Mining	Fractions	Luxury
Cobwebs	French	Machines
Cocktails	Freedom	Madness

Sample Inspirational Subjects

Magic	Poverty	Speed
Makeover	Power of Nature	Spiders
Making Wine	Precious Stones	Spiritualism
Man Eaters	Printed Designs	Sports
Manufacturing	Prison	Spying
Maps	Professions	Stars
Marine Life	Punk	Steam Trains
Markets	Racism	Stone
Math	Rain Forests	Stone Age
Mazes	Religion	Storage
Meat	Renaissance	Submarines
Medical	Reproduction	Surgery
Medieval	Reptiles	Tapestry
Melting	Rituals	Tastes
Memories	Rivers	Technology
Metal	Roads	Teeth
Microscopic Photography	Rockets	Telecommunications
Military	Roman Empire	Temples
Money	Romance	Textures
Monsters	Royalty	Toxins
Mouth	Rubber	Traditions
Movies	Ruins	Tramp
Mushrooms	Russia	Travel
Music	Sailing	Trees
Mythology	Sand	Tribes
New Year	School	Tunnels
Nuclear Reactors	Science	TV Programs
Numbers	Scottish	Uniforms
Ocean	Scrap	Vacations
Oil	Sculptures	Vegetables
Optical Art	Secrets	Victorian
Pain	Sex	Vikings
Paintings	Sexism	Villages
Parts of a Car	Shakespeare	Violence
Peace	Shapes	Volcanoes
People You Admire	Shells	War
Pets	Shipping	Water
Philosophy	Shopping	Weapons
Photographs	Skin	Weaving
Phrase or Saying	Sky	Welding
Physics	Slavery	Western
Planets	Smells	Windmills
Plastic	Snow	Wonders of the World
Pleasure	Snow Boarding	Wood
Poetry	Soil	
Politics	Space Travel	
Port	Sparkle	

Sample Inspirational Images

Sample Inspirational Images

Sample Inspirational Images

Sample Inspirational Images

Sample Inspirational Images

FABRICATION & COLOR

INTRODUCTION

Choosing fabric and color is a large part of the design process, and getting it right is important. We strongly recommend that you invest in a basic fabric resource that will give you an in-depth understanding of the textiles that are available and how to use them; specifically in the context of fashion design.

In this section, we provide an overview of the key factors involved regarding fabric and color.

When you get into the design process, you'll focus on fabrication and color choices in relation to the target customer, season, style and type of garment.

The following subjects are covered:

BUYING FABRIC IN THE INDUSTRY

PRICE

CONTENT & PROPERTIES

COLORS, PRINTS & TREATMENTS

FABRIC, COLOR WAYS & COLOR STORIES

BUYING FABRIC IN THE INDUSTRY

The flowchart below shows a simplified view of the manufacturing and distribution channels within the textiles market.

| MILL | The mill produces untreated fabric (known as 'greige' or 'grey' goods) in large quantities. |

| CONVERTER | The converter treats the fabric (adds color, texture and other embellishments). |

| JOBBER | Jobbers buy the treated fabric in smaller quantities, or lots, from the converter. |

| WHOLESALER | Wholesalers buy the treated fabric in smaller quantities from the jobber. |

| RETAILER | Retailers buy the treated fabric in smaller quantities from the wholesaler. |

Garment manufacturers can buy fabric at any stage of the manufacturing and distribution chain.

The key factors to appreciate here are **quantity**, **availability** and **price**.

Typically, a garment manufacturer will make a sample line using 'sample' (smaller) quantities of fabric, which is used to attract and secure orders at market. The garment manufacturer will then require 'production' (larger) quantities of those same fabrics some months later, to fulfill the orders they received.

When buying fabric at the retail level it is possible to buy in small quantities (low minimums), but the price is at its highest and there is no guarantee that the same fabric will be available in the future when you need to produce and deliver the orders you received. Conversely, garment manufacturers must buy in large quantities (high minimums) from a mill or a converter, but the price is at its lowest and the possibility of it being available in the future, is high. Therefore, garment manufacturers have to find the balance of quantity-versus-price-versus-availability that works for their organization and pricing structure, and then, buy from an appropriate vendor.

PRICE

Designers must source fabric at a price that brings the total cost of producing a garment, plus a profit amount, up to a price that their customer will pay. Designers, therefore, always have to work within a budget, when choosing fabric.

Garment manufacturers that make budget clothing have to buy fabric at low prices.

Garment manufacturers that make moderate clothing have to buy fabric at low to moderate prices.

Garment manufacturers that make better clothing can buy fabric at moderate to higher prices.

Garment manufacturers that make designer clothing can buy fabric at moderate to very high prices.

Designers must take into consideration the affect that any trim, treatments, embellishments or special sewing techniques will have on the cost of manufacturing a particular garment, so they can make sure that the total cost does not exceed their budget.

CONTENT & PROPERTIES

In choosing fabric, designers also have to know the fiber content, the ways in which the fabrics have been constructed (their weave or knit) and how these factors affect their properties. In particular, designers must consider the properties of fabric in the following areas:

- Appearance

- Suitability for the target customer, in general

- Appropriate for the season

- Ability to perform under the conditions that the designer intended

- Ability to be laundered, cleaned and cared for in a way that suits the customer (easy care)

- Ability to withstand wear and tear for the duration of its expected lifespan

- Appropriate level of comfort for the customer and purpose

- Safety factors, particularly for childrenswear

COLORS, PRINTS & TREATMENTS

COLORS

In the industry, the color of a fabric is referred to as a colorway. To avoid confusion, each colorway is given a separate name and reference number, for identification purposes. If the same fabric is available in five different colors, then it is said to be available in five colorways. Some fabrics are woven or knitted as 'grey' or 'greige' goods, then dyed into different colorways by a converter, thereby pre-determining what colorways are available to buy. Some garment manufacturers buy greige goods then have the fabric dyed, so they can determine the colorways they want for themselves.

PRINTS

Prints are also developed in a limited number of colorways, by converters. Where multi-colored printed fabrics are concerned, the predominant color determines the colorway. Some manufacturers will arrange to have printed fabrics produced in their own choice of colorways. NOTE: Printed fabrics, by their more unique nature, are harder than solid fabrics to secure for production of orders.

TREATMENTS

Treatments are a variety of additional processes that add interest to, but often change the properties of, fabric. Popular treatments include beading, embossing, embroidering, flocking, glazing, glittering, sand-washing and sizing. Designers need to be aware of the processes that fabrics have undergone to understand how these will affect their properties and price.

FABRIC, COLORWAYS & COLOR STORIES

These are traditional structures around which groups can be fabricated and colored. Here's how it works, using a sportswear group and a dress group as examples:

SPORTSWEAR GROUP

Typically, a sportswear group will contain three or four fabrications, each in two or more different colorways, as follows:

Fabrication	Fabric Sample	Purpose	Colorway 1	Colorway 2
BASE	DENIM 98% Cotton 2% Spandex Width: 48" Price: $2/yd	This is the fabrication that forms the foundation of the group. Garments made from the base fabric are designed to sell the most. They are of bottom weight; that means that they are heavy enough to make a jacket, pant or skirt for the season.	INDIGO Ref: IN149	COPPER Ref: CP258
NOVELTY	DONEGAL TWEED 80% Wool 20% Nylon Width: 36" Price: $3/yd	This fabrication is designed to be an interesting compliment to the base fabrication. They are of bottom weight; that means that they are heavy enough to make a jacket, pant or skirt for the season.	SCOTTISH BLUE Ref: BL7940	IRISH RED Ref: IR2337
WOVEN LAYERING	BROADCLOTH 96% Cotton 4% Spandex Width: 48" Price: $1/yd	This fabrication is for woven tops. Layering fabrics are of top weight; meaning that they are light enough to make a top suitable for the season.	IVORY Ref: IV23	STONE Ref: ST58
KNIT LAYERING	MATTE JERSEY 65% Cotton 35% Poly Width: 36" Price: $1/yd	This fabrication is for knit tops. Layering fabrics are of top weight; meaning that they are light enough to make a top suitable for the season.	ICE Ref: IC345	SUNSET Ref: SS278

In this example, the fabric story, colorways & color stories are:

Fabric Story offered is:	Denim + Donegal Tweed + Broadcloth + Matte Jersey
Base fabric offered in two colorways:	Indigo + Copper
Novelty fabric offered in two colorways:	Scottish Blue + Irish Red
Woven layering fabric offered in two colorways:	Ivory + Stone
Knit layering offered in two colorways:	Ice + Sunset
1st Color Story offered is:	Indigo + Scottish Blue + Ivory + Ice
2nd Color Story offered is:	Copper + Irish Red + Stone + Sunset

DRESS GROUP

Typically, a dress group will contain one or two fabrications in three or more different colorways, as follows:

Fabrication	Fabric Sample	Purpose	Colorway 1	Colorway 2	Colorway 3
BASE	CHARMEUSE 100% Silk Width: 28" Price: $4/yd	The base fabrication for a dress group may be a print.	CHOCOLATE Ref: CHOC34	PALMA VIOLET Ref: PVIO87	CARAMAC Ref: CARA11
BASE OR CONTRAST	DOUBLE KNIT 100% Polyester Width: 48" Price: $1/yd	A solid fabrication can be used as the base and/or as a contrast. Contrast solids, when used with a print, are often colors from within the print itself, as shown.	BROWN Ref: BR34	BLUE Ref: BL90	BEIGE Ref: BG23

In this example, the fabric story, colorways and color stories are:

Fabric Story offered is:	Charmeuse +/or Double Knit
Base print fabric offered in three colorways:	Chocolate + Palma Violet + Caramac
Base or contrast solid fabric offered in three colorways:	Brown + Blue + Beige
1st Color Story offered is:	Chocolate + Brown
2nd Color Story offered is:	Palma Violet + Blue
3rd Color Story offered is:	Caramac + Beige

IN SUMMARY:

A FABRIC STORY refers to the collection of different fabrics that are used within a group.

A COLORWAY refers to the different colors a garment is offered in.

A COLOR STORY refers to the colorways of different garments that are designed to be worn as an outfit.

ITEMS, ENSEMBLES, GROUPS & COLLECTIONS

INTRODUCTION

Fashion design is the business of selling clothing. It is not coincidental that design houses work within seasons. These seasonal introductions are made available to the target customer based on the goal of maximizing sales, because changes in the weather, holidays and events generate demand for new clothes. Also, it is not coincidental that, in certain markets, the fashion cycle (the period of time it takes for a style to be introduced, accepted, reach peak sales, go into decline, then go out of fashion) is increasing in pace, for it is in the financial interests of the fashion industry as a whole, to sell more product.

So, it is not surprising, that this same strategy comes into play when fashion houses carefully plan the content of their seasonal collections. Their goal is to sell as much product, within the season, as they can.

GLOSSARY OF TERMS

Item:
An item is a single garment, or two garments on one hanger with one price ticket. An item is designed to be sold as-is, not necessarily part of an ensemble, group or collection.

Body:
The term 'body' is used in the industry to refer to the shape of a garment. Hard bodies are garments, such as jackets, pants and skirts, made from heavier, or 'bottom weight' fabrics. Soft bodies are garments, such as tops, made from lighter, or 'top weight' fabrics. One to five bodies make up one ensemble.

Ensemble:
An ensemble is another word for an outfit or a number of garments that are designed to be worn together and fully cloth the target customer for a particular occasion or activity. Several ensembles, typically four to six, make up one group.

Group:
A group is made up, typically, of four to six ensembles, or outfits, that share common sub-themes, fabric, notions, trim and color stories. The purpose of a group is to offer the target customer an opportunity to buy new clothes for carrying out a specific activity, in the new season. Groups are formulated so that there is enough choice to suit the varying tastes within the target customer group yet, at the same time, encourage your customer to buy as many pieces from the group as possible.

Mini Collection:
A mini collection is typically made up of three or less separate groups that are linked together by a common theme. Each group, therefore, is different, but the collection, on the whole, has a cohesive look and/or 'feel.' The purpose of a mini collection is to offer the specific target customer an opportunity to buy new clothes suitable for the season and the various activities they carry out as part of their lifestyle. The only difference between a mini-collection and a collection is that a mini collection is smaller in size, and would be offered for a minor, rather than a major selling season, and at the manufacturer's discretion.

Collection:
A collection is typically made up of four or more separate groups that are linked together by a common theme. Each group, therefore, is different, but the collection, on the whole, has a cohesive look and/or 'feel.' The purpose of a collection is to offer the specific target customer an opportunity to buy new clothes suitable for the season and for the various different activities they carry out as part of their lifestyle.

FORMULATING GROUPS

There are different types of groups depending upon the category of garment being designed. However, the most common types of groups are **SPORTSWEAR** and **DRESS** groups.

SPORTSWEAR GROUPS

These comprise of mixed separates, as follows:

Hard bodies made from the BASE or NOVELTY fabrics that are of 'bottom weight,' and
Soft bodies made from the WOVEN LAYERING and/or KNIT LAYERING fabrics that are of 'top weight.'

There are two types of sportswear groups:

Coordinated sportswear – where the layering pieces do not intermix with the base and novelty pieces. In other words, the outfits are designed to be worn one way only.

Related sportswear – where the layering pieces intermix with the base and novelty pieces, providing a variety of different possible options from which your customer can choose.

Examples of Hard Upper bodies:

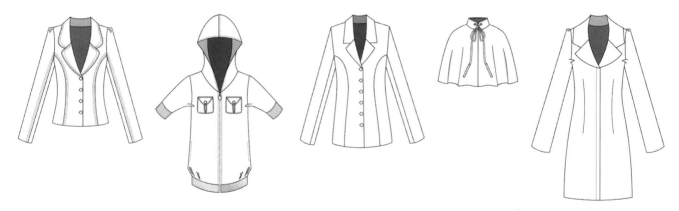

Examples of Hard Lower bodies:

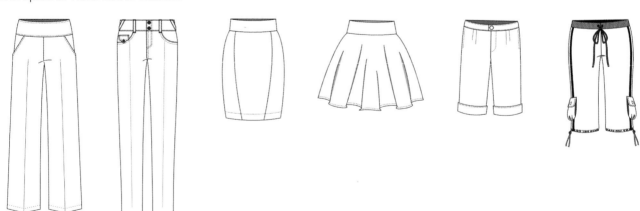

Examples of Woven Soft bodies:

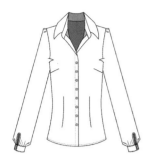 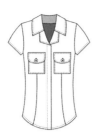

Examples of Knit Soft bodies:

SPORTSWEAR GROUP FORMULAS:

A six piece sportswear group contains:
One Hard Upper Body in Base Fabric
One Hard Upper Body in Novelty Fabric
One Hard Lower Body in Base Fabric
One Hard Lower Body in Novelty Fabric
One Soft Body in Woven Layering Fabric
One Soft Body in Knit Layering Fabric

An eight piece sportswear group contains:
One Hard Upper Body in Base Fabric
One Hard Upper Body in Novelty Fabric
One Hard Lower Body in Base Fabric
One Hard Lower Body in Novelty Fabric
Two Soft Bodies in Woven Layering Fabric
Two Soft Bodies in Knit Layering Fabric

A twelve piece sportswear group contains:
Two Hard Upper Bodies in Base Fabric
Two Hard Upper Bodies in Novelty Fabric
Two Hard Lower Bodies in Base Fabric
Two Hard Lower Bodies in Novelty Fabric
Two Soft Bodies in Woven Layering Fabric
Two Soft Bodies in Knit Layering Fabric

A sixteen piece sportswear group contains:
Two Hard Upper Bodies in Base Fabric
Two Hard Upper Bodies in Novelty Fabric
Two Hard Lower Bodies in Base Fabric
Two Hard Lower Bodies in Novelty Fabric
Four Soft Bodies in Woven Layering Fabric
Four Soft Bodies in Knit Layering Fabric

NOTE: Remember, these formulas are to give you guidance. When you get into the industry and understand your target customers' needs and what will sell, you will be able to formulate your groups accordingly.

DRESS GROUPS

Dress groups are simply made up of different dress bodies using one BASE fabrication along with the same notions and trim; sometimes used in conjunction with one or more CONTRAST fabrications. Each dress within the group should capture the same 'look and feel' of the designer's theme/sub-theme but, collectively, the choices that are offered will satisfy the varied tastes from within the targeted customer market. In other words, a dress group is designed so that every customer within the target market will buy at least one dress from the group.

Example of bodies in a dress group:

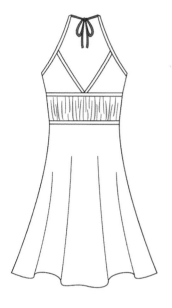 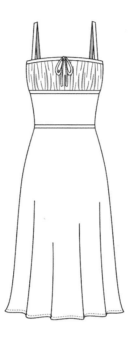

DRESS GROUP FORMULAS:

A three piece dress group contains:
One Dress Body in Base Fabric (with or without contrast fabric) - Style #1
One Dress Body in Base Fabric (with or without contrast fabric) - Style #2
One Dress Body in Base Fabric (with or without contrast fabric) - Style #3

A six piece dress group contains:
One Dress Body in Base Fabric (with contrast fabric) - Style #1
One Dress Body in Base Fabric (with contrast fabric) - Style #2
One Dress Body in Base Fabric (with contrast fabric) - Style #3
One Dress Body using Contrast Fabric as the Base Fabric - Style #1
One Dress Body using Contrast Fabric as the Base Fabric - Style #2
One Dress Body using Contrast Fabric as the Base Fabric - Style #3

NOTE: Remember, these formulas are meant to give you guidance. When you get into the industry and understand your target customers' needs and what will sell, you will be able to formulate your groups accordingly.

PUTTING IT ALL TOGETHER

INTRODUCTION

The design process encompasses all the elements covered in the previous sections. So, remember to keep in mind the following subjects but also remember that this is the fun part!

> Season
> Target Customer
> Principles & Elements of Design
> Garment Categories
> Garment Lengths
> Garment Parts & Details
> Fabrication & Color
> Items, Ensembles, Groups & Collections

Once your designs are sketched and finalized, then you'll be ready to go on to the Professional Design Presentation section.

Naturally, each designer develops their own method of working, however, here are the steps of the process which you can follow, until you develop your own:

STEPS OF THE DESIGN PROCESS:

1. Identify Target Customer
Identify the target customer group, including price category. Write your customer profile, including their age, place of residence, figure type, occupation, marital status, income, number of children, lifestyle and behaviors. Give them a name and draw or find a picture of someone who represents your customer (a muse).

2. Identify Season & Formulate The Group
Based on what you know about the target customer, their lifestyle and activities and the season you're designing for, formulate the type, size and content of your group(s).

3. Inspiration Think Tank
Collect your images and ideas and develop your theme/sub-themes. Do more research if necessary, to fuel your creativity.
- Pull the shapes and lines out from your inspirational images/ideas; add in other shapes and lines if you like
- Pull the colors out from your inspirational images and ideas; change or add in other color schemes if you like
- Pull in any ideas or trends about styling
- Pull in ideas, or swatches, of fabrics and trims.

4. Sketch Designs
- Think about your theme/sub-themes
- Think laterally; add an unexpected inspirational element; compound two or more ideas; add a twist or slant
- SKETCH EVERYTHING, EVEN IF IT LOOKS TERRIBLE
- Take the design sketches you like and develop them.

5. Plug In & Fill Gaps
- Choose the sketched designs that you like and plug them into the group formula you developed in Step 2
- Firm up on major fabrics and trims (small details can be added later, when you draw your technical flats)
- Fill in any gaps you may have; use the designs you have already chosen to guide you.

6. Review & Finalize
Make sure the designs accomplish what you set out to do regarding your target customer and season.

STEP 1
Identify Target Customer

Identify the target customer group, including price category. Write your customer profile, including their age, place of residence, figure type, occupation, marital status, income, number of children, lifestyle and behaviors. Give them a name and draw or find a picture of someone who represents your customer (a muse).

TARGET CUSTOMER (MARKET):

Contemporary Woman, Designer

CUSTOMER PROFILE:

NAME:	Jo Walker
AGE:	38
MARITAL STATUS:	Married, to Bob, a screen-writer, age 45
CHILDREN:	Harry, age four and Lily, age six
OCCUPATION:	Owner of a small but successful interior design company
HOME:	They own their home - a four bedroomed house in Malibu, California
INCOME:	Household income is $350k per annum
LIFESTYLE:	Jo works three days a week at her interior design company. She enjoys working out, going to the spa and dining with her friends. She often goes to high profile social events. She reads Vogue and Cosmopolitan. Her favorite designers are Karl Lagerfeld for Chanel and Fendi. Her favorite place to shop for clothes is Bloomingdales.

STEP 2

Identify Season & Formulate The Group

Based on what you know about the target customer, their place of residence, lifestyle and activities and the season you're designing for, formulate the type, size and content of your group(s).

SEASON: FALL

GROUP: A 16 piece related sportswear group - to wear to a social daytime event.

BASE:

A jacket (style 1)
A vest
A skirt (style 1)
A short (style 1)

NOVELTY:

A cape
A jacket (style 2)
A skirt (style 2)
A short (style 2)

WOVEN LAYERING:

Two long sleeved tops (style 1 & 2)
A short sleeved top
A sleeveless top

KNIT LAYERING:

Two long sleeved tops (style 1 & 2)
A short sleeved top
A sleeveless top

STEP 3

Inspiration Think Tank

Collect your images and ideas and develop your theme/sub-themes. Do more research, if necessary, to fuel your creativity.

- Pull the shapes and lines out from your inspirational images and ideas; add in other shapes and lines if you like
- Pull the colors out from your inspirational images and ideas; change or add in other color schemes if you like
- Pull in any ideas or trends about styling
- Pull in ideas, or swatches, of fabrics and trims.

Social Sporting Event
- Dog Races
- Horse Races (more upscale)

Winner's paddock
Start/Finish
Starting Line
Circuit Map
Contestent Colors
· Out The Gate

Trim
Bound edges - like a horse blanket
Belts/ribbon w/ arrow motif (circuit)
Silver + Bronze hardware (burnished/tarnished?)
Studs/Grommits

Fabrics
Leather (saddle)
Silk Charmeuse (Jockey tops)
Canvas?
Wool Tweed (Horse blanket)
Leaf print (hedges/jumps)
Screen prints of blurred horses racing

> **NOTE:** This part of the process is meant to be 'rough & raw' - the main goal being to capture your creative ideas

STEP 4

Sketch Designs

- Think about your theme/sub-themes
- Think laterally; add an unexpected inspirational element; compound two or more ideas; add a twist or slant
- SKETCH EVERYTHING, EVEN IF IT LOOKS TERRIBLE.

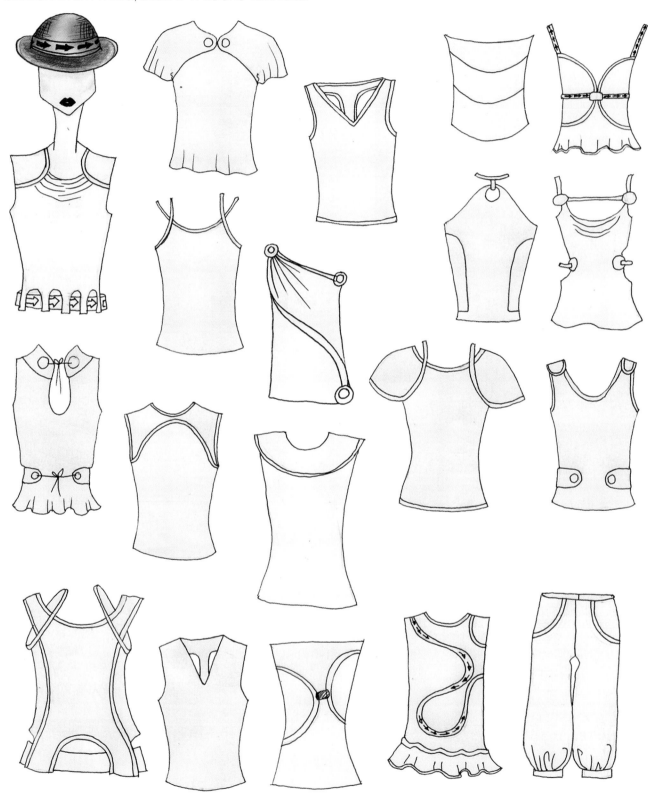

STEP 4, continued

Sketch Designs

- Take the design sketches you like and develop them.

The designer liked this one; particularly the collar style, and developed it into more bodies, below:

NOTE: This part of the process is meant to be 'rough & raw' - the main goal being to capture your creative ideas

STEP 4, continued

Sketch Designs

- Take the design sketches you like and develop them.

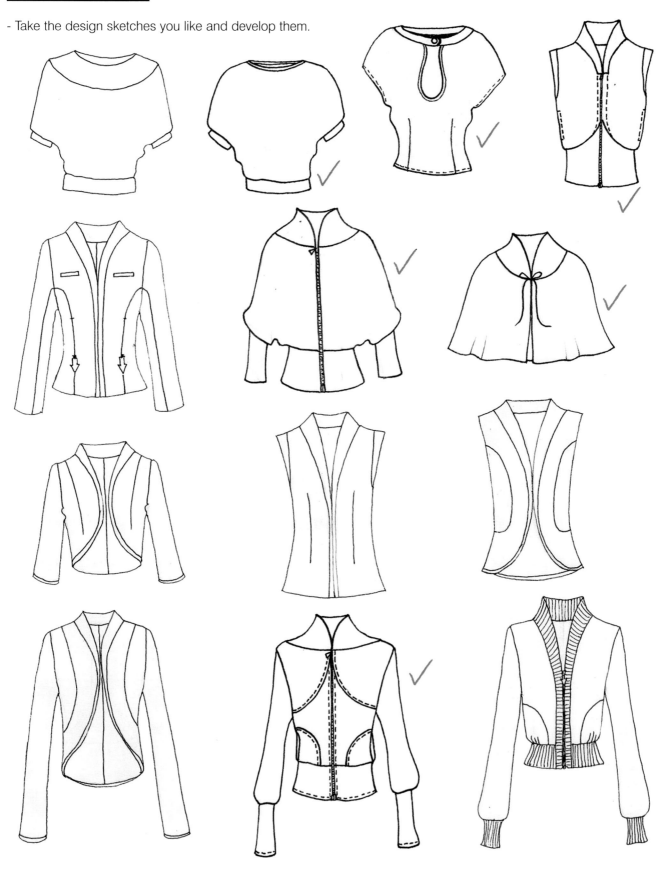

STEP 5

Plug In & Fill Gaps

NOTE: This part of the process is meant to be 'rough & raw' - the main goal being to formulate your group

- Choose the sketched designs that you like and plug them into the group formula you developed in Step 2
- Firm up on major fabrics and trims (small details can be added later, when you draw your technical flats)
- Fill in any gaps you may have; use the designs you have already chosen to guide you.

GROUP FORMULA:

BASE:
Worsted
100% Wool
Flannel w/
Leather contrast

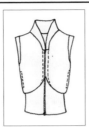

A jacket (style 1)
A vest
A skirt (style 1)
A short (style 1)

NOVELTY:
100% Wool
Herringbone
w/Leather
contrast

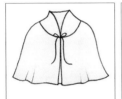

A cape
A jacket (style 2)
A skirt (style 2)
A ~~short~~ cropped pant

(**NOTE:** Designer decided to change the formula from a short to a cropped pant, in novelty fabric. It is best to make any major changes like this at an early stage).

WOVEN LAYERING:
100% Silk
Charmeuse
w/solid
contrast

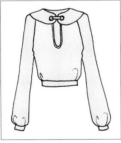

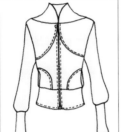

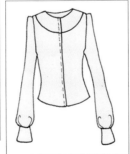

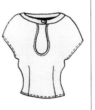

Two long sleeved tops
A short sleeved top
A sleeveless top

KNIT LAYERING:
100% Silk
Jersey w/
racing scene
prints

Two long sleeved tops
A short sleeved top
A sleeveless top

STEP 5, continued

Plug In & Fill Gaps

- Fill in any gaps you may have; use the designs you have already chosen to guide you.

NOTE: The group is completed by designing a skirt and short in base fabric, and a skirt and cropped pant (changed from a short) in novelty fabric.

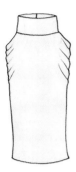 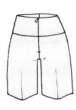 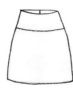 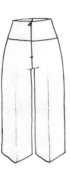

> **NOTE:** This part of the process is meant to be 'rough & raw' - the main goal being to finalize your group

STEP 6

Review & Finalize

Make sure the designs accomplish what you set out to do regarding your target customer and season:

If helpful, put fabrications and colorways ROUGHLY into the bodies (see example on opposite page), to allow you to envisage the group as a whole.

Here are points to consider:

1. This is a related sportswear group – check to be sure that all pieces inter-match.
2. Identify major trims, decorative stitching and notions.
3. Identify any artwork/treatments you will need to source (in this case, horse-racing prints).
4. Check that you have the right styling for the target customer and the season.
5. Check that you have the right colorways for the target customer and the season.
6. Check that you have the right fabrics (and at the right price) for the target customer and the season.
7. Check that you are offering enough variety to suit all tastes within your target customer group.
8. Note how many actual pieces your group consists of, when you multiply each garment, or item, by the colorways you are making available.
9. Check to see if there is anything you could add to the group to enhance sales. In this case, a belt and a hat were added.
10. Check to see if there is anything you could eliminate from the group that won't enhance sales, but will just increase costs.
11. Keeping in mind the fabrication, make sure that the design allows for getting the garment on and off the body.
12. Check that the garments perform under the conditions they were designed for (especially for active sportswear).

STEP 6

Review & Finalize

If helpful, put fabrications and colorways ROUGHLY into the bodies to allow you to envisage the group as a whole.

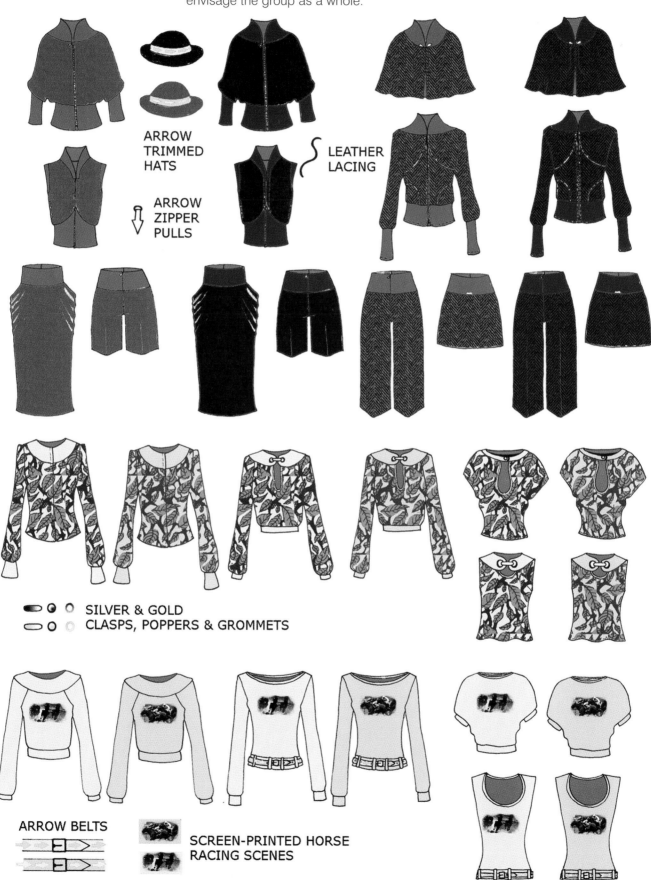

ARROW TRIMMED HATS

LEATHER LACING

ARROW ZIPPER PULLS

SILVER & GOLD
CLASPS, POPPERS & GROMMETS

ARROW BELTS

SCREEN-PRINTED HORSE RACING SCENES

PROFESSIONAL DESIGN PRESENTATION

Professional presentation of your work is key to your success. Here are techniques that will help you to be consistent, accurate, speedy and stunning:

Page #

Technical Flat Drawing 156
Technical flat drawing tips and techniques.

Illustrations . 161
Illustration tips and techniques.

Presentation Boards 177
Quick reference for all boards required for a fashion design project.

TECHNICAL FLAT DRAWING

INTRODUCTION

A technical flat, or 'flat,' is a line drawing that reflects the exact proportions, styling and fit of a design, in miniature format. They are 'technical' because the details are accurate and precise, and 'flat' because they are two dimensional drawings. As the name indicates, they serve the specific purpose of relaying information about the garment to others, both inside and outside of the organization, so that the item can be constructed accurately and to the exact specifications of the designer as well as be instantly visually recognized.

ALWAYS USE A TECHNICAL FLAT TEMPLATE APPROPRIATE TO YOUR TARGET CUSTOMER (EXPLAINED & SUPPLIED ON PAGES 213-248)

TECHNICAL FLAT DRAWING TECHNIQUES

FIT

Demonstrate the fit of your design by drawing your outline closer to the silhouette of the technical flat template for tighter-fitting garments, and further away for looser-fitting garments.

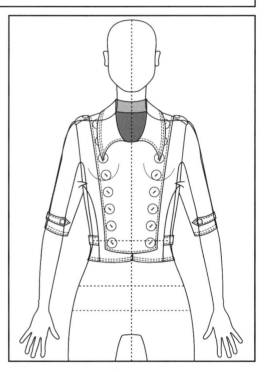

SYMMETRICAL DESIGNS

For symmetrical designs, save time by creating one half of the garment, then tracing or copying it over.

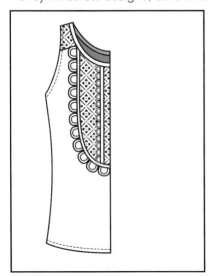
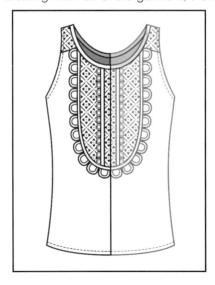
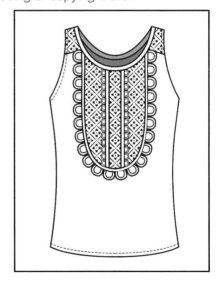

BACK

For the back, save time by tracing or copying the parts of the front that look the same from the back, then fill in the gaps and the back details.

The back view is placed next to, or slightly overlapped by the front, making sure that none of the major back details are obscured. The back may be reduced in size, if desired, to save space.

'INKING' IN

For 'inking' in lines, always use your creative eye first, but as a general rule, use a heavy line for the outline, or silhouette, a medium line for the stylelines and major details within the silhouette and a fine line for the minor details, such as topstitching. When working manually, avoid smudges by using pens with quick-drying, even-flowing ink. If you like to draw your flats in pencil first, use a sharp hard-leaded pencil with light pressure - it's easier to ink over.

COLOR

For colored flats, pick one of the colorways being offered and use it throughout. If adding color makes it difficult to see the stylelines and details, use partial color only in an open area of the design.

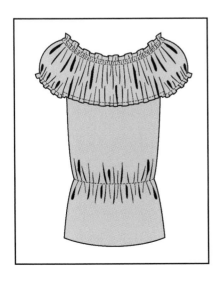

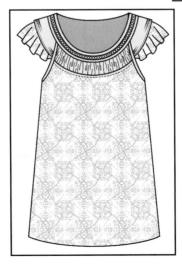

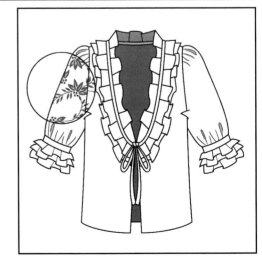

TECHNICAL FLAT EXAMPLES AND DESCRIPTIONS

3/4 LENGTH COAT
- with princess seams, epaulettes, tabs and metal closures.

CASUAL SHIRT
- with long, banded sleeve, center front opening and tie, gathered waistband and shoulder panel.

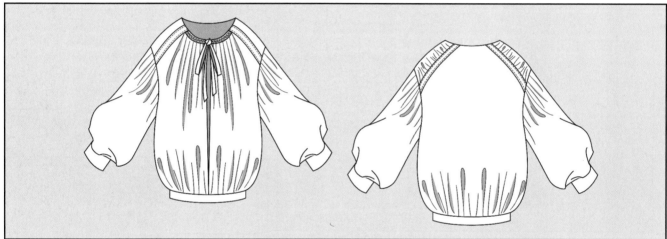

COCKTAIL DRESS
- calf length, bubble with print bodice, elasticated hem with lace-trimmed ruffle and center front bow; invisible side seam zipper.

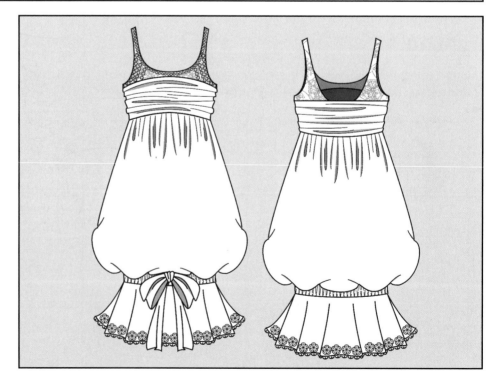

CASUAL JACKET
- funnel neck, with 3/4 sleeves, center front zipper and decorative studs.

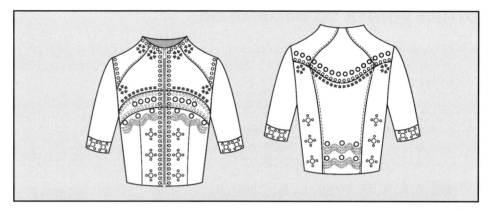

DRESSY BLOUSE
- hip length, with gaping center front, long sleeves, french cuffs, tucks, back yoke and decorative tie at the hem.

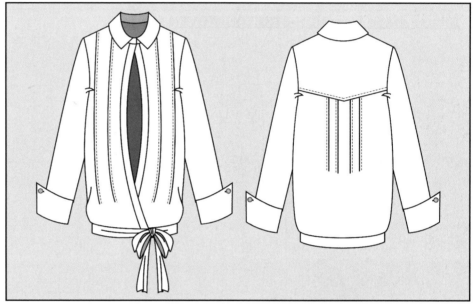

CASUAL PANT
- Six pocket pant with drawstring hem and jodhpur stylelines.

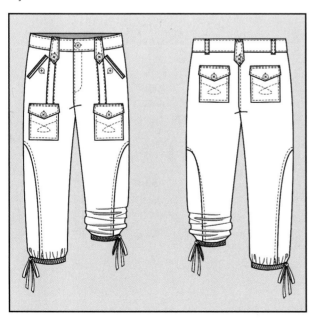

DRESSY SKIRT
- Above-the-knee, pleated skirt with yoke, buttoned tabs and center back zipper.

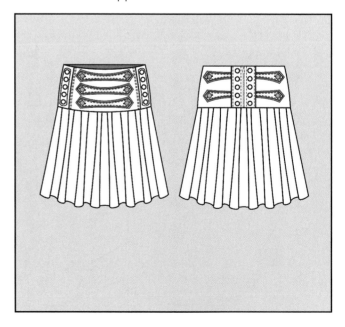

OTHER POINTS TO REMEMBER:

1. Take into account the fabric of the piece and make sure it is possible for each garment to be put on and taken off the body. Typically, woven fabrics stretch less, knit fabrics and fabrics cut on the bias grain (45 degree angle) stretch more.

2. Now is the time to finalize the practical elements of each garment, so remember to include details such as pockets and darts as well as indicating how the garment is finished.

3. Contrast fabrication can be indicated by filling these area with shades of grey.

4. Refer to the section 'Garment Parts & Details' to help you to draw your flats.

Blouse made from NON-STRETCH WOVEN fabric

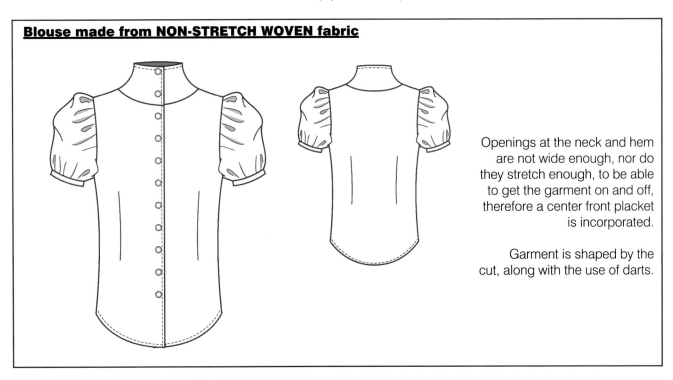

Openings at the neck and hem are not wide enough, nor do they stretch enough, to be able to get the garment on and off, therefore a center front placket is incorporated.

Garment is shaped by the cut, along with the use of darts.

Top made from KNIT fabric with natural STRETCH

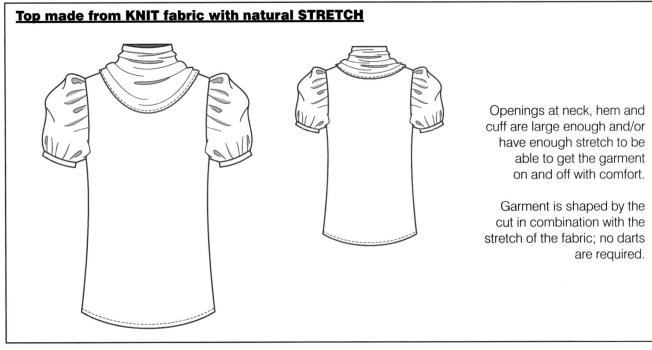

Openings at neck, hem and cuff are large enough and/or have enough stretch to be able to get the garment on and off with comfort.

Garment is shaped by the cut in combination with the stretch of the fabric; no darts are required.

ILLUSTRATIONS

INTRODUCTION

Illustrating your designs is an essential part of the educational process of fashion design. The best results will be included in a portfolio – the industry-standard tool used for getting a job. The primary goal, therefore, is to demonstrate your skill through an image that speaks 'a thousand words.' A well-executed illustration will clearly show off your ability to capture a mood/attitude/overall style; one that will convince your interviewer that you understand the target customer and the market and promptly hire you! Once you're working in the industry, you'll rarely, if ever, be called upon to produce such elaborate illustration work.

Typically, the adult, human figure used for a fashion illustration differs in proportion from a regular human figure. Instead of an 8:1 ratio, where 8 times the length of the head is equal to the height of one figure, a fashion croquis, or figure uses a 9:1 ratio, incorporating an extra head length in the leg, to give a taller, more glamorous appearance. This does not necessarily apply to all target customer groups; the figures used for babies and children, for example, are more likely to be illustrated using their regular proportions.

ALWAYS USE A FASHION CROQUIS TEMPLATE APPROPRIATE TO YOUR TARGET CUSTOMER (EXPLAINED & SUPPLIED ON PAGES 249-268)

THE ILLUSTRATION PROCESS

There are two distinct parts to the illustration process:

Illustration of The Fashion Croquis, or Figure

The key considerations are that the figure should be representative of the target customer's body, mood and attitude; include movement that is appropriate to the purpose of the design; include accessories as applicable AND look stunning! It is generally accepted that fashion designers should source a fashion figure if their drawing skills prove (after some time and effort on their part, of course) to be less than fantastic. Remember, it's VERY difficult to draw a human being, especially when mood and movement come into play.

Illustration of The Design(s) Themselves

A designer must develop the skills to illustrate their own designs. It is considered unethical not to do so.

The basic steps of the illustration process are:

Step 1: Create or source a fashion croquis with the look, mood and attitude of your target customer.

Step 2: On a separate piece of paper, if working manually, or on a new layer, if working digitally within a drawing program, use the croquis as your guide to draw your garment or ensemble. Remember to incorporate movement of the fabric, as appropriate and take into consideration the effects of gravity.

Step 3: Draw in the details on the garment(s), including creases and folds in the fabric where it drapes.

Step 4: Color and shade with your choice of media, working from light to dark. Add your own hairstyle and accessories, if desired.

The following pages include:
tips & techniques for producing great illustrations,
samples of how to render different fabrics and
examples of more advanced poses, for inspiration.

ILLUSTRATION
TECHNIQUES

Demonstrate movement of fabric, where the body bends, or where excess fabric drapes by showing bulges and creases; take into account how different fabrics behave:

> This <u>pleather</u> harness is stiff enough to defy gravity and actually stands off from the body.

> This silk <u>charmeuse</u> blouse is much more drapable. Note how creases in a <u>print fabric</u> break up the pattern.

Show where the body curves by curving the edges of garments and the stylelines accordingly.

Pick a light source and use it throughout (here the light is coming from the front, slightly above the figure so that shadows fall underneath objects).

Highlight the 'core' light at the center of any items that curve out towards you and graduate into darker areas where the light cannot reach.

This heavyweight <u>ultrasuede</u> skirt has little movement in the hemline.

Shadows also appear where items touch.

Use an appropriate amount of white to show the texture and luster of the fabrics:

> The <u>napped suede</u> skirt has a dull, diffused luster (white is used lightly).

> The supple <u>vinyl</u> boots have a soft, undulating but intense shine (white is used heavily).

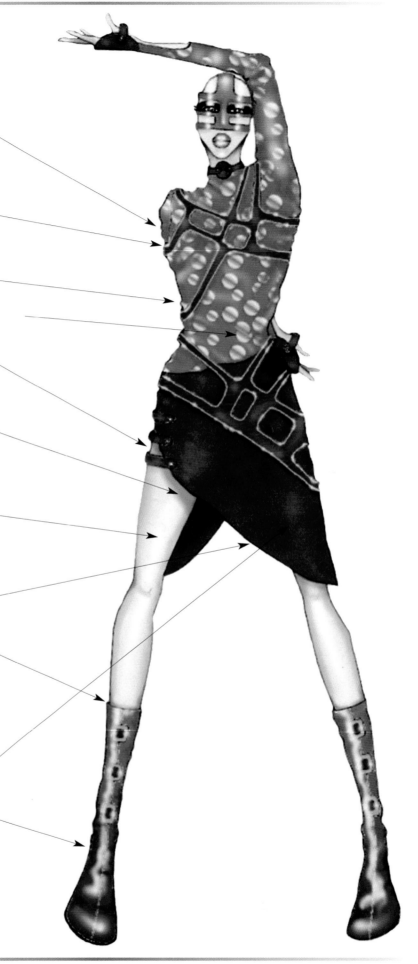

Illustration Techniques - Leather & Faux Fur
Media: Colored Pencil & Marker Pen

Illustration Techniques - Taffeta & Velvet
Media: Colored Pencil & Marker Pen

Illustration Techniques - Cotton Print & Eyelet
Media: Colored Pencil & Marker Pen

Illustration Techniques - Sequined Velour & Denim
Media: Colored Pencil & Marker Pen

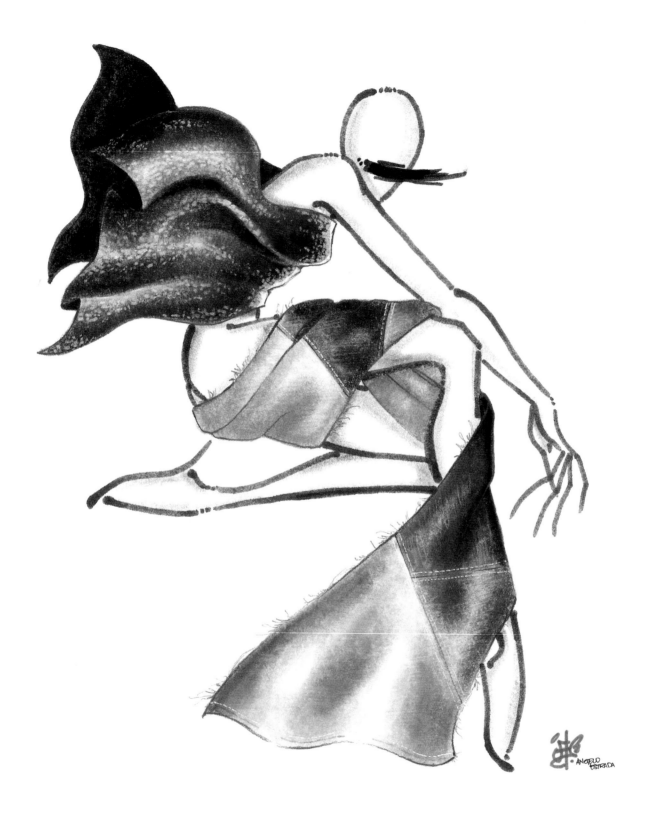

Illustration Techniques - Satin & Tulle
Media: Colored Pencil & Marker Pen

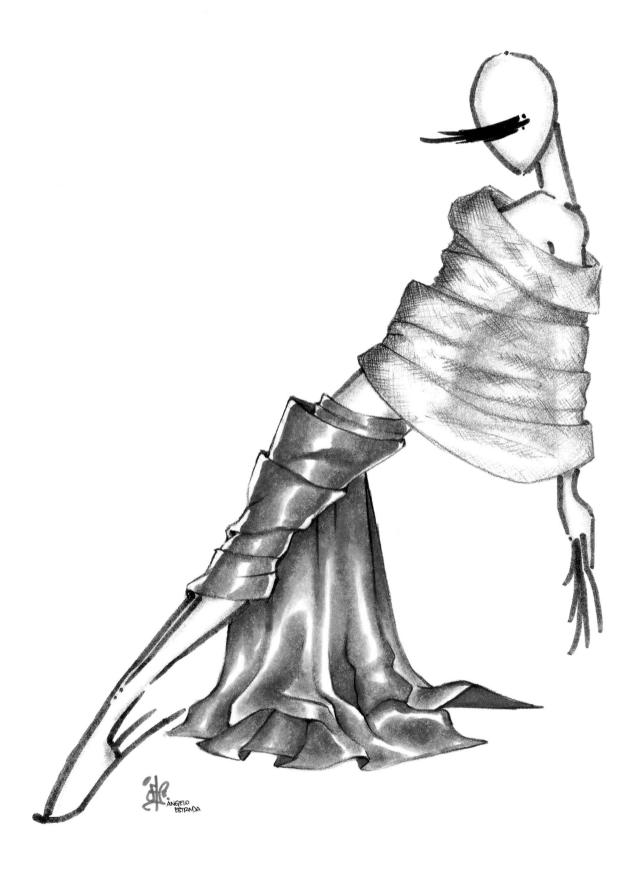

Illustration Techniques - Wool Bouclé & Ultrasuede
Media: Colored Pencil & Marker Pen

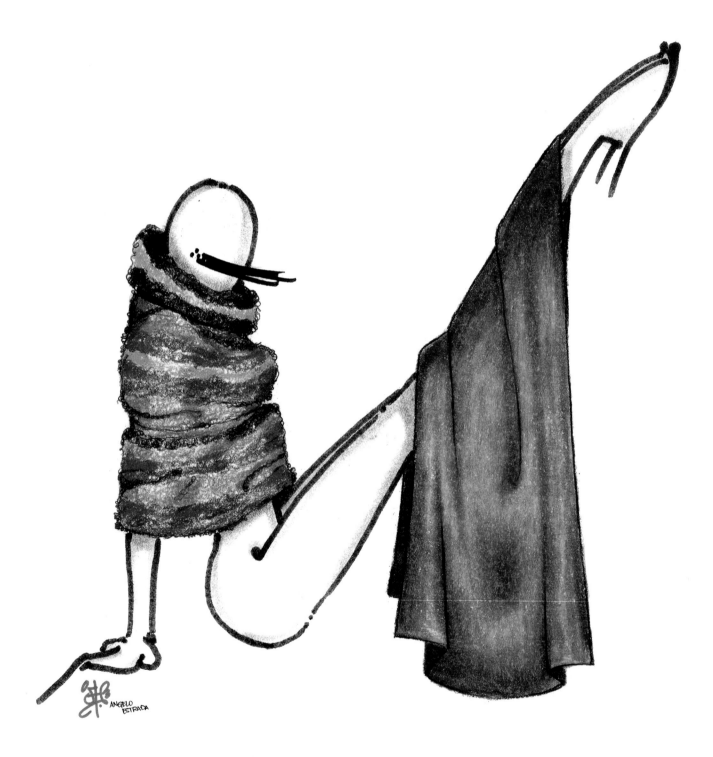

Illustration Techniques - Wool Herringbone & Chiffon
Media: Colored Pencil & Marker Pen

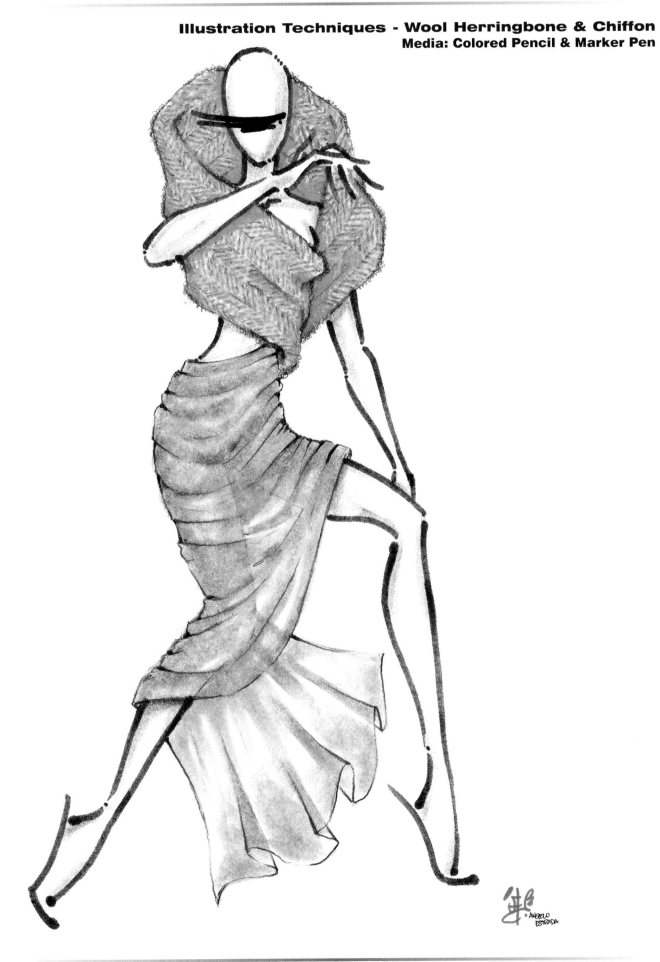

Illustration Techniques - Douppioni Silk & Wool Plaid
Media: Colored Pencil & Marker Pen

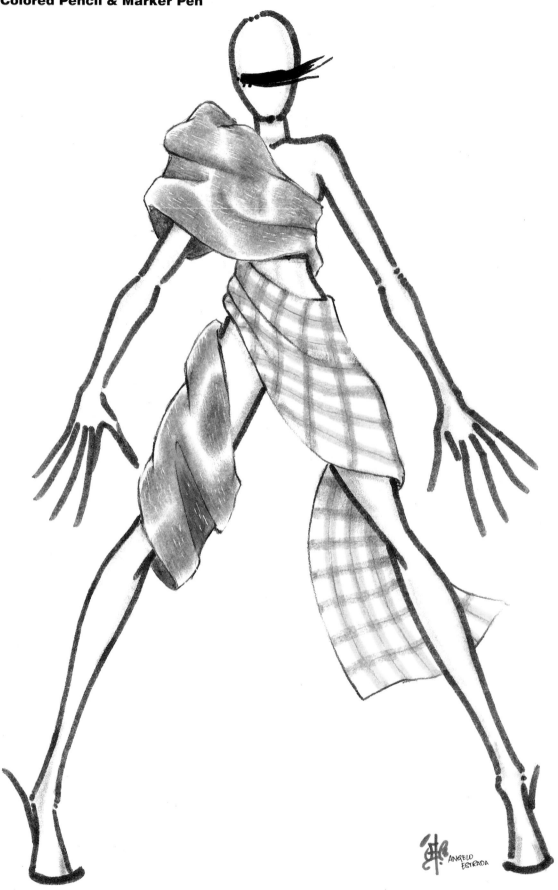

Illustration Techniques - Silk Brocade & Corduroy
Media: Colored Pencil & Marker Pen

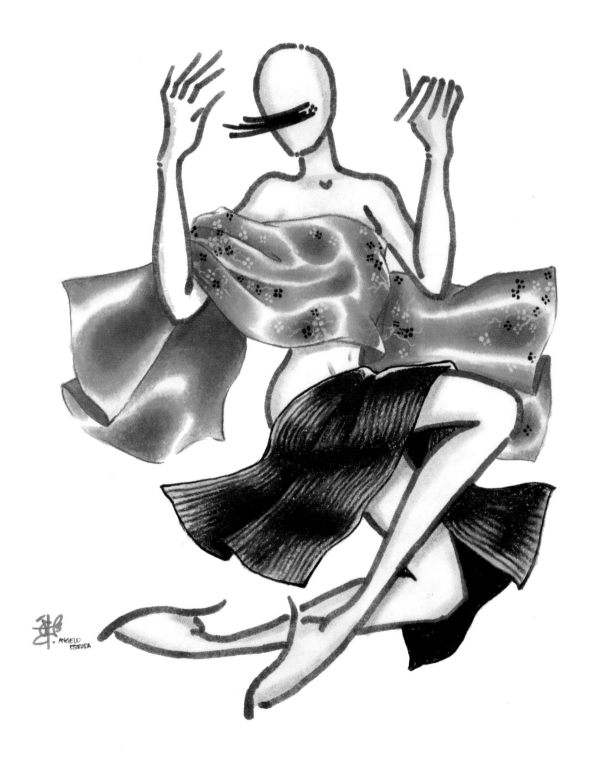

ADVANCED POSES & TECHNIQUES

The following pages show examples
of poses with more movement and
other creative elements, for
inspiration. For further
information on developing
more advanced poses,
see page 250.

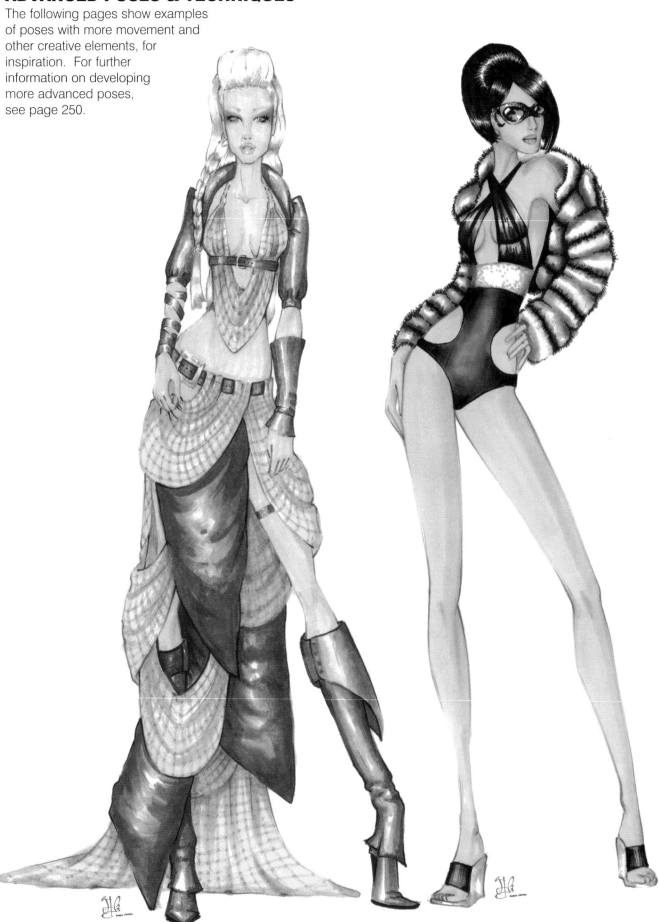

ADVANCED POSES
& TECHNIQUES

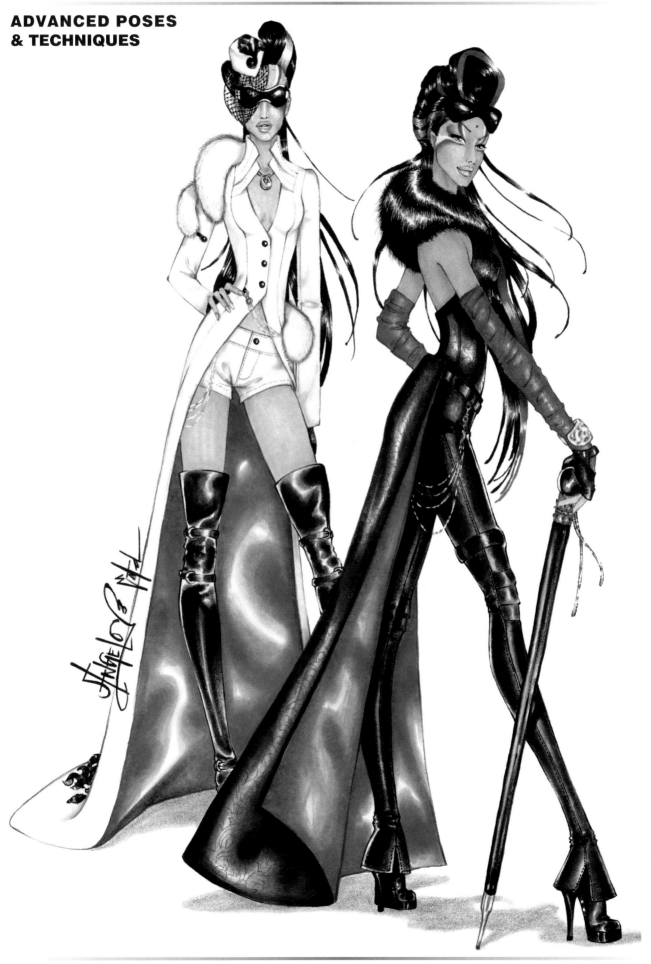

ADVANCED POSES
& TECHNIQUES

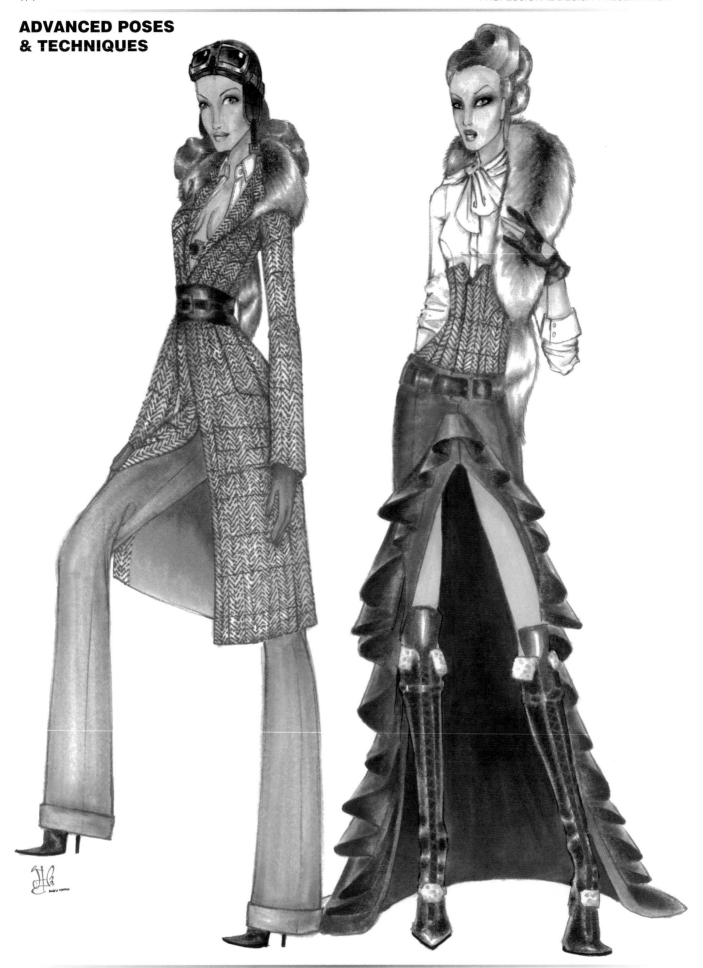

ADVANCED POSES & TECHNIQUES

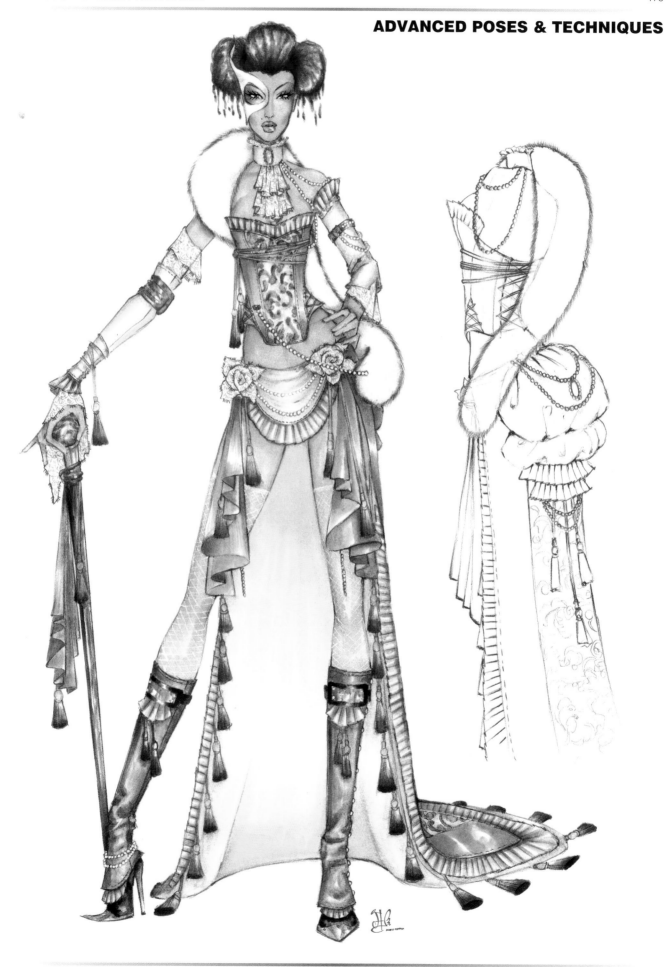

ADVANCED
POSES &
TECHNIQUES

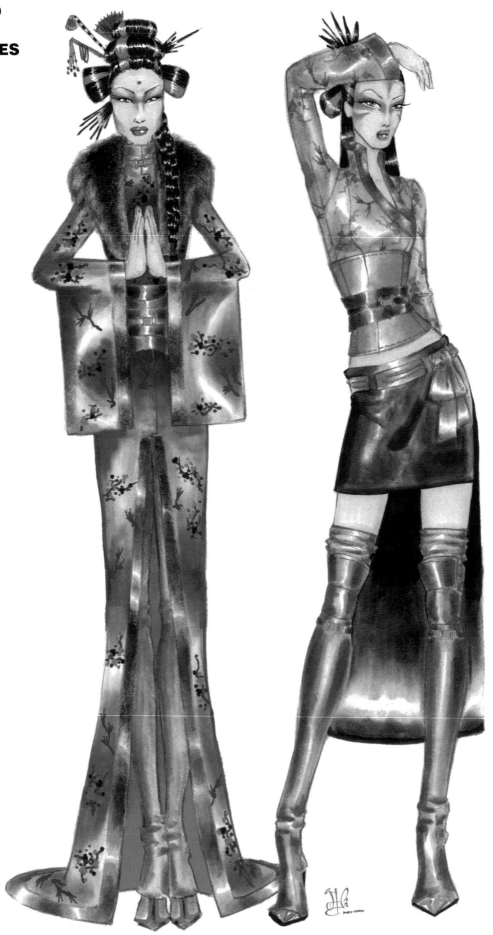

PRESENTATION BOARDS

INTRODUCTION

The presentation of your work is an important part of being a fashion designer, both as a student and in the industry. However, it's easy to spend all your time and efforts on the design project in hand and miss out on the potential benefits that a good presentation has to offer.

As a student, the potential benefits are in getting an 'A' and in generating work that reflects your talents to the maximum; work that can be included in your portfolio and help get you a great job in the industry.

As a working professional, the potential benefits are in being able to effectively communicate your ideas to your co-workers and your boss and enable them to 'get on board' with your designs. Furthermore, presentation boards include both subtle and precise information about the target customer and the collection; vital information that allows the management, design, production, sales/marketing and merchandising teams to accurately perform their roles and avoid misunderstandings and mistakes.

Not only are there different types of presentation boards, where purpose and scope vary depending on whether you're in school or at work, but there are many other factors to consider such as content, layout, board size, use of color, materials and effective time management. It is with these factors in mind that the elements, listed below, have been included. Our aim is to provide a clear understanding of what to do, when and how, in each of the key areas where boards are commonly required. Here are the topics covered in this section:

THE BASICS ABOUT BOARDS

TIPS

GLOSSARY OF ELEMENTS

THEME/INSPIRATION BOARDS

CUSTOMER PROFILE BOARDS

MERCHANDISING BOARDS

TECHNICAL FLAT BOARDS

ILLUSTRATION BOARDS

NOTE

Some of the Presentation Boards shown in this section relate to the example in the 'Putting It All Together' section of 'The Design Process,' on Pages 144-153.

THE BASICS ABOUT BOARDS

This section covers the general factors that apply to all types of presentation boards. Here are the key elements to consider:

PURPOSE

Whether you're in school, or at work, the purpose of any presentation is to clearly and accurately relay information about your group or collection.

CIRCUMSTANCES

Defining the circumstances of your presentation will help you to make appropriate choices. The main consideration is whether you are in school or at work.

In school:
Your goal is to get an 'A' and to produce work that will enhance your portfolio. You want to display your creativity and talent to the best of your abilities; the sky is the limit.

At work:
Your goal is to do your job by effectively seducing your audience with your designs, demonstrating your understanding of your target customers' needs and relaying vital information to the team you work with to ensure success. Now you're in the business arena; time is money. You have to determine how much time to spend on a presentation, based on the Company's budget and expectations. In most cases, fanciful and elaborate presentations will not be appreciated in the same way as they would be in a school environment. It's up to you to find out which approach will be most appreciated.

AUDIENCE

The size of your audience will directly impact the size of your presentation boards and the way in which you can effectively present them.

RESOURCES

The location of your presentation, and the resources there will also affect your decisions. If you've ever done a presentation of your work, then you'll know how much easier it is to execute if you have both hands free. Unless you're able to present your work down flat on a surface, then you're going to need an easel, a stand or an assistant; otherwise you need to be extremely co-ordinated! If you intend to put your presentation boards into some sort of presenter or portfolio, then you need to think about the light and the reflectivity of the presenter – sometimes these factors can prevent your audience from being able to see your boards at all.

TIPS

Board Material - Make sure that the board you choose is sturdy and clean. An all-purpose pressed board, available at art supply stores, is commonly used. They come in a variety of sizes and colors.

Board Size - Consider the size of the audience to whom you will present your work, as well as the layout of the room to help you to choose an appropriately-sized board. Typically, a presentation board should be no smaller than 15" by 20".

Format - Each group has its own theme, merchandising information, technical flats and illustrations that can either be presented on individual boards, as is common for fashion design, or on one large board that folds in on itself, as is often the case for fashion merchandising. Mock-ups of both types are shown below, however, we have used the fashion design approach throughout this section.

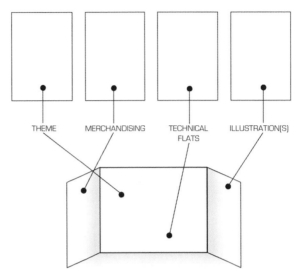

THEME MERCHANDISING TECHNICAL FLATS ILLUSTRATION[S]

INDIVIDUAL FASHION BOARDS

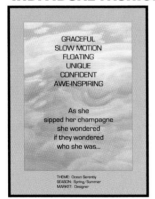
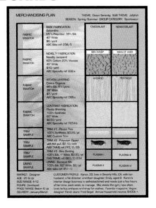
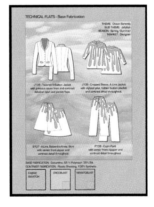
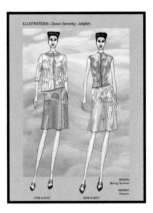

ONE FOLDING FASHION BOARD

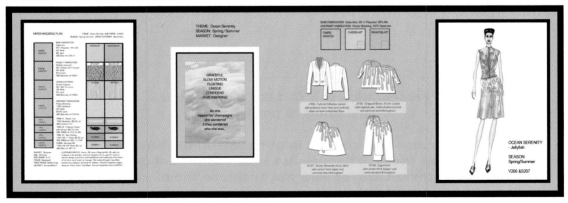

Layout - First consider defining a standard layout that ties in with the theme of your work. This may include a border, choosing an appropriate font/type-face as well as the use of color, images and/or graphics.

Preparation - Completing presentation boards can be a time-consuming process, so give yourself as much time as you can; consider preparing the basic layout of your boards ahead of time. Borders and titles can be inserted; graphic elements and images can be inserted, or their position on the board marked off, etc.

Output Method - Essentially, you'll either be using the cut-&-paste, the digital method of creating your boards, or a combination of the two. Unless your instructor has stipulated which method you must use, the following factors will help you to decide which is the best option for you:

Cut-&-Paste:

Equipment - You many need to purchase a variety of special papers and art materials; glue; ready-to-use illustrations/images/pictures; some means of applying text (unless you're an expert calligrapher, always use mechanical type).

Skill - It takes planning, patience, precision and care to get professional results through the cut & paste method. You may also need to practice with the materials you're using to avoid some of the downfalls – such as using a glue that doesn't show through to the face of your artwork, etc.

Output Size - One of the benefits of this method is that you can easily produce over-sized boards.

Editability - The biggest downfall of cut & paste is that it's very hard to edit the work once it has been produced.

Digital:

Equipment - You'll need to own, or have lots of access to, a decent computer system with graphics software (such as Adobe Illustrator, Adobe Photoshop, Adobe InDesign, Quark Xpress, etc.), a printer and scanner.

Skill - You'll need to be proficient enough to easily layout, edit and manipulate your text and images.

Output Size - The biggest downfall of the digital method is that you'll probably have to take your final composition elsewhere, on disk, to be printed out at an appropriate size for mounting onto your boards.

Editability - The major benefit of working digitally, is the ability to edit, refine and re-use your work.

IMPORTANT NOTE: Always consider the target customer/market in all elements of presentation boards, including shapes, imagery and colors. Always use a technical flat template and fashion croquis that represents the figure of your target customer.

> **Presentation boards take a lot of time and effort to produce.**
>
> **Put your name and contact information on the back of all boards so that you'll maximize your chances of getting them back, should you misplace them.**

GLOSSARY OF ELEMENTS

The following are elements that you will incorporate into one or more of the presentation boards.

IMPORTANT NOTE: Until you are actually working within the industry, this process is always going to be a little unreal. As a fashion designer, you'll have all your vendors, prices and options at your fingertips; as a student you won't. Don't become frustrated by this and remember that the point of the exercise is to train you to be able to put together a group or collection that satisfies the needs of your customer in terms of styling, salability and price.

Age Range - The age range of the market, or target customer (detailed on pages 16-33).

Colorways - Colorways refer to the different colors that one garment will be offered in. Attach a swatch of the actual fabric, in the correct colorways being offered if you have swatches available. Most instructors will accept a color-rendering of a swatch (your drawing in color) for the colorways (and representing the print, where applicable). Each colorway should be given an appropriate name and labeled accordingly. See pages 137 and 138 for detailed explanations of colorways.

Color Story - A color story refers to the use of color within one complete ensemble. By reading vertically down the merchandising plan, your audience can understand which of the colorways for each garment within the group, have been designed to be worn together. See pages 137 and 138 for detailed explanations of color stories.

Customer Profile - A brief, but detailed breakdown of the lifestyle and behaviors of the market, or target customer, including age, place of residence, marital status, number of children, occupation, leisure activities, buying habits (favorite magazines, designers and stores) and annual household income. See sample customer profiles on pages 145 and 184.

Delivery - The months the orders received will be delivered to the buyers (detailed on page 13).

Fabrication Category - The role of the fabric, as it relates to the group, within your collection:

> Base Fabrication - a bottom-weight fabric that provides the foundation of the group, and the one which will sell the best – consisting of 'hard bodies' (jackets, vests, skirts, pants, shorts, etc.).

> Novelty fabrication - a bottom-weight fabric that provides the 'added interest' that jazzes up the group, and the one which many, but not all, of your customers will buy – again, consisting of 'hard bodies' (jackets, vests, skirts, pants, shorts, etc.).

> Layering Fabrication - top-weight fabrics that make the items that are worn with the hard bodies, to complete the outfit, or ensemble – consisting of 'soft bodies' (shirts, blouses, sweaters, cardigans, camisole tops, tanks). Layering fabrications are broken down into two categories, woven or knit.

Fabric Swatch - Attach a swatch of the actual fabric. Most instructors will accept a swatch that is not correct in terms of color (and print, where applicable), providing that it is the correct type of fabric, with the correct fiber content. Swatches should be no smaller than 1.5" square, cut neatly and securely adhered to the appropriate presentation board(s). In the industry, you will be required to provide a swatch of the exact fabric that you are proposing – one that you will have received from one of your fabric vendors.

Fabric Description - Include the following information:
1. Name of the fabric
2. Fiber Content
3. Fabric Width
4. Wholesale Price per Yard
5. Vendor Reference Number.

Figure Type - The figure type of the market, or target customer (detailed on pages 16-33).

Group Category - The type of group you have designed, such as Dresses, Lingerie, Active Sportswear, etc. (detailed on pages 56-65).

Market - The target customer for whom the collection has been designed (detailed on pages 16-33).

Price Range - The category of pricing that relates to the market, or target customer, such as budget, moderate, better or designer (detailed on pages 16-33).

Season - The season for which the collection is designed (detailed on page 13). You would also include the year, in the industry; however, you may opt to leave the year out while you are studying, so that your work can be included in your portfolio without the negative impact of displaying an old date.

Size Range - The range of sizes that will be offered, based on the market, or target customer (detailed on pages 16-33).

Style Number - Every new style that is developed is issued with a unique style number for identification purposes. Methods of identification will vary from company to company. In the meantime, make up your own system and use it to identify your styles.

Style Description - Include a brief description of each style.

Sub-Theme - The titles you've given to each group within your collection based on the Theme.

Theme - The main title you've given to your collection based on your inspiration.

Trim/Notion/Closure Description - Include the following information:
1. Name
2. Fiber Content and/or description, as applicable
3. Dimensions
4. Price per unit or yard
5. Vendor & Reference Number.

Trim/Notion/Closure Sample - Attach a sample of each of the items that are used within the group. Ask your instructor whether they will accept a color drawing (rendering) or an image of the item, if you are unable to get an actual sample.

THEME/INSPIRATION BOARDS

PURPOSE: A Theme Board is designed to define the 'look', 'feel' or mood of your collection at a glance. So, whether you use images, words, a combination of these, or other media, your main focus is to translate the essence of your collection to your audience.

ELEMENTS: Along with your image(s) and/or words, you must include the following:

THEME / SEASON / TARGET CUSTOMER (MARKET)

AS SHE SIPPED HER CHAMPAGNE SHE WONDERED IF THEY WONDERED WHO SHE WAS...

THEME
A Day at The Races
SEASON
Fall
MARKET
Designer Women

CUSTOMER PROFILE BOARDS

PURPOSE: A Customer Profile Board is designed to define the facts about your target customer, including an image or picture, their name, age, place of residence, marital status, number of children, occupation, lifestyle, buying habits and annual household income. Sometimes this information is incorporated into the Merchandising Plan; our example shows a separate board for this element of your project.

ELEMENTS: Along with your image(s) and/or words, you must include the following:

THEME / SUB-THEME / SEASON / TARGET CUSTOMER (MARKET)

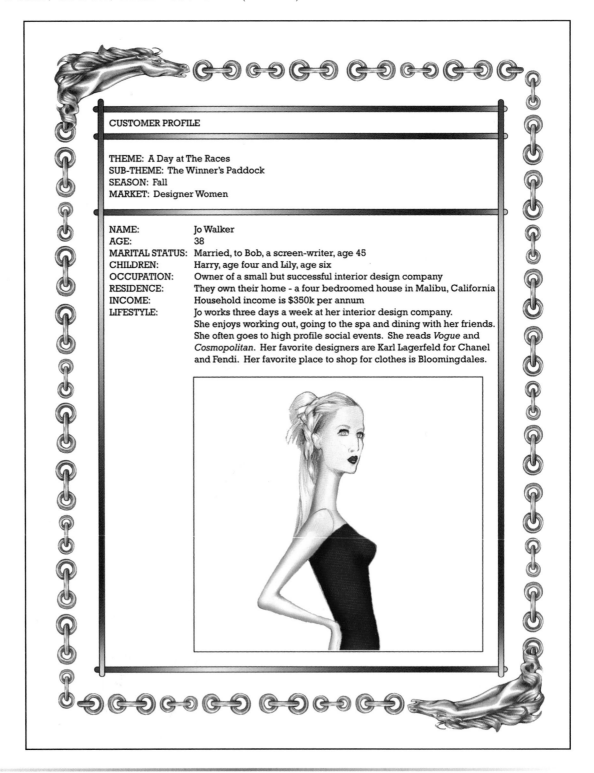

CUSTOMER PROFILE

THEME: A Day at The Races
SUB-THEME: The Winner's Paddock
SEASON: Fall
MARKET: Designer Women

NAME: Jo Walker
AGE: 38
MARITAL STATUS: Married, to Bob, a screen-writer, age 45
CHILDREN: Harry, age four and Lily, age six
OCCUPATION: Owner of a small but successful interior design company
RESIDENCE: They own their home - a four bedroomed house in Malibu, California
INCOME: Household income is $350k per annum
LIFESTYLE: Jo works three days a week at her interior design company. She enjoys working out, going to the spa and dining with her friends. She often goes to high profile social events. She reads *Vogue* and *Cosmopolitan*. Her favorite designers are Karl Lagerfeld for Chanel and Fendi. Her favorite place to shop for clothes is Bloomingdales.

MERCHANDISING PLAN BOARDS

PURPOSE: A Merchandising Plan is a 'road-map' to your collection. It tells the audience what fabrics are used, what is the color story, what are your colorways; what prints, trims and notions are used. It is the practical solution to achieving the 'look' you have defined within your theme/inspiration board.

ELEMENTS: You must include the following:
THEME / SUB THEME / SEASON / GROUP CATEGORY / TARGET CUSTOMER (MARKET) / AGE RANGE / SIZE RANGE / FIGURE TYPE / PRICE RANGE / DELIVERY / CUSTOMER PROFILE (IF NOT DONE ON A SEPARATE BOARD) / FABRIC SWATCHES / FABRIC CATEGORIES / FABRIC DESCRIPTIONS (including NAME, CONTENT, WIDTH, PRICE & VENDOR REFERENCE) / COLORWAYS / TRIM/NOTION/CLOSURE SAMPLES / TRIM/NOTION/ CLOSURE DESCRIPTIONS (including NAME, CONTENT &/OR DESCRIPTION, DIMENSIONS, PRICE & VENDOR REFERENCE)

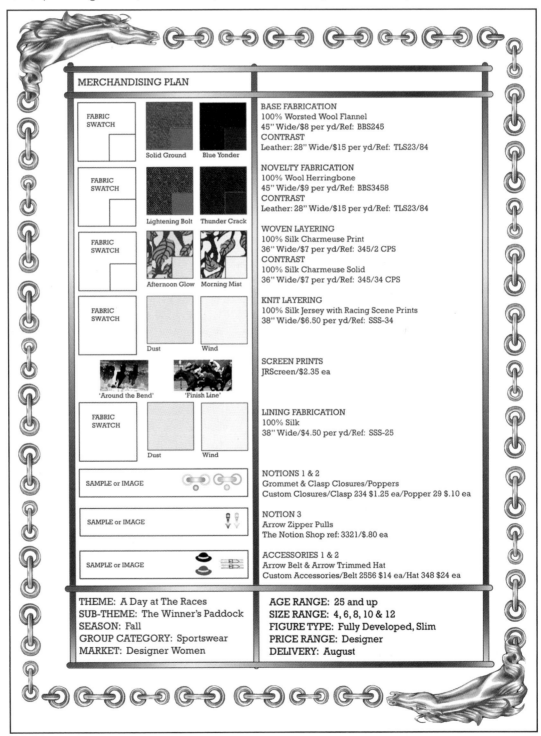

TECHNICAL FLAT BOARDS

PURPOSE: These boards lay out the technical flats, by <u>fabrication category</u>. The audience can clearly comprehend the style of the garments, both front and back, how they open and close, placement of any embellishments and/or trims and, of course, the fabric(s) they are to be made from.

ELEMENTS: Along with your front and back flats, you must include the following:

FABRIC CATEGORY / THEME / SUB THEME / SEASON / TARGET CUSTOMER (MARKET) / FABRIC DESCRIPTIONS (including NAME & CONTENT) / FABRIC SWATCHES / COLORWAYS / STYLE NUMBERS / STYLE DESCRIPTIONS

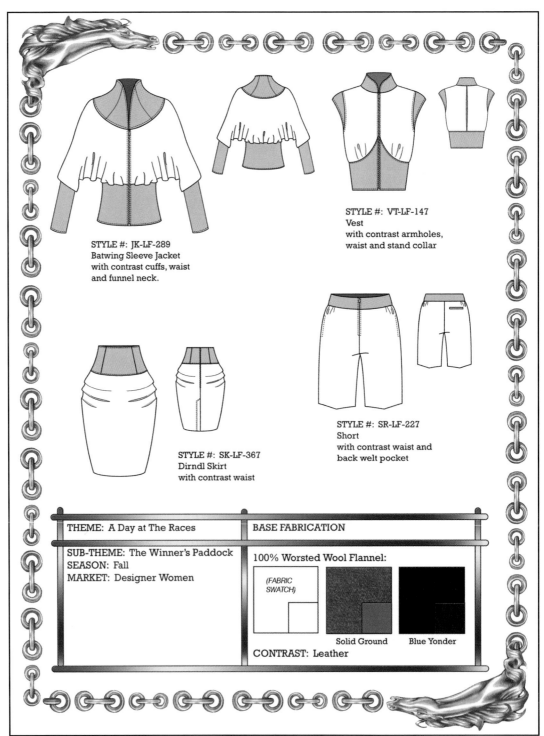

STYLE #: JK-LF-289
Batwing Sleeve Jacket
with contrast cuffs, waist
and funnel neck.

STYLE #: VT-LF-147
Vest
with contrast armholes,
waist and stand collar

STYLE #: SK-LF-367
Dirndl Skirt
with contrast waist

STYLE #: SR-LF-227
Short
with contrast waist and
back welt pocket

THEME: A Day at The Races

BASE FABRICATION

SUB-THEME: The Winner's Paddock
SEASON: Fall
MARKET: Designer Women

100% Worsted Wool Flannel:

(FABRIC SWATCH)

Solid Ground Blue Yonder

CONTRAST: Leather

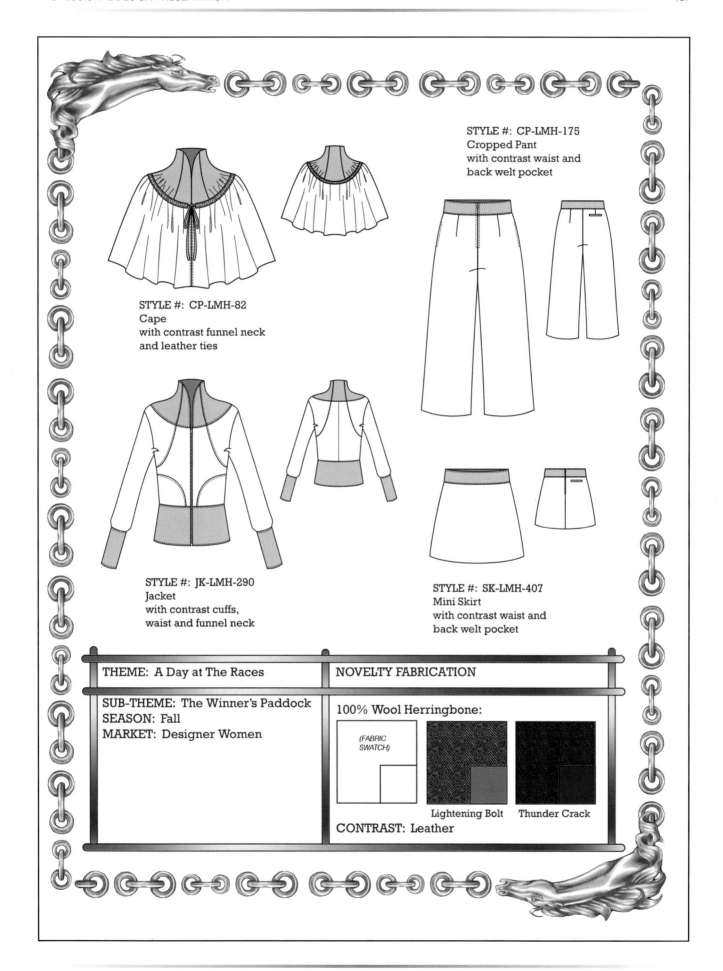

STYLE #: CP-LMH-82
Cape
with contrast funnel neck
and leather ties

STYLE #: CP-LMH-175
Cropped Pant
with contrast waist and
back welt pocket

STYLE #: JK-LMH-290
Jacket
with contrast cuffs,
waist and funnel neck

STYLE #: SK-LMH-407
Mini Skirt
with contrast waist and
back welt pocket

THEME: A Day at The Races

SUB-THEME: The Winner's Paddock
SEASON: Fall
MARKET: Designer Women

NOVELTY FABRICATION

100% Wool Herringbone:

(FABRIC SWATCH)

Lightening Bolt Thunder Crack

CONTRAST: Leather

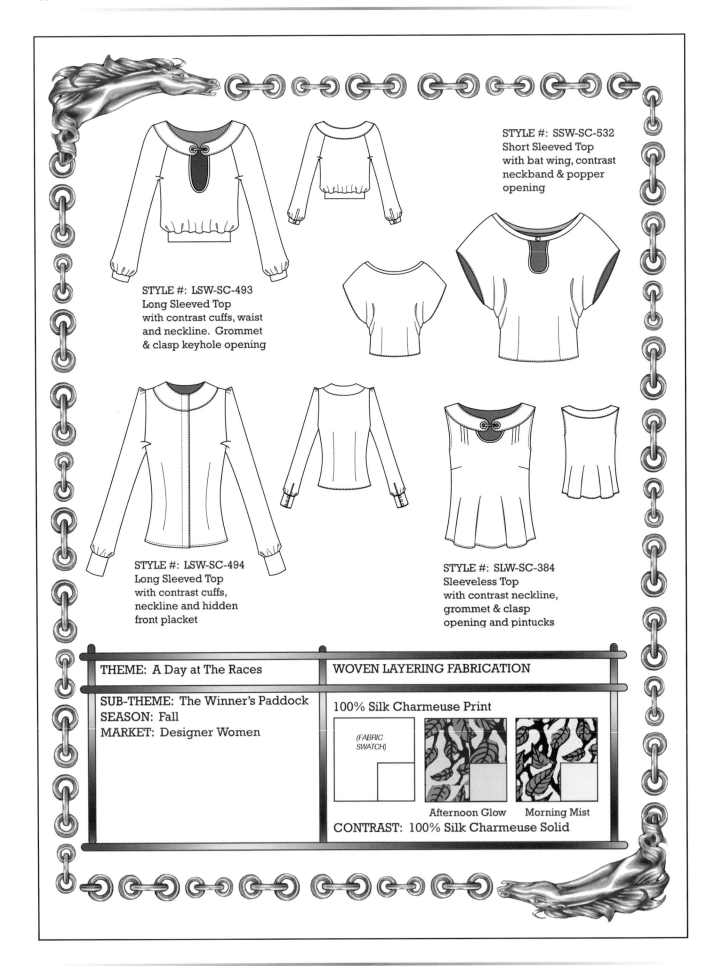

STYLE #: SSW-SC-532
Short Sleeved Top
with bat wing, contrast
neckband & popper
opening

STYLE #: LSW-SC-493
Long Sleeved Top
with contrast cuffs, waist
and neckline. Grommet
& clasp keyhole opening

STYLE #: LSW-SC-494
Long Sleeved Top
with contrast cuffs,
neckline and hidden
front placket

STYLE #: SLW-SC-384
Sleeveless Top
with contrast neckline,
grommet & clasp
opening and pintucks

THEME: A Day at The Races

WOVEN LAYERING FABRICATION

SUB-THEME: The Winner's Paddock
SEASON: Fall
MARKET: Designer Women

100% Silk Charmeuse Print

(FABRIC SWATCH)

Afternoon Glow Morning Mist

CONTRAST: 100% Silk Charmeuse Solid

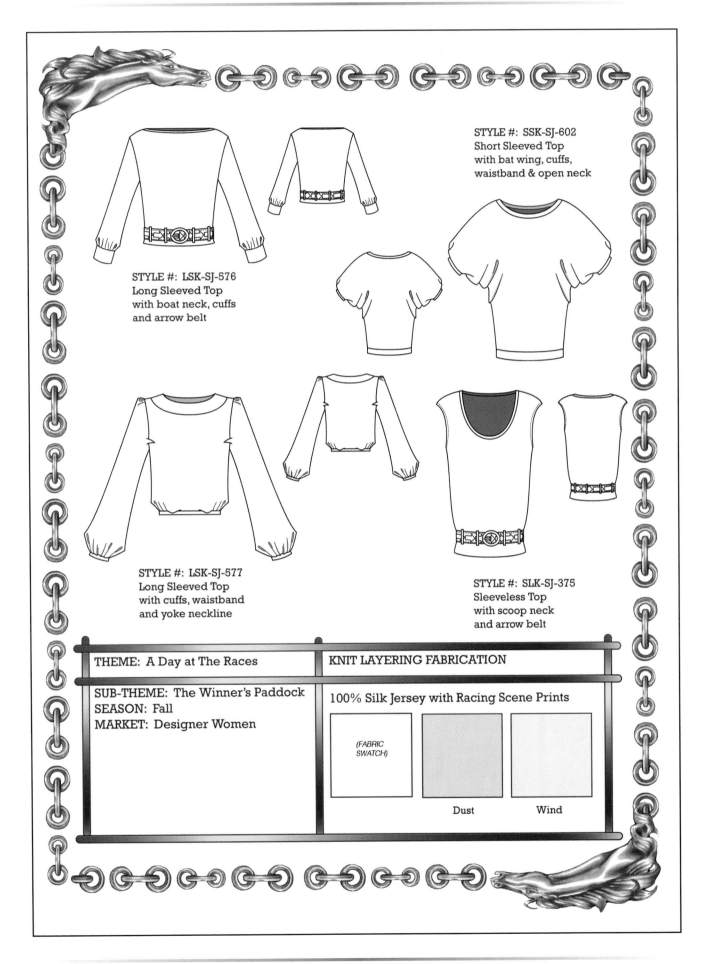

STYLE #: LSK-SJ-576
Long Sleeved Top
with boat neck, cuffs
and arrow belt

STYLE #: SSK-SJ-602
Short Sleeved Top
with bat wing, cuffs,
waistband & open neck

STYLE #: LSK-SJ-577
Long Sleeved Top
with cuffs, waistband
and yoke neckline

STYLE #: SLK-SJ-375
Sleeveless Top
with scoop neck
and arrow belt

THEME: A Day at The Races

SUB-THEME: The Winner's Paddock
SEASON: Fall
MARKET: Designer Women

KNIT LAYERING FABRICATION

100% Silk Jersey with Racing Scene Prints

(FABRIC SWATCH)

Dust

Wind

ILLUSTRATION BOARDS

PURPOSE: Your illustrations show the audience the strongest ensembles from your group; displaying them precisely as they were designed to be worn. The fashion figures should reflect the body types of your target customer (market). You can get really creative since this is another opportunity to reiterate the 'essence'/'mood.'

ELEMENTS: Along with your illustration(s), you must include the following:
THEME / SUB THEME / SEASON / TARGET CUSTOMER (MARKET) / STYLE NUMBERS ILLUSTRATED

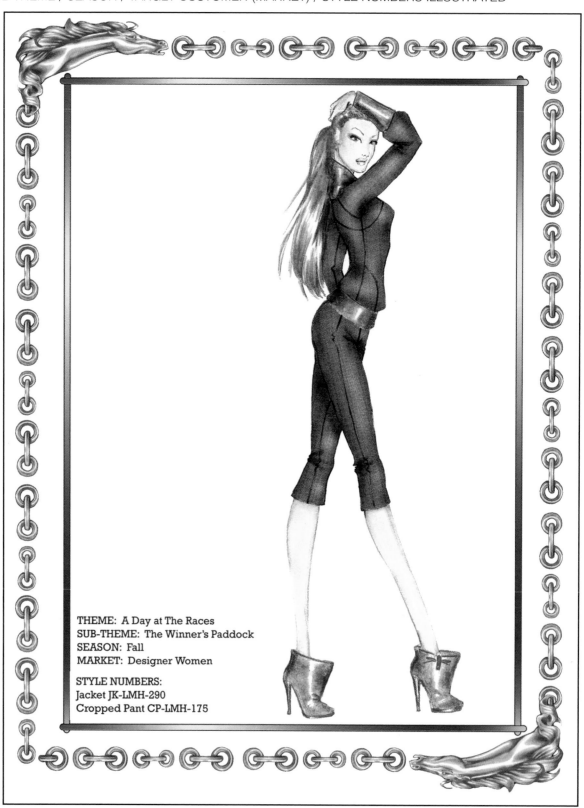

THEME: A Day at The Races
SUB-THEME: The Winner's Paddock
SEASON: Fall
MARKET: Designer Women

STYLE NUMBERS:
Jacket JK-LMH-290
Cropped Pant CP-LMH-175

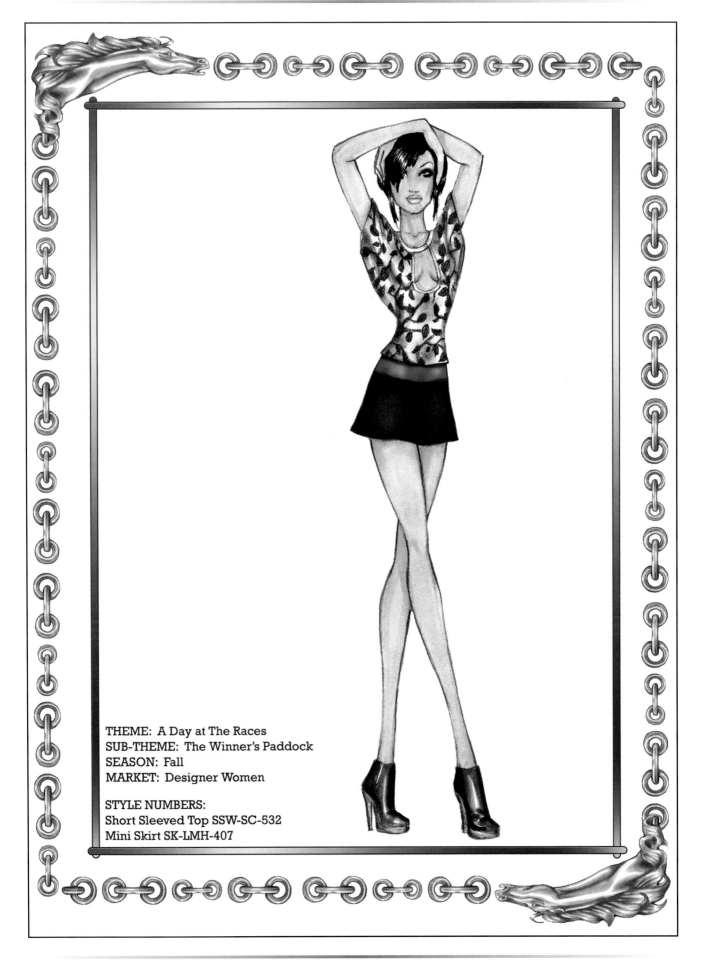

THEME: A Day at The Races
SUB-THEME: The Winner's Paddock
SEASON: Fall
MARKET: Designer Women

STYLE NUMBERS:
Short Sleeved Top SSW-SC-532
Mini Skirt SK-LMH-407

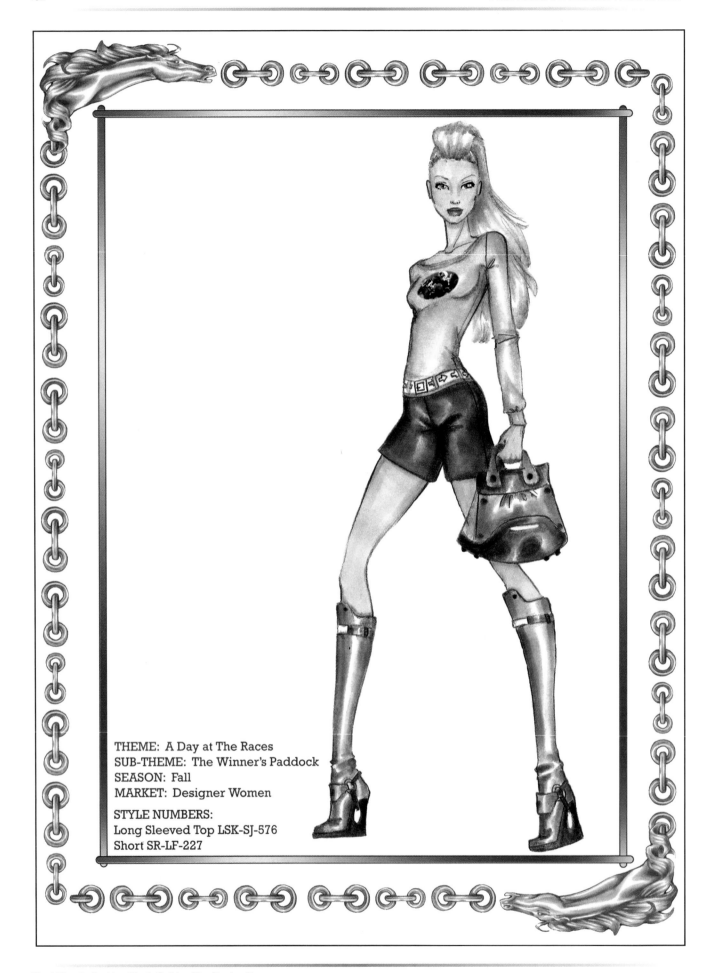

THEME: A Day at The Races
SUB-THEME: The Winner's Paddock
SEASON: Fall
MARKET: Designer Women

STYLE NUMBERS:
Long Sleeved Top LSK-SJ-576
Short SR-LF-227

SOURCING

Knowing how and where to find the materials and services for apparel manufacture is an integral and essential part of the process; superior sourcing skills and resources can provide a garment manufacturing company with a competitive edge.

Page #

SOURCING GUIDE

INTRODUCTION

Sourcing is the process of finding vendors to supply you with the materials and services you need to construct a clothing line. They include:

1. Woven Fabric
2. Knit Fabric
2. Trim
3. Notions (buttons, zippers, closures, thread etc.)
4. Construction Items (interfacing, shoulder pads, linings, etc.)
6. Contractors
7. Ancillary supplies (dot paper, sewing machine parts, etc.)

In the industry:

To build good working relationships with your vendors is one of the keys to your success. Good working relationships are built on trust, respect and understanding as well as a 'win-win' scenario. In other words, treat your vendors with respect, set out deadlines and a payment structure from the beginning to avoid any misunderstandings, and recognize that you need to buy a product or service at a price that works for you and your market. Your vendor also needs to be able to make a profit to be successful and offer continued service and supplies.

In school:

It's hard to have a 'good working relationship' when you aren't yet working in the industry, yet you still need access to information, samples and swatches. It can sometimes be challenging to get these items but remember that you are a potential customer. Behaving in a professional manner, and utilizing the contents of this section will also help you.

Included in this section are:

WHERE TO FIND MATERIALS

SAMPLE INFORMATION

OVERCOMING PITFALLS

WHERE TO FIND MATERIALS

There are many fabric, trim and notions resources available to you. Students have even more options since, in the majority of cases, the garments designed will not ever be produced and so information and swatches/samples are all that is required. Note, however, that in the industry, designers have to be sure that they can buy the volumes of yardage they need to fulfill orders later on down the line. In the meantime, here are some options:

INSTRUCTORS
Talk to them about resources on campus and locally. Perhaps there is a library with sample/swatching facilities available at your school or a fashion district close by with wholesale and retail stores.

LIBRARY
Seek out the reference desk, by phone or in person and explain what you are looking for. The staff at libraries are extremely knowledgeable and may be able to suggest organizations and companies who can help you.

ONLINE
Do a search to find pricing and pictures of the items you require. You may be able to purchase swatches and/or samples.

EXISTING GARMENTS
Thrift stores, student stores and even your own wardrobe can be a great source of fabric swatches, trim and notions. Most garments have labels to tell you fabric content, as well.

GARMENT MANUFACTURERS/SUPPLIERS
Talk to your careers department about arranging an Informational Interview with local apparel manufacturers and/or vendors and take the opportunity to ask for any spare fabric swatches or samples. Manufacturers are visited by wholesalers who often leave samples of fabrics, trims, etc. they can supply, in the form of sample headers (samples attached to a description card). Many of these headers include different colorways and sizes of the same items which may be useful. Alternatively, perhaps your school already receives old headers from local manufacturers/ suppliers; or would be willing to put a program in place to provide this.

FABRIC SWATCH KIT
If you don't already have one, we highly recommend that you invest in a good fabric swatch kit; be sure that the resource you get focuses on the use of fabrics from fashion designer's perspective.

SAMPLE INFORMATION

Make sure you collect the following information about any samples you receive; it will save you a great deal of time when putting together your design projects. In the industry it will save you from making some huge mistakes:

NAME & DESCRIPTION

Get the name and description of the sample given.

PRICE

You need to know the price per piece/yard to be able to calculate the cost of manufacturing your garment(s). Ask for the price at wholesale level. Wholesale is the price at which you would be buying fabric if you were a manufacturer buying materials to make garments to sell. The wholesale price does not include tax, since garment manufacturers are not the end user and tax, therefore, does not apply. If you can only get the retail price then, as a rough guide, divide the price by 2 to get an estimated wholesale price.

NOTE: As a student, there's an element of guesswork. As a manufacturer, you will know the exact price, (including delivery). Also note that prices vary between resources and according to quantity purchased. The more you buy, the cheaper the price per piece/yard.

FIBER CONTENT

Try to have an idea of what you are looking for ahead of time. Once you have found the item you want to use in your project, find out and note the fiber content.

FABRIC WIDTH

Different fabrics are produced to different widths. The wider the fabric, the more garments you can cut from it, per yard (higher yield). By knowing the fabric width, you can accurately cost your garment. While in school, if you are unable to find out the width, guess! Here are some guidelines to help improve your guesswork:

Narrowest fabrics (silk brocades, beaded, specialty) = 28"-36" wide
Average width of most fabrics = 44"-60" wide
Widest fabrics (bed sheeting, etc.) = 90" + wide

NOTE: Widths are INCLUSIVE of 1-2" selvedge (usually), 1/2-1" on each side of the fabric, which is most often unusable by garment manufacturers.

TRIM/NOTION/CLOSURE DIMENSIONS

Get the dimensions of the sample, such as length (for zippers etc.), size (for buttons etc.).

REFERENCE

A reference number is required for your fashion design projects, and it may seem a little ridiculous at this point since, without real contacts and real numbers, it's often a case of making one up. However, getting into the habit of always requesting this information from your vendors is invaluable in the industry. Reference numbers can identify the PRECISE product or service you ordered before, making sure that production and repeat orders are accurate and consistent.

OVERCOMING PITFALLS

The main problem that students encounter when getting samples of fabric, trim and notions is that, since they are a 'potential' customer, as opposed to a 'revenue-generating' customer, vendors may be less willing to accommodate their needs. Here are some tips to help you understand and overcome this dynamic:

PUT YOURSELF IN THEIR POSITION

Understand that vendors are in business because they make money selling fabric, trim and notions. If you are looking for free swatches/samples, rather than buying yardage or pieces, you are not going to be their highest priority. Be prepared to experience some resistance, even rudeness, and move on to other resources, if necessary.

COURTESY

Be really, really, really polite and friendly. Smile a lot, be patient and appeal to people's good nature. In most cases, this will be much appreciated and reciprocated.

BE EFFICIENT

Once you have the attention of a staff member, help them by knowing what you're looking for and asking for information in a concise manner. Get in, get your swatches/samples and get out. Vendors will often be unwilling to spend a lot of time with you if you are swatching/sampling.

BE AN OPPORTUNIST

If you are in the market to buy something, take the opportunity to ask for a few samples at the same time. Staff are much more willing if you are buying as well.

SIZE OF THE SWATCH/SAMPLE PROVIDED

Often you will not be able to dictate the size of the swatch/sample provided, so adjust your project presentation accordingly. If you are given a tiny sliver of fabric, as has happened to us, recognize the resistance, thank them and move on.

BE SMART

Swatching/sampling without permission is unwise and ill-received by vendors.

SOURCING DIRECTORY

INTRODUCTION

Now is the time to begin compiling your own sourcing directory. Use the Sourcing Directory Card Templates on the following pages to build contacts of vendors who you can work with, both now and in the future.

The format of the Sourcing Directory Card Templates allow you to capture the pertinent information about each resource onto a 5" x 3" index card and one template is provided for each of the following major sourcing categories

WOVEN FABRIC
KNIT FABRIC
TRIM
NOTION
CONSTRUCTION ITEMS
CONTRACTOR
ANCILLARY

We suggest you add to your sourcing directory as often as you can. Don't just add names to your directory willy nilly – qualify the entry first – find out information about the company and their methods of doing business and work, where possible, with recommendations from others you respect in the industry. Keep in mind the different markets towards which the fashion industry is geared, and ensure that your vendor has what you need at a price that you can afford or are willing to pay, in view of your pricing structure.

INSTRUCTIONS

1. Copy each of the template files (front and back) onto the lightweight card stock of your choice.
2. Cut apart to generate 5" x 3" index cards (there are 3 cards per page).
3. Fill out an appropriate card for each vendor, depending on source category.
4. Store in a file index box (available at any office supply store, at low cost).

IMPORTANT COPYRIGHT NOTICE ABOUT SCANNING & COPYING TEMPLATES
The purchaser of this Guide is granted permission to scan and/or copy the Sourcing Directory Card Templates included herein for their own work only. The purchaser may not share these files or copies thereof.
All rights are reserved.

CD-ROM
An accompanying CD-ROM is available which includes the following printable .pdf files for each of the major sourcing categories featured in this section:

Front & back black & white templates at 8.5" x 11"
Front & back color-coded templates at 8.5" x 11"

If you purchased the version of this Guide that did not include this CD-ROM, you may purchase one at www.hpcwww.com

Source Type:
WOVEN
FABRIC

Name: ..

Main Tel: ..

Address:
..

Fax: .. www: ..

Contact/Position	Phone(s)	Email
..
..
..
..

Source Type:
WOVEN
FABRIC

Name: ..

Main Tel: ..

Address:
..

Fax: .. www: ..

Contact/Position	Phone(s)	Email
..
..
..
..

Source Type:
WOVEN
FABRIC

Name: ..

Main Tel: ..

Address:
..

Fax: .. www: ..

Contact/Position	Phone(s)	Email
..
..
..
..

Notes:

Source Type:
WOVEN FABRIC

..
..
..
..
..
..
..
..
..
..

Notes:

Source Type:
WOVEN FABRIC

..
..
..
..
..
..
..
..
..
..

Notes:

Source Type:
WOVEN FABRIC

..
..
..
..
..
..
..
..
..
..

Source Type:

**KNIT
FABRIC**

Name: ...

Main Tel: ..

Address:
..

Fax: ... www:

Contact/Position	Phone(s)	Email
..........................
..........................
..........................
..........................

Source Type:

**KNIT
FABRIC**

Name: ...

Main Tel: ..

Address:
..

Fax: ... www:

Contact/Position	Phone(s)	Email
..........................
..........................
..........................
..........................

Source Type:

**KNIT
FABRIC**

Name: ...

Main Tel: ..

Address:
..

Fax: ... www:

Contact/Position	Phone(s)	Email
..........................
..........................
..........................
..........................

Notes:

Source Type:
KNIT FABRIC

Notes:

Source Type:
KNIT FABRIC

Notes:

Source Type:
KNIT FABRIC

Source Type:
TRIM

Name: ...

Main Tel: ...

Address:
...

Fax: ... www: ..

Contact/Position Phone(s) Email

...

...

...

...

Source Type:
TRIM

Name: ...

Main Tel: ...

Address:
...

Fax: ... www: ..

Contact/Position Phone(s) Email

...

...

...

...

Source Type:
TRIM

Name: ...

Main Tel: ...

Address:
...

Fax: ... www: ..

Contact/Position Phone(s) Email

...

...

...

...

Notes: Source Type:
 TRIM

Notes: Source Type:
 TRIM

Notes: Source Type:
 TRIM

Source Type:
NOTION

Name: ..

Main Tel: ..

Address:
..

Fax: ... www: ..

Contact/Position Phone(s) Email

..

..

..

..

Source Type:
NOTION

Name: ..

Main Tel: ..

Address:
..

Fax: ... www: ..

Contact/Position Phone(s) Email

..

..

..

..

Source Type:
NOTION

Name: ..

Main Tel: ..

Address:
..

Fax: ... www: ..

Contact/Position Phone(s) Email

..

..

..

..

Notes: Source Type:
 NOTION

Notes: Source Type:
 NOTION

Notes: Source Type:
 NOTION

Source Type:

CONSTRUCTION ITEMS

Name: ...

Main Tel: ...

Address:
...

Fax: .. www:

Contact/Position	Phone(s)	Email
.................................
.................................
.................................
.................................

Source Type:

CONSTRUCTION ITEMS

Name: ...

Main Tel: ...

Address:
...

Fax: .. www:

Contact/Position	Phone(s)	Email
.................................
.................................
.................................
.................................

Source Type:

CONSTRUCTION ITEMS

Name: ...

Main Tel: ...

Address:
...

Fax: .. www:

Contact/Position	Phone(s)	Email
.................................
.................................
.................................
.................................

Notes: Source Type:

CONSTRUCTION ITEMS

Notes: Source Type:

CONSTRUCTION ITEMS

Notes: Source Type:

CONSTRUCTION ITEMS

Source Type:
CONTRACTOR

Name: ...

Main Tel: ..

Address:
...

Fax: .. www:

Contact/Position	Phone(s)	Email
....................................
....................................
....................................
....................................

Source Type:
CONTRACTOR

Name: ...

Main Tel: ..

Address:
...

Fax: .. www:

Contact/Position	Phone(s)	Email
....................................
....................................
....................................
....................................

Source Type:
CONTRACTOR

Name: ...

Main Tel: ..

Address:
...

Fax: .. www:

Contact/Position	Phone(s)	Email
....................................
....................................
....................................
....................................

Notes:

Source Type:
CONTRACTOR

Notes:

Source Type:
CONTRACTOR

Notes:

Source Type:
CONTRACTOR

Source Type:
ANCILLARY

Name: ..

Main Tel: ..

Address:
..

Fax: ... www:

Contact/Position Phone(s) Email

..................................

..................................

..................................

..................................

Source Type:
ANCILLARY

Name: ..

Main Tel: ..

Address:
..

Fax: ... www:

Contact/Position Phone(s) Email

..................................

..................................

..................................

..................................

Source Type:
ANCILLARY

Name: ..

Main Tel: ..

Address:
..

Fax: ... www:

Contact/Position Phone(s) Email

..................................

..................................

..................................

..................................

Notes:

Source Type:

ANCILLARY

Notes:

Source Type:

ANCILLARY

Notes:

Source Type:

ANCILLARY

TECHNICAL FLAT TEMPLATES

INTRODUCTION

Technical flat templates are essential tools that fashion designers use to draw professional, technical flat sketches of their designs. They reflect average body types; one for each of the major target customer groups. By using an appropriate technical flat template, fashion designers can ensure that their flats accurately reflect the body type of their particular target customer. Using a template also keeps the flats in proportion with each other, making them directly comparable and easy to recognize and understand.

Technical flat templates (front & back) for the following major target customer groups are featured in this section:

CHILDRENSWEAR

- Layette/Newborn
- Infant
- Toddler
- Little Girl
- Little Boy
- Big Girl/Kid
- Big Boy/Kid

WOMENSWEAR

- Tween
- Junior
- Junior Plus
- Contemporary
- Missy/Misses
- Plus Size
- Petite
- Maternity

MENSWEAR

- Contemporary
- Big & Tall

HOW TO USE A TECHNICAL FLAT TEMPLATE

Manual

1. Position the template underneath a blank piece of paper.
2. Use paper that is light weight enough to allow the lines of the template to show through, or use heavier weight paper and a lightbox.
3. Draw your flats, using the outline as a guide.

TIP: To produce very detailed flats, use an enlarged template to draw in your flats as described above, then reduce the resulting flats down to an appropriate size, for presentation.

Digital

1. Use a digital file of the template.
2. Open the document in the drawing program of your choice (we like Adobe Illustrator).
3. Either lock the layer, or save it as a template.
4. Open a new layer on which to create your flat.
5. Use the 'save as' command to rename the file, using the technical flat name.
6. Print out, enlarged if necessary, for presentation.

Combination

1. Draw your flats using the manual instructions above.
2. Draw one half of the flat, for symmetrical designs.
3. Scan in your flats at 72-150 dpi (dots per inch/resolution) as an 'illustration' and finalize them using the program of your choice (we like Adobe Photoshop).
4. Print out, enlarged if necessary, for presentation.

CD-ROM
An accompanying CD-ROM is available which includes the following printable .pdf files for each of the major target customer groups featured in this section:

Front templates at 8.5" x 11"
Back templates at 8.5" x 11"
Over-sized Upper Front Templates at 8.5" x 11"
Over-sized Lower Front Templates at 8.5" x 11"
Over-sized Upper Back Templates at 8.5" x 11"
Over-sized Lower Back Templates at 8.5" x 11"

If you purchased the version of this Guide that did not include this CD-ROM, you may purchase one at www.hpcwww.com

LAYETTE/NEWBORN FLAT TEMPLATE
FRONT

INFANT FLAT TEMPLATE
FRONT

TODDLER FLAT TEMPLATE
FRONT

LITTLE GIRL FLAT TEMPLATE
FRONT

LITTLE BOY FLAT TEMPLATE
FRONT

BIG GIRL/KID FLAT TEMPLATE
FRONT

BIG BOY/KID FLAT TEMPLATE
FRONT

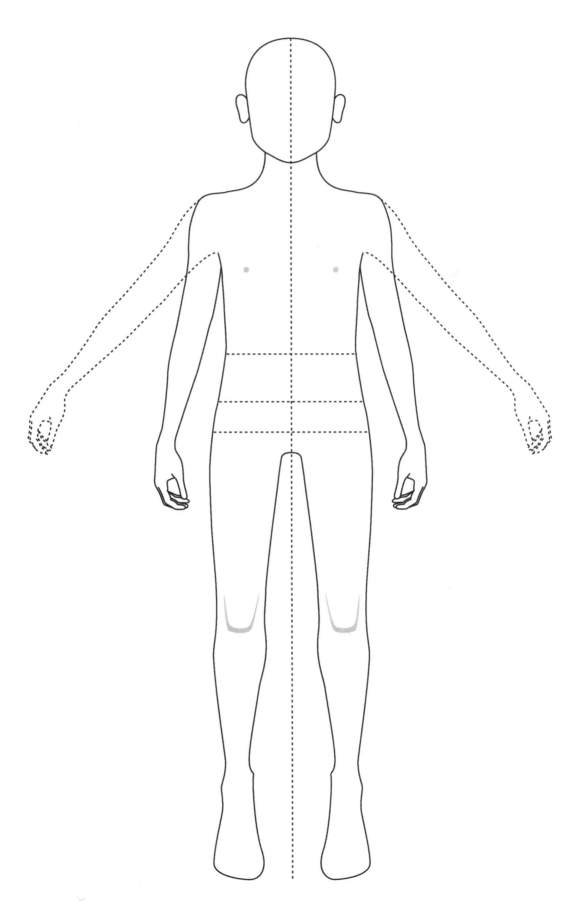

The Ultimate Fashion Study Guide - The Design Process

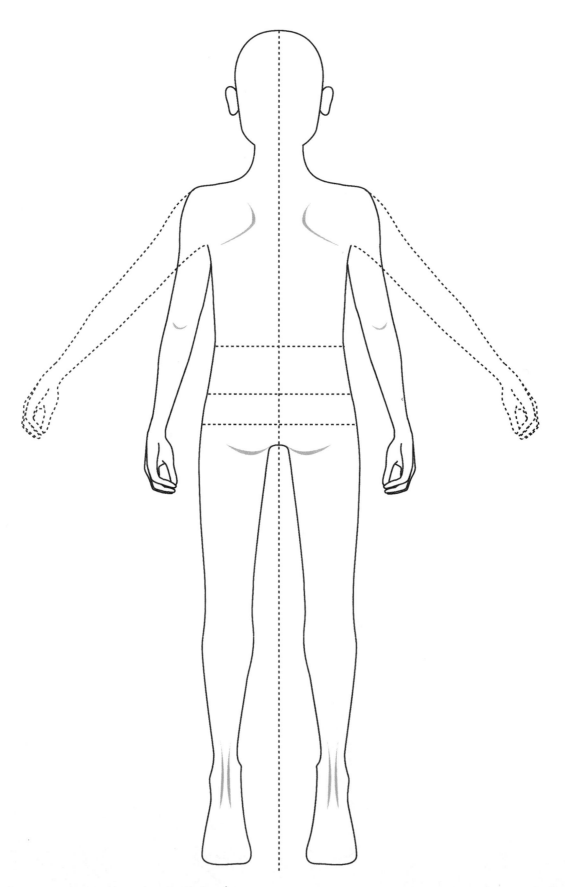

TWEEN FLAT TEMPLATE
FRONT

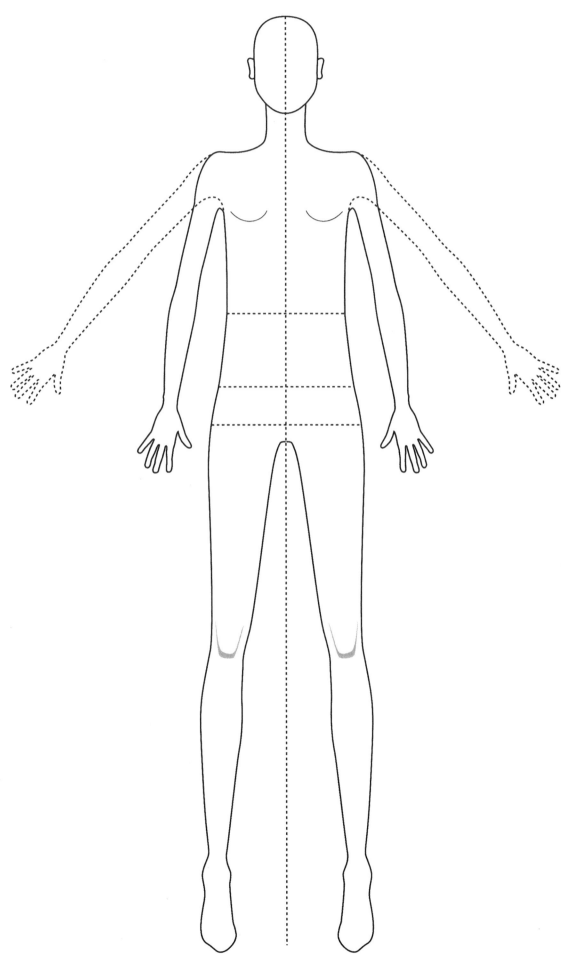

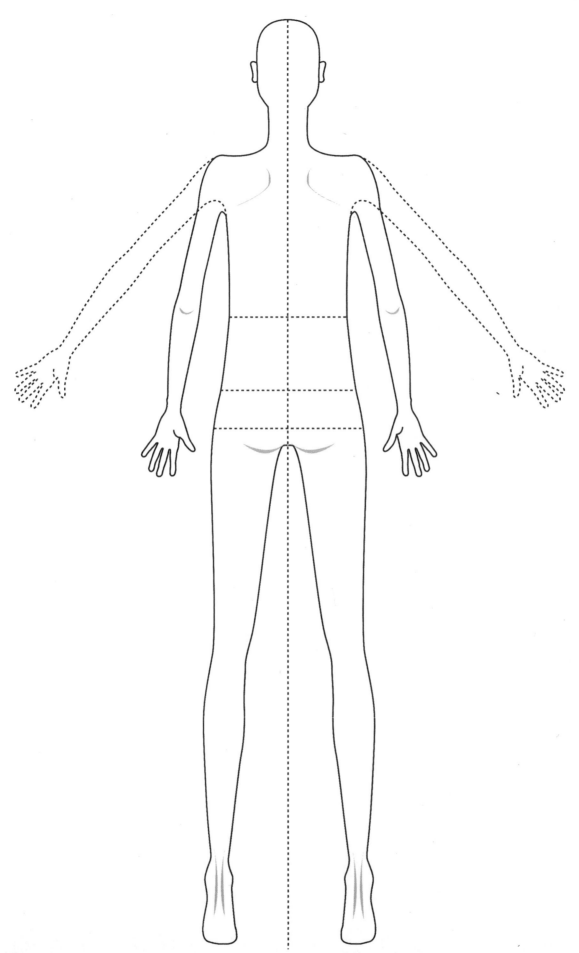

JUNIOR FLAT TEMPLATE
FRONT

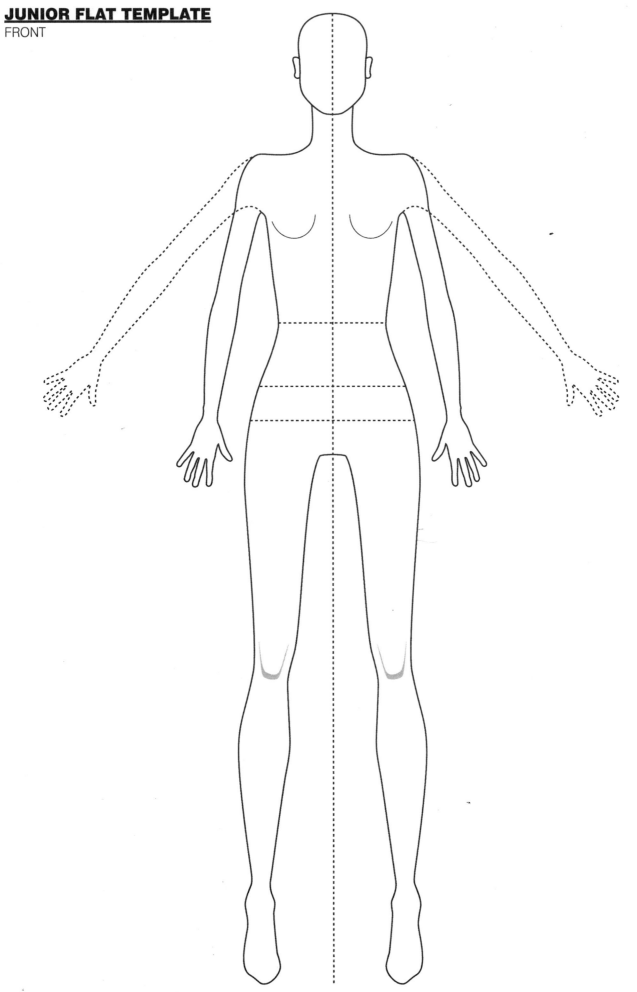

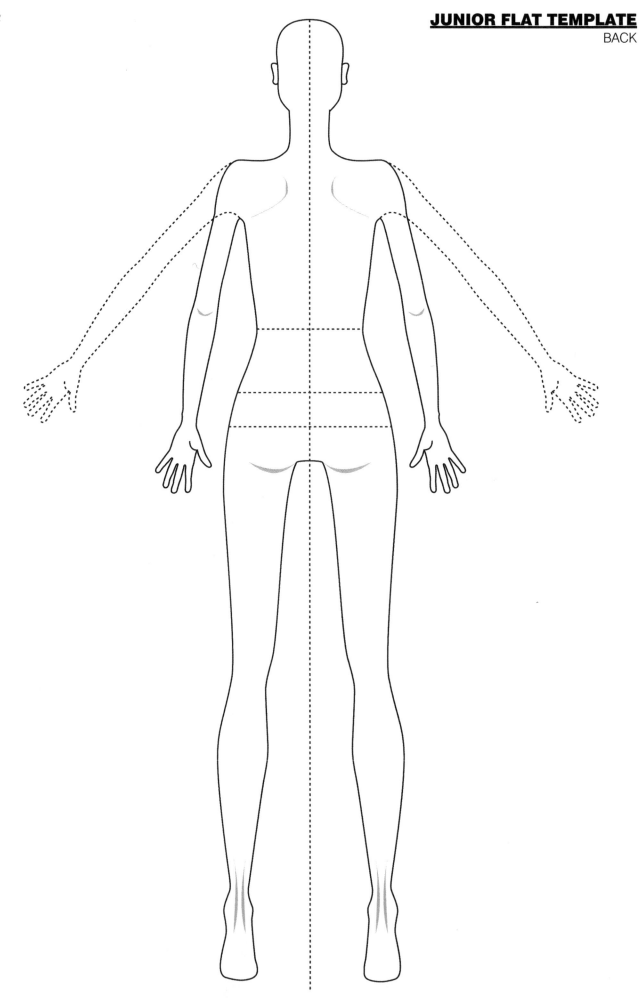

JUNIOR PLUS FLAT TEMPLATE
FRONT

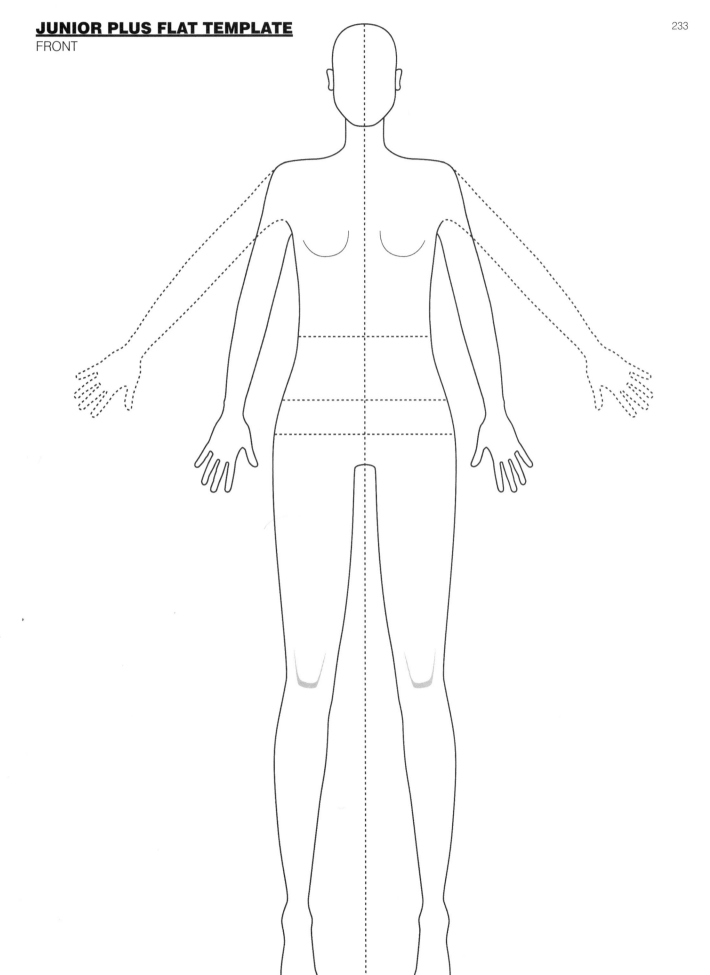

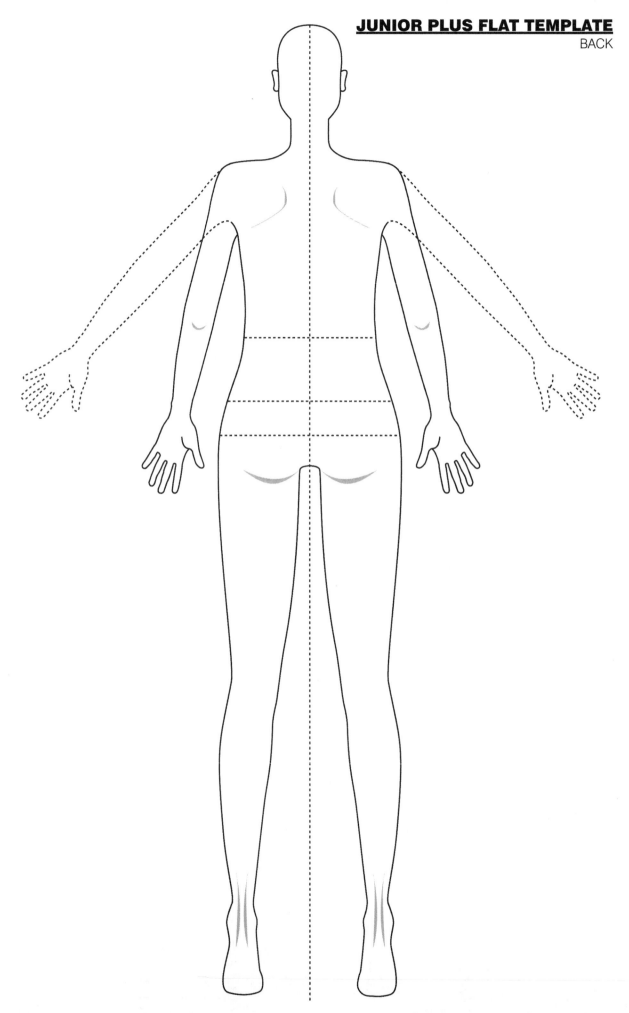

CONTEMPORARY WOMAN
FLAT TEMPLATE
FRONT

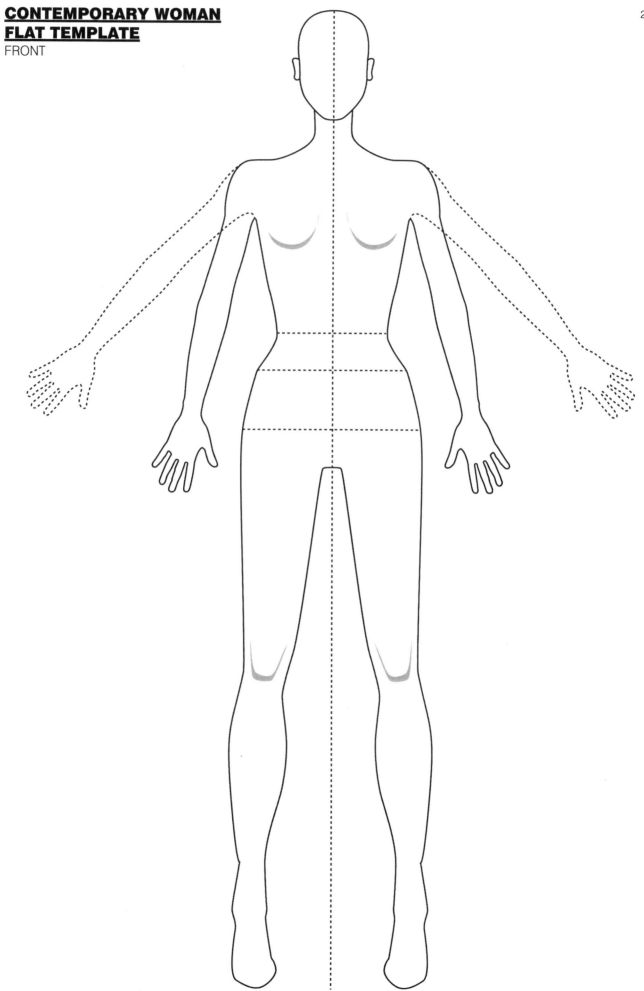

CONTEMPORARY MAN
FLAT TEMPLATE
FRONT

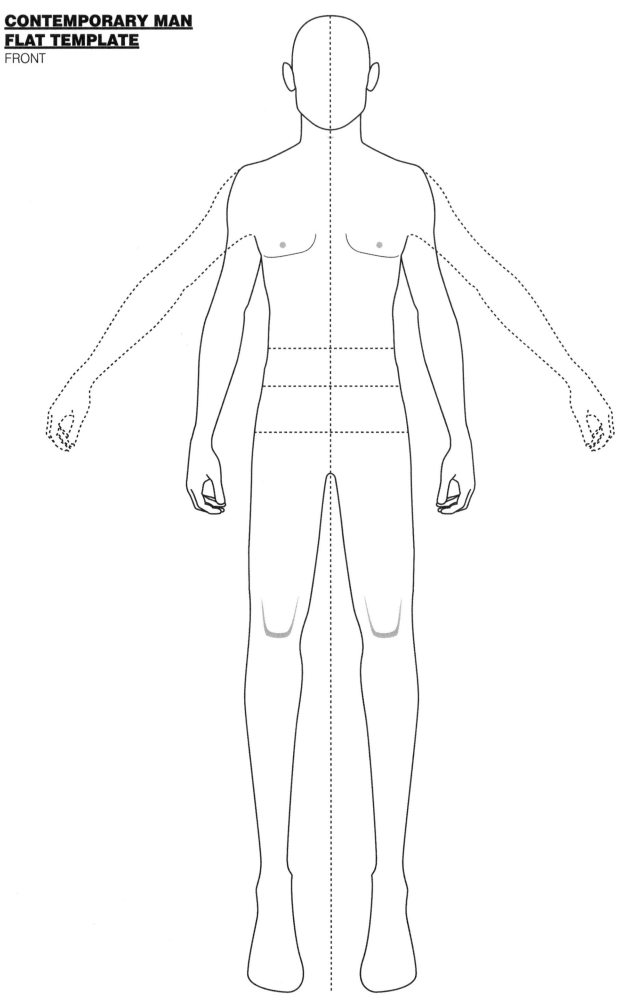

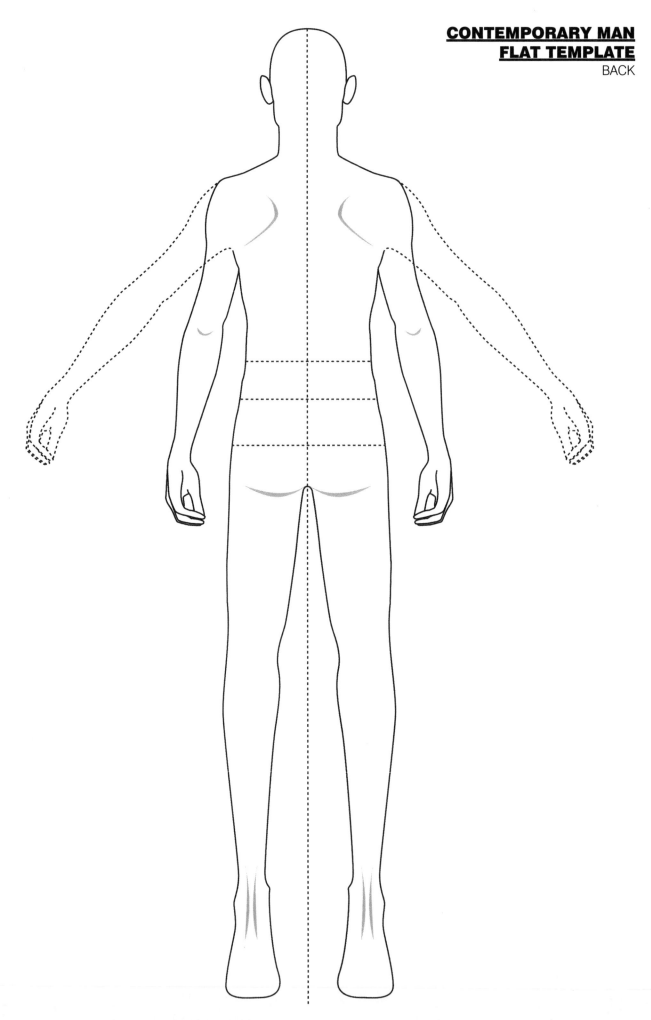

MISSY/MISSES FLAT TEMPLATE
FRONT

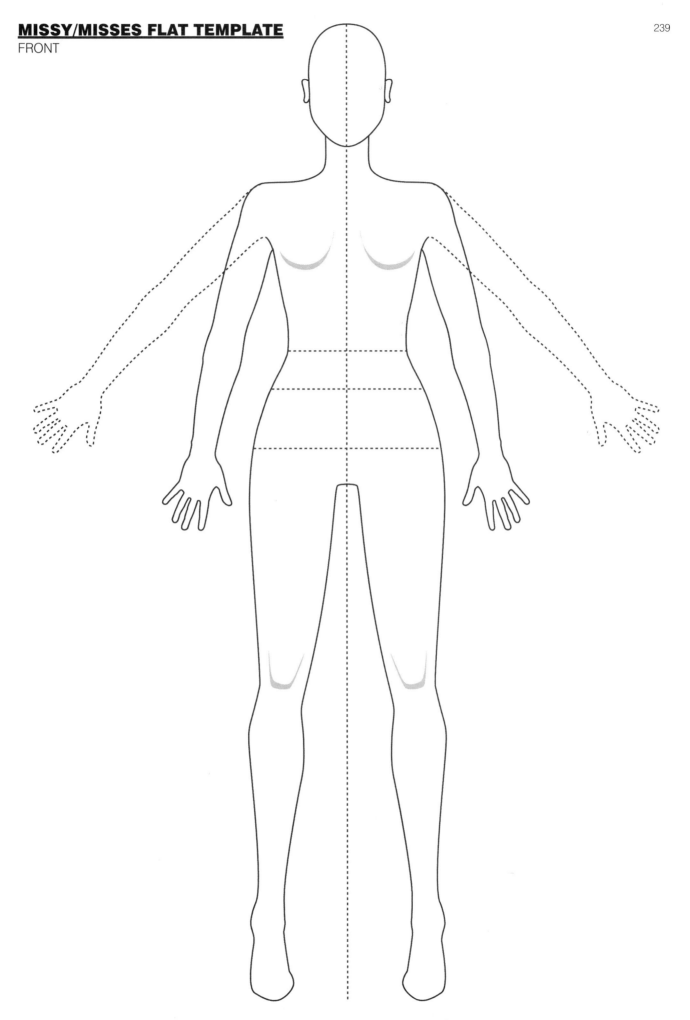

PETITE FLAT TEMPLATE
FRONT

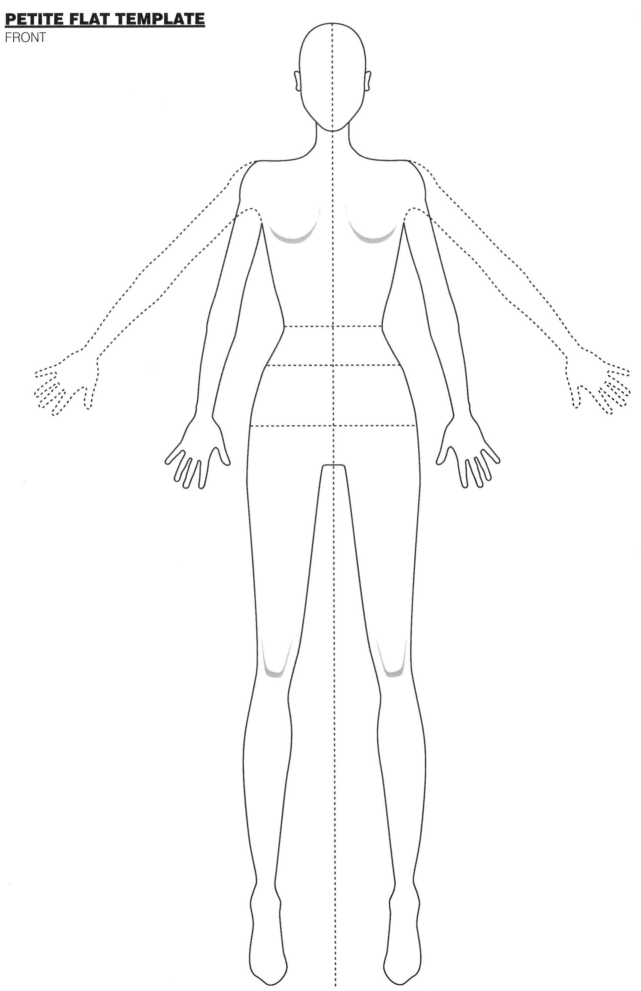

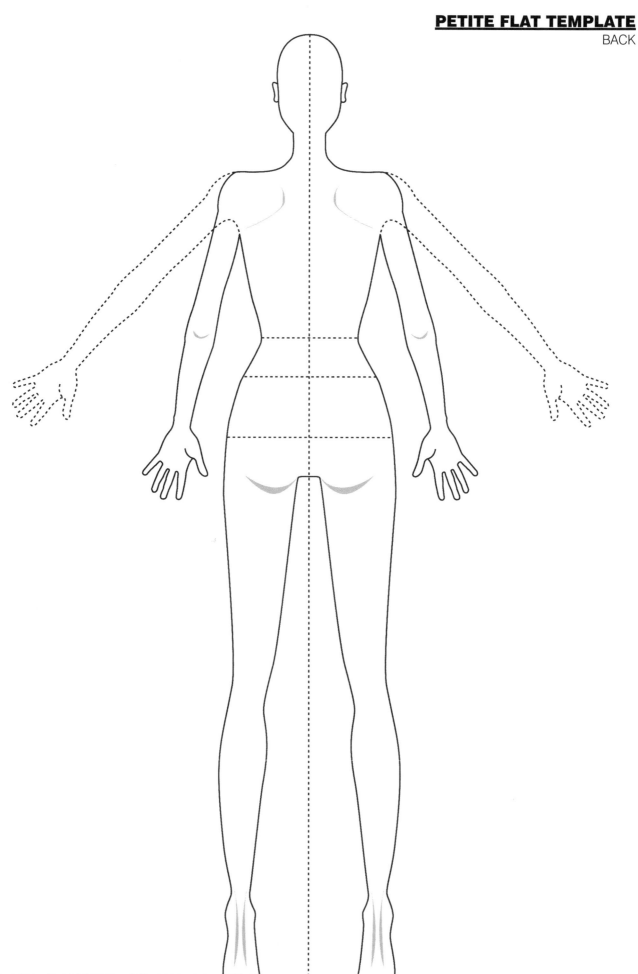

PLUS FLAT TEMPLATE
FRONT

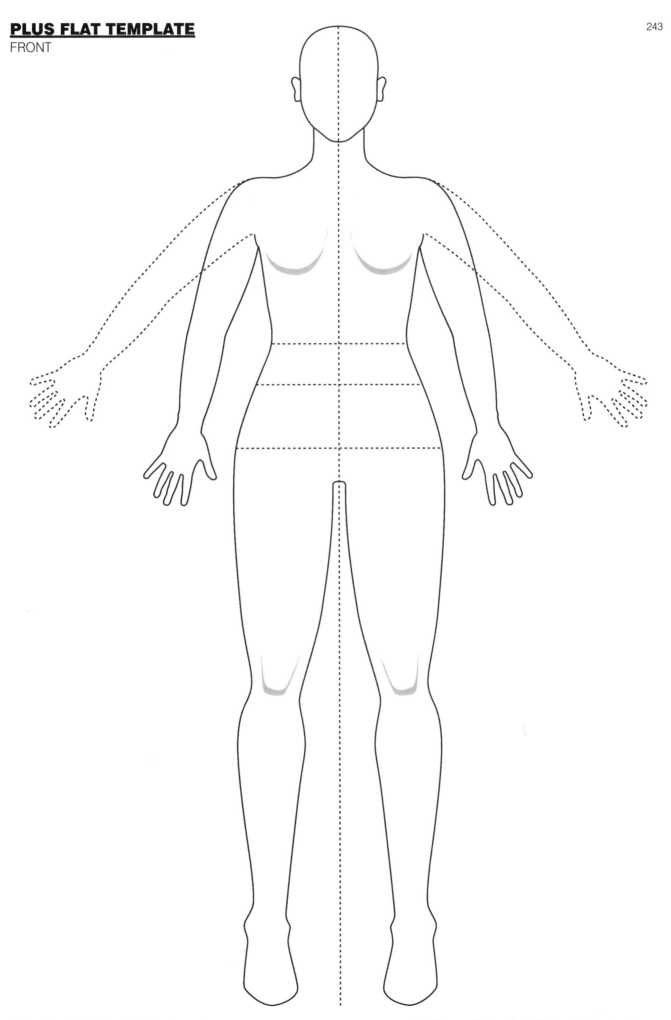

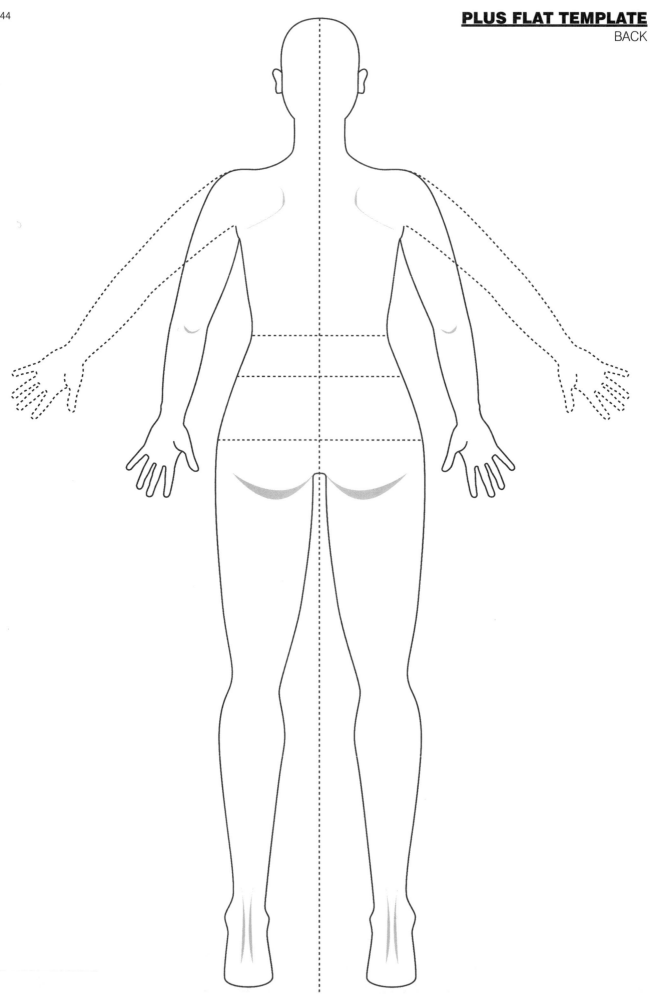

MATERNITY FLAT TEMPLATE
FRONT

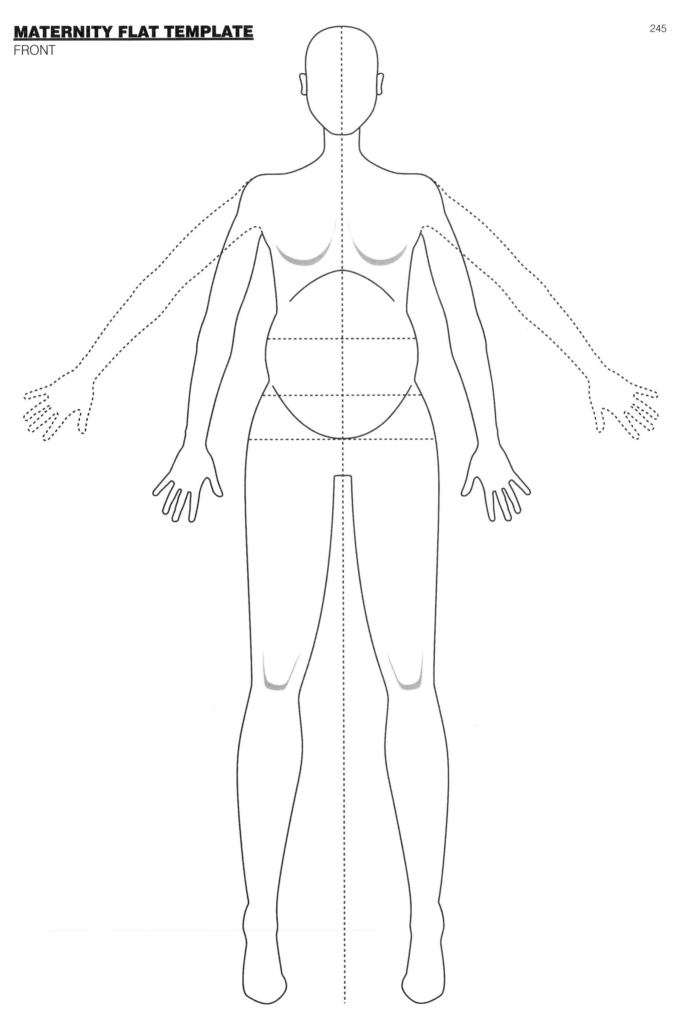

BIG & TALL FLAT TEMPLATE
FRONT

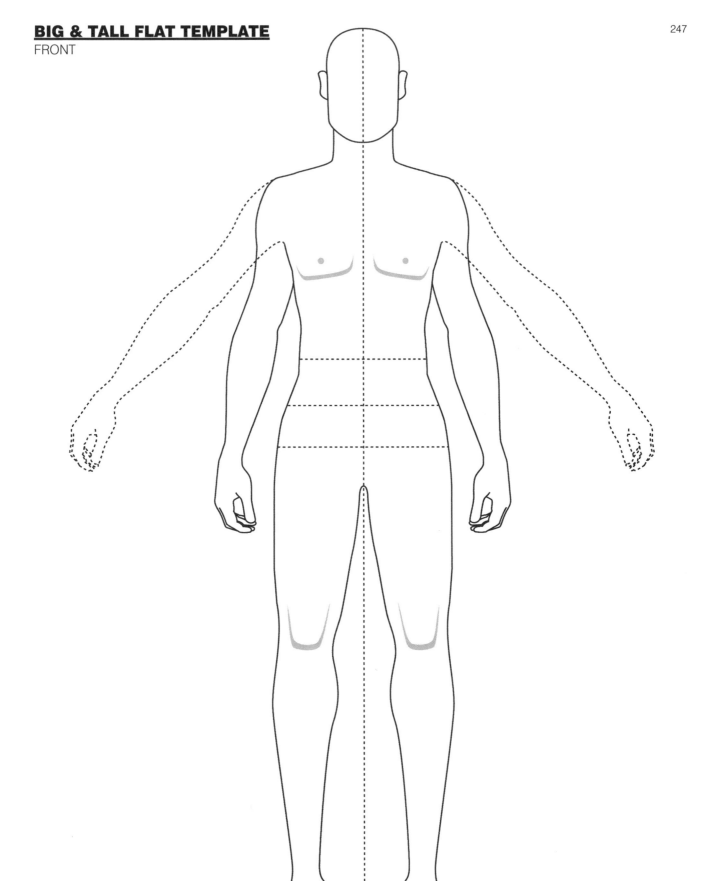

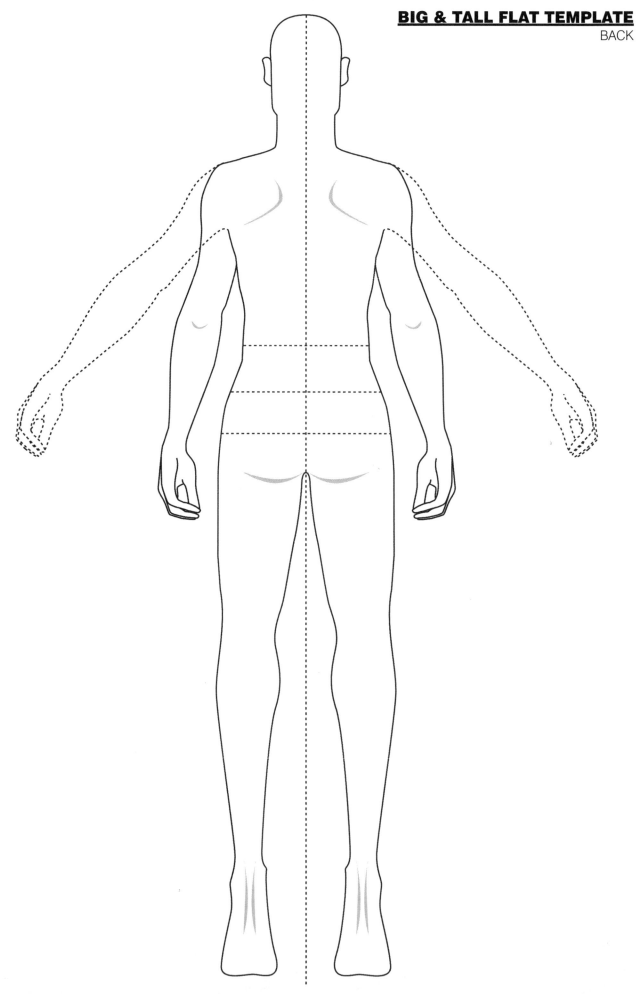

FASHION CROQUIS TEMPLATES

INTRODUCTION

Fashion croquis templates are essential tools that fashion designers use to draw professional illustrations of their designs. They reflect each of the major target market/customer groups. Where appropriate, the proportions are extended to represent a taller, more glamorous figure.

The following pages contain a basic fashion croquis template for the major target market/customer groups listed below. The poses are relatively simple, without too much movement, to provide you with a platform from which to develop your illustration skills.

CHILDRENSWEAR

- Layette/Newborn
- Infant
- Toddler Girl
- Toddler Boy
- Little Girl
- Little Boy
- Big Girl/Kid
- Big Boy/Kid

WOMENSWEAR

- Tween
- Junior
- Junior Plus
- Contemporary
- Missy/Misses
- Petite
- Plus Size
- Maternity

MENSWEAR

- Contemporary
- Big & Tall

HOW TO USE A FASHION CROQUIS

Manual

1. Position the template underneath a blank piece of paper.
2. Use paper that is light weight enough to allow the lines of the template to show through, or use heavier weight paper and a lightbox.
3. Draw in your design, using the outline as a guide, tracing the parts of the croquis that are not covered by the garment(s).
4. Enlarge your final illustration on a color copier, if necessary, for presentation.

Digital

1. Use a digital file of the template.
2. Open the document in the program of your choice (we like Adobe Illustrator and Adobe Photoshop).
3. Either lock the layer, or save it as a template.
4. Open a new layer on which to create your illustration.
5. Use the 'save as' command to rename the file, using the illustration name.
6. Print out, enlarged if necessary, for presentation.

Combination

1. Draw your illustration using the manual instructions above.
2. Decide whether you are going to draw in the croquis manually, or use the digital file of the croquis.
3. Scan in your illustration at 72-150 dpi (dots per inch/resolution) as an 'illustration' and finalize it using the program of your choice (we like Adobe Photoshop).
4. Print out, enlarged if necessary, for presentation.

CHOICE OF MEDIA

Work with the media you feel most skilled at using. Here are some considerations:

<u>Colored Pencil:</u> Good for creating the effect of texture and allows for building up color in shadowed areas while leaving white in highlighted areas. Errors are difficult, but not impossible to correct.

<u>Marker Pens:</u> Good for creating solid coverage of color and allows build up of color in shadowed areas since you can work from both the front and the reverse side of the paper. Requires more planning and skill to achieve highlighted areas. Errors cannot be corrected, unless scanned and erased digitally.

<u>Water Color:</u> Good for creating very artistic and stunning results, providing that you have the high level of skill required. Errors cannot be corrected, unless scanned and erased digitally. Use paper that won't buckle or disintegrate when exposed to water.

<u>Paper:</u> Use paper that suits the method of color you opt for, yet still allows you to see through to the outline of the fashion croquis (use a lightbox if required). Textured paper and paper with different opacities may be suitable, under certain circumstances, to enhance the overall effect of your illustration.

DEVELOPING MORE ADVANCED POSES

Here are some points to consider, whether you are working manually or digitally when you are ready to stretch yourself towards developing and improving your illustration skills:

1. Change the shape of the face, eyes, lips, nose, hair style and skin color to represent different ethnicities.
2. Add accessories, such as jewelry, sunglasses, shoes, bags, hats or a tattoo, to give your illustration some attitude.
3. Take small steps to add more movement. Develop your own croquis by making changes to those provided. Start with one limb, perhaps an arm. Trace the croquis, with the exception of the arm then draw it in freehand, in a different position. Once it looks right, ink it in and save it for future use.

CD-ROM
An accompanying CD-ROM is available which includes the following printable .pdf files for each of the major target customer groups featured in this section:

Fashion Croquis templates at 8.5" x 11"
Fashion Croquis templates at 8.5" x 14"

If you purchased the version of this Guide that did not include this CD-ROM, you may purchase one at www.hpcwww.com

LAYETTE/NEWBORN

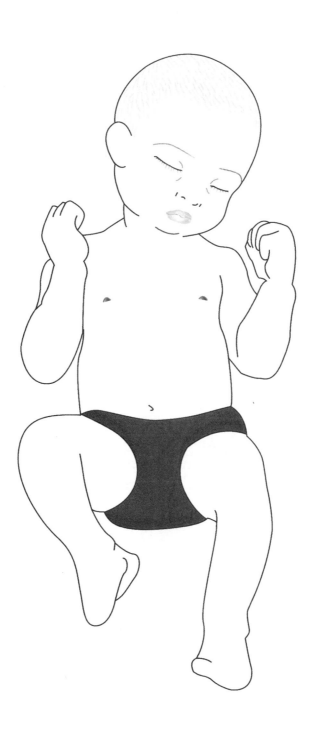

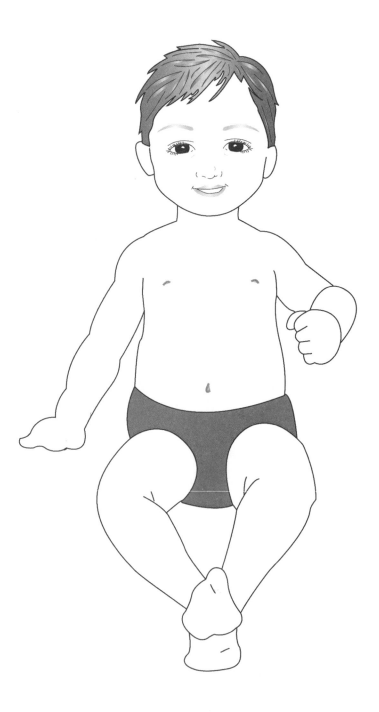

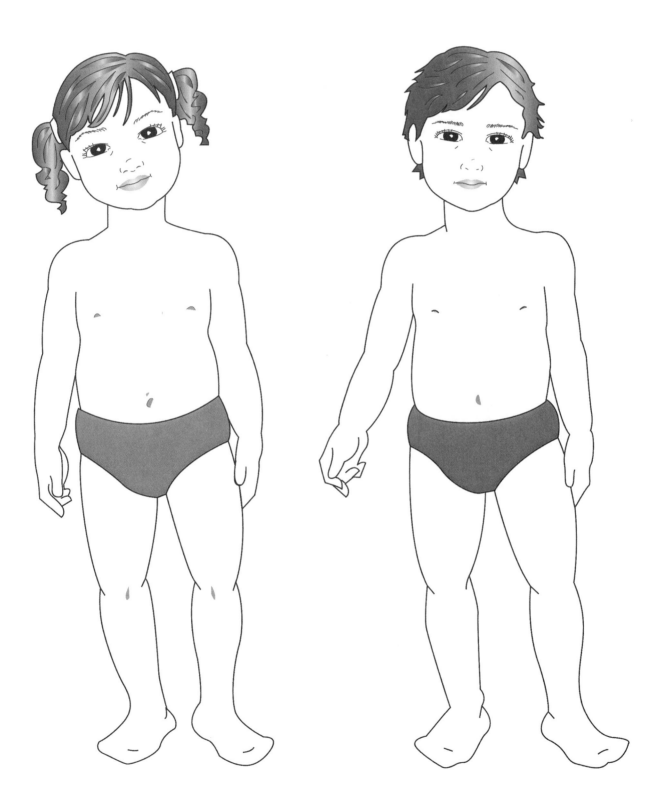

The Ultimate Fashion Study Guide - The Design Process

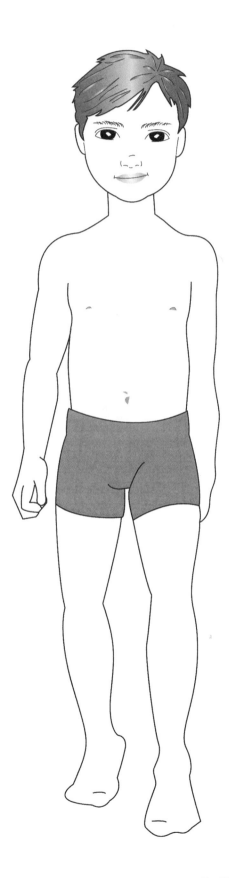

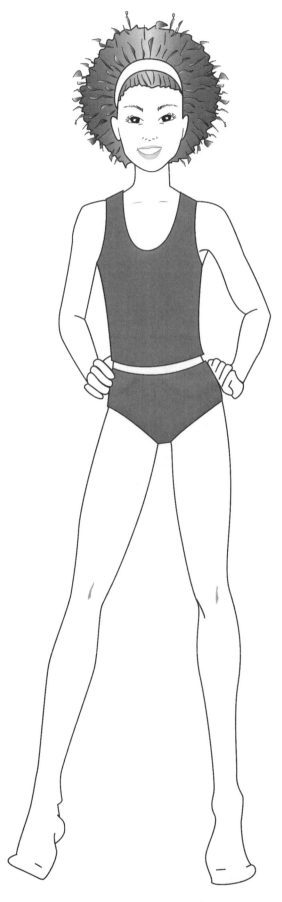

FASHION CROQUIS
BIG BOY/KID

FASHION CROQUIS
JUNIOR

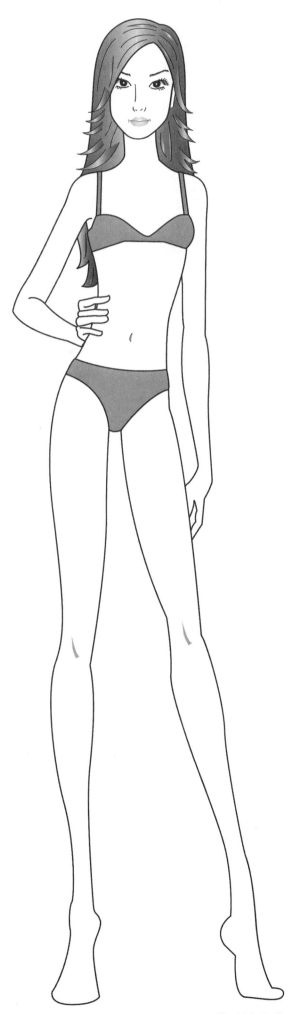

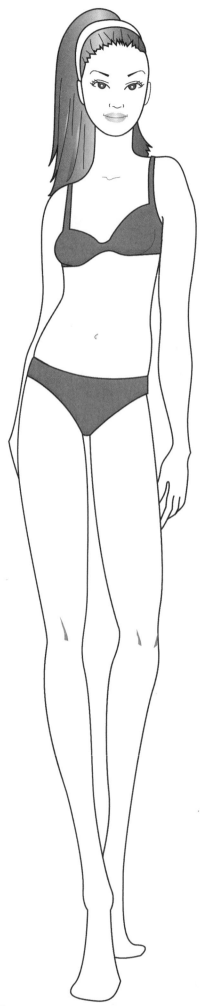

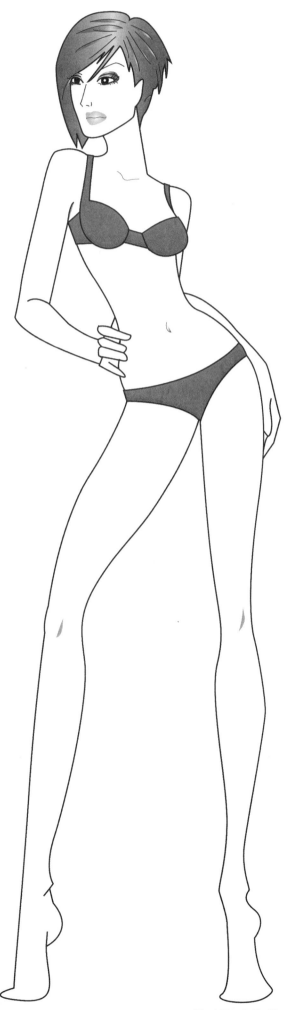

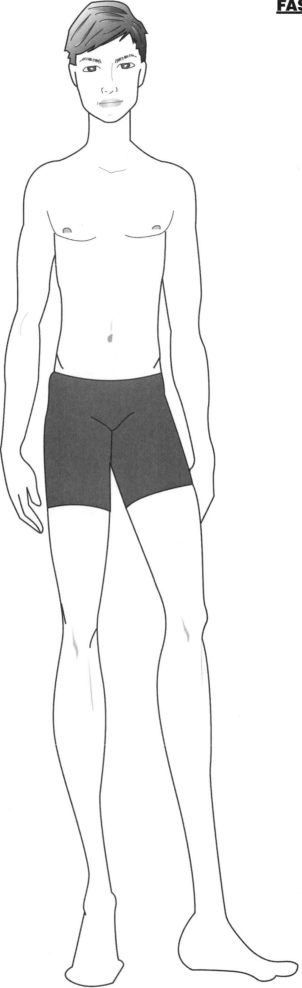

FASHION CROQUIS
MISSY/MISSES

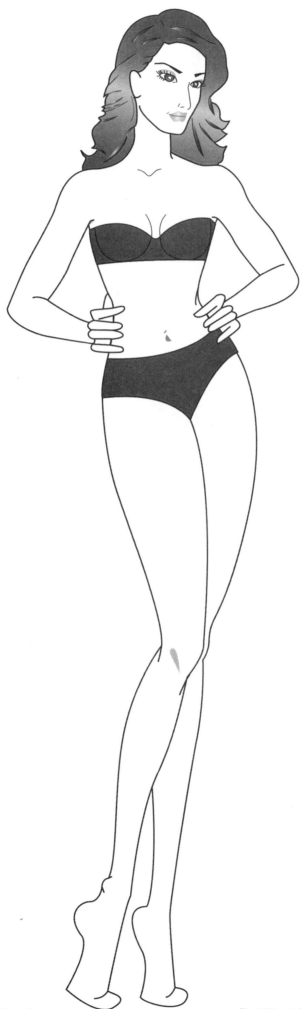

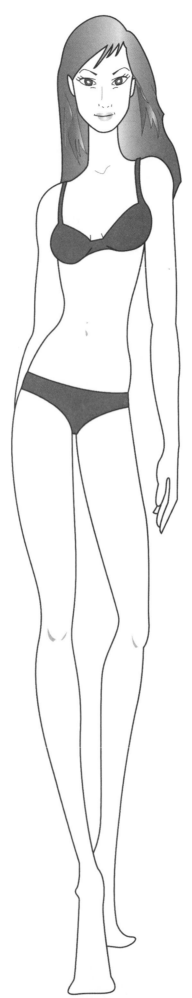

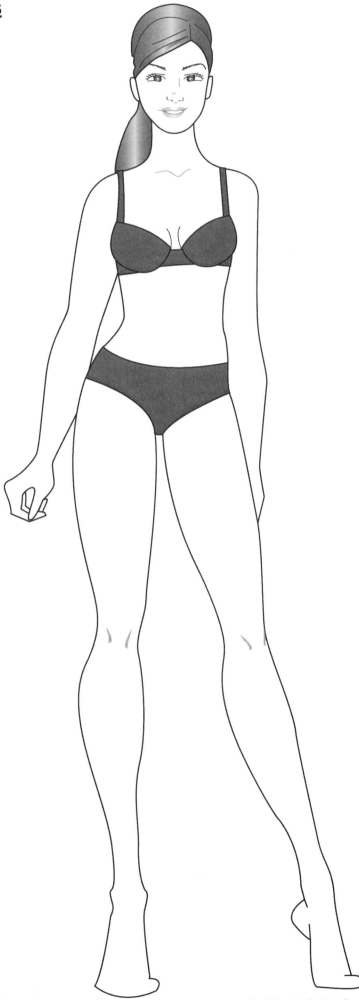

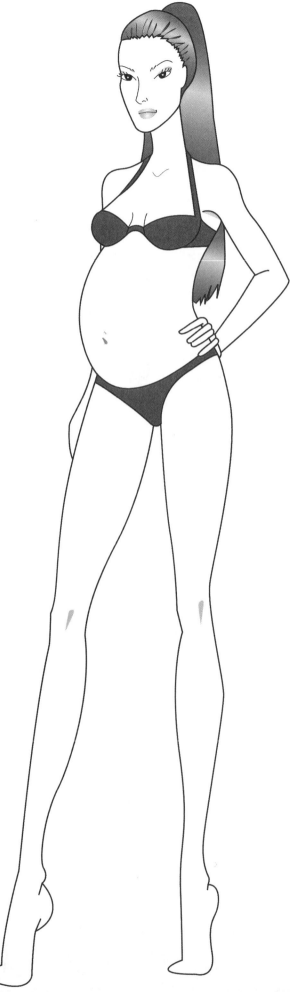

FASHION CROQUIS
BIG & TALL

The Ultimate Fashion Study Guide - The Design Process

CLASS NOTES

Maximize your chances of success by keeping clear, concise notes from your lectures and tutorials as well as recording accurate information about what homework projects are assigned, what they entail and when they are due.

Furthermore, set yourself up with good habits in preparation for your successful fashion career.

CLASS NOTES

INTRODUCTION

This section is primarily incorporated to help you to succeed in your studies, but also to develop skills that will assist you in your fashion career. It consists of a simple Class Notes Form Template, however, the thought process behind it is an extremely relevant and important one, where your success is concerned.

Whether you are attending a study lecture, or a business meeting, it is vital to do the following:

1. Record information regarding the subjects discussed.
2. Record any decisions/observations that were made.
3. Record what action points are required; by whom; by what date/timeframe.

TIME IS MONEY & MONEY IS THE BOTTOM LINE

In a study situation, the student pays for the tuition provided within their program. Each lecture comes at a price. Therefore, it's not only attending the lecture, but gaining knowledge from the content and getting details of the assignments that must be completed in order to pass the class that make the students' efforts worthwhile. Failing the class equates to paying again – this equation does not 'fly' in the world of commerce.

In the commercial world, the time that each attendant spends at a meeting directly equates to a portion of their salary. In some instances, travel costs are incurred and become an addition to the overall expenditure. Understand that, when your salary and expenses are being paid for by someone else, how you spend your time, how productive you are, and the comparison between what you bring into the business versus what you cost the business, becomes a major factor in determining your professional 'viability' and success.

The Class Notes Form Template is the means to making the most of your lectures and developing good habits for the future.

INSTRUCTIONS

1. Copy the Class Notes Form Template (front and back) onto the paper of your choice (something that receives ink/pencil well).
2. Fill out a separate form for each study lecture you attend.
3. File it in a binder or folder and store it where you can see it and refer to it on a regular basis.
4. Devise your own system of using this data within a diary system – so you get your assignments done according to the guidelines specified and within the time allowed.

CD-ROM
An accompanying CD-ROM is available which includes the following printable .pdf file featured in this section:

Front & back black & white templates at 8.5" x 11"

If you purchased the version of this Guide that did not include this CD-ROM, you may purchase one at www.hpcwww.com

CLASS NOTES

Class Title: .. Date:

..

..

..

..

..

..

..

..

..

..

..

..

..

..

..

..

..

..

..

..

..

..

..

..

.. Continue overleaf ...

Continued: ..

...

...

...

...

...

...

...

...

...

...

...

...

...

...

...

...

...

...

...

...

...

...

...

Homework: ..

...

...

...

.. Due Date:

INDEX

INDEX

INDEX

INDEX

INDEX

INDEX

INDEX

INDEX

INDEX

CONTACT US

MAILING ADDRESS: Hunter Publishing Corporation, 115 West California Boulevard, Suite 411
 Pasadena, CA 91105

TELEPHONE: 626 792 3316
FAX: 626 792 7077
WEBSITE: www.hpcwww.com
EMAIL: info@hpcwww.com

PRODUCT LIST

The Ultimate Fashion Study Guide - The Design Process
How to Generate Inspiration & Produce Grade A Fashion Design Projects
Softbound, with 'THE TEMPLATES' CD-ROM
ISBN# 978-0-9794453-1-6

The Ultimate Fashion Study Guide - The Design Process
How to Generate Inspiration & Produce Grade A Fashion Design Projects
Softbound ONLY
ISBN# 978-0-9794453-2-3

The Ultimate Fashion Study Guide - The Design Process Templates
CD-ROM ONLY
ISBN# 978-0-9794453-3-0

CD-ROM CONTAINS THESE PRINTABLE .PDF FILES:

SOURCING
Sourcing Directory Card Templates (front & back; black & white and color-coded) for the following
categories: - Woven Fabric - Knit Fabric - Trim - Notion - Construction Items - Contractor - Ancillary

PROFESSIONAL DESIGN PRESENTATION
Technical Flat Templates (Front, Back & Oversized) &
Fashion Croquis Templates (8.5" x 11" and 8.5" x 14) for the following major target customer groups:

CHILDRENSWEAR	WOMENSWEAR	MENSWEAR
- Layette/Newborn	- Tween	- Contemporary
- Infant	- Junior	- Big & Tall
- Toddler	- Junior Plus	
- Little Girl	- Contemporary	
- Little Boy	- Missy/Misses	
- Big Girl/Kid	- Plus Size	
- Big Boy/Kid	- Petite	
	- Maternity	

CLASS NOTES
Class Notes Form Template
